ART OF INDIA AND SOUTHEAST ASIA

ART OF INDIA AND SOUTHEAST ASIA

Text by HUGO MUNSTERBERG

HARRY N. ABRAMS, INC. Publishers NEW YORK

For my friends and colleagues John Frank and Robert Pyle
in appreciation of their help in making this book possible

Front end papers:
Scene from Ramayana, Prambanan, Java. Stone relief. Tenth century

Back end papers:
Dharmaraja Rath and Durga Sanctuary at Mamallapuram.
Early Medieval period, seventh century A.D.

Standard Book Number: 8109–8013–4
Library of Congress Catalogue Card Number: 69–12487

Contents

PREFACE

This book could never have been produced without the generous help of the many private collectors and museums who permitted me to reproduce objects in their collections, and the friends who made their photographs taken in India available to me. Among the latter I am particularly indebted to John Frank, Robert Pyle, and Dan and Anita Christoffel. As on many previous occasions, I am also deeply indebted to my wife who with painstaking care went over the manuscript and made many helpful suggestions and corrections. Finally I wish to thank my teacher, Professor Benjamin Rowland, with whom I had the privilege to study Indian art during my years as a graduate student at Harvard.

NEW PALTZ, NEW YORK HUGO MUNSTERBERG

Introduction

The last of the great artistic traditions of Asia to be recognized and appreciated was that of India. In fact all memory of the earliest phase of Indian civilization, namely, that of the Indus Valley, had been lost until the spade of the modern archaeologist uncovered the ruins of Mohenjo-Daro and Harappa in 1924. Since that time a wealth of material dating from the third and second millennia has been found, not only in the Indus Valley itself but all over northern India. This suggests that a great civilization with large urban centers and highly developed arts flourished in India during prehistoric times long before the Aryan invaders came from the north, destroying these cities and replacing this civilization with one of their own. Just who these ancient Indian people were and where they came from is still being debated by scholars, but it is generally believed that the bulk of the prehistoric population was of a negroid stock related to the modern Dravidians now inhabiting southern India, while others, perhaps no more than a small ruling group, were of a different racial type, probably of Near Eastern origin and related to the Sumerian people of ancient Mesopotamia.

After the end of the so-called Indus Valley, or Indo-Sumerian, civilization, the visual arts languished for over a thousand years, since the Aryan people, although very creative in religion, philosophy, and literature, had no artistic tradition of their own and had destroyed the one they found when they conquered India. The only artistic monuments surviving from this Vedic age are clay idols, sacred implements used in religious services and rituals, and a large quantity of pottery which is closely related to that of prehistoric Iran.

A revival of art occurred in the third century B.C. under Buddhist inspiration

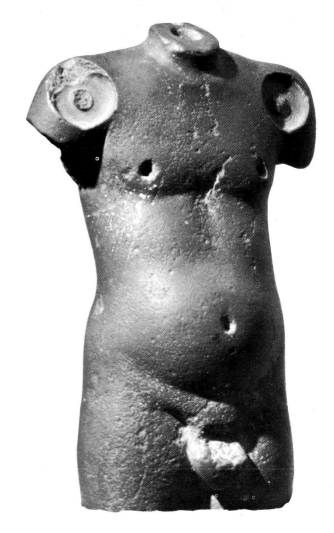

Male torso. Limestone. Indus Valley civilization, third millennium B.C. Museum of Central Asian Antiquities, New Delhi

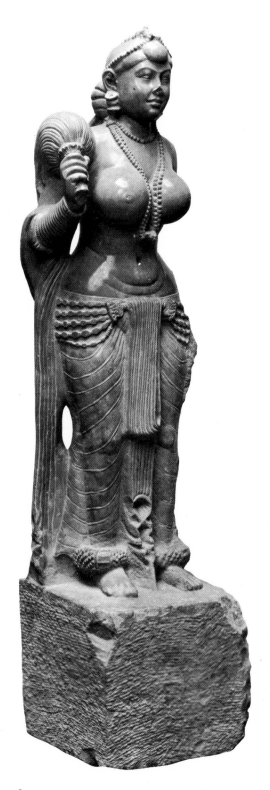

when the famous Indian king Ashoka, after establishing a large empire, became a devout Buddhist and a great patron of Buddhist art. With his reign the arts began to flourish again, and especially in the realm of sculpture, which at all times was the most important art form in India, outstanding results were achieved. Although the subjects represented and the iconography employed were truly Indian and Buddhist, the forms and the style of carving were derived from Persian sources. It is even possible that some of the builders and carvers working for Ashoka were actually of Persian origin, no doubt refugees from Achaemenid Persia which had recently been conquered by Alexander the Great and had become part of the Hellenistic empire.

The following centuries saw a great outburst of artistic activity, largely in the service of Buddhism and the Buddhist church. Most outstanding among these monuments are the gravemounds, called stupas in Indian Buddhism, which were erected in memory of the Buddha and his saints, the caitya halls used for religious services, and the viharas which were used to house the monks. Yet here again the most important works are no doubt the sculptures produced during this period which are among the masterpieces of Indian art. Some of them, sculptured in the round, served as sacred icons, others were architectural in character and formed part of the stupas and caitya halls, but all of them show that wonderful feeling for plastic form which is so characteristic of Indian carving throughout the ages. Although the person of the Buddha was never depicted in these early Buddhist works, episodes from his life and legend were represented in which the presence of the Great Teacher was indicated by symbols such as the wheel, the tree under which he achieved Enlightenment, and the trident.

The second phase of Indian Buddhist art began under the Kushan rulers who came to power during the first century A.D., and it was during this period that the type of image which to this day is thought of as the classical representation of the Buddha was first created. The two great centers of artistic activity were Mathura in the central section of northern India, and Gandhara province in northwestern India where a hybrid style called Greco-Buddhist flourished. The great patron of the

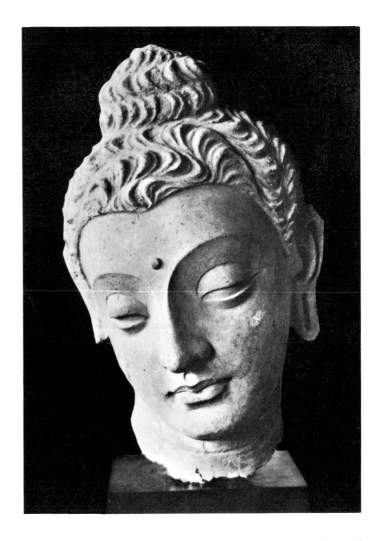

Head of Buddha. Stucco. Greco-Buddhist, fourth century A.D. British Museum, London

arts at this time was King Kanishka who was responsible for the erection of innumerable temples and stupas and the production of huge quantities of sacred images. Among these the most impressive are those of the historical Buddha Sakyamuni, who is now treated in human form. The standard way of depicting him is as an Indian monk dressed in a monk's garment, his face reflecting the serenity of the Enlightened One, and his body showing the marks of the Great Being: the ushnisha, or protuberance on his head, symbolizing his omniscience; the urna, or third eye, indicating that he sees all; and the large ears showing that he hears all.

The classical formulation of the Buddha image and the high point of Indian Buddhist art come with the next major period, the Gupta age, which lasted from the fourth through the sixth century. In Gupta art the two earlier strains, the native Mathura and the late classical Gandharan, were merged into a new style which gives perfect expression to the ideals of Buddhism. Many splendid works have survived from this period: architecture, sculpture, and also painting, notably that at Ajanta in the Deccan. Although the pictorial arts had flourished earlier and some small fragments of frescoes dating from an earlier period have survived, it was only during the Gupta period that this art form reached its maturity. In fact it can be safely said that no paintings from this period comparable to those at Ajanta can be found elsewhere in Asia or in Europe.

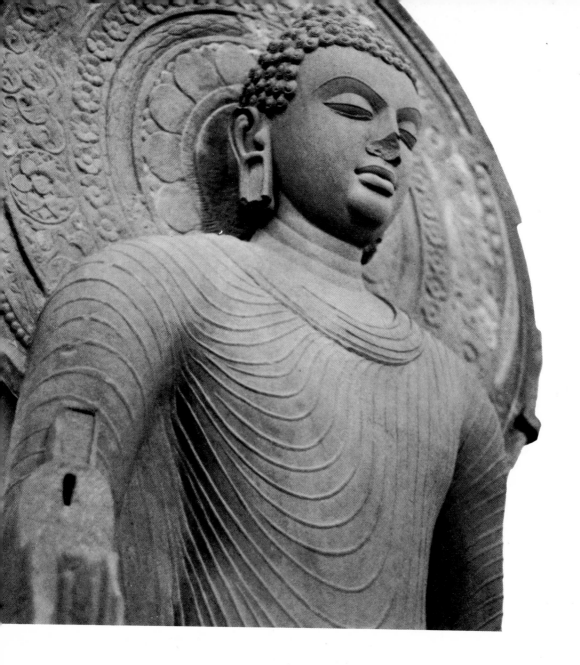

With the seventh century a completely new epoch of Indian art began during which Hinduism rather than Buddhism played the dominant role. Only in Bengal and Bihar in eastern India did Buddhism continue to be a major source of inspiration, while in the rest of India almost all art was produced under Hindu auspices. This age, which is usually called the Hindu Medieval period, lasts from the seventh to the thirteenth century when northern India was overrun by Islamic conquerors. The two chief deities worshiped by the Hindus and represented over and over again in the art of the period were Shiva, the Destroyer, and Vishnu, the Preserver, who to their devotees became the gods par excellence, far more important than all the many other deities

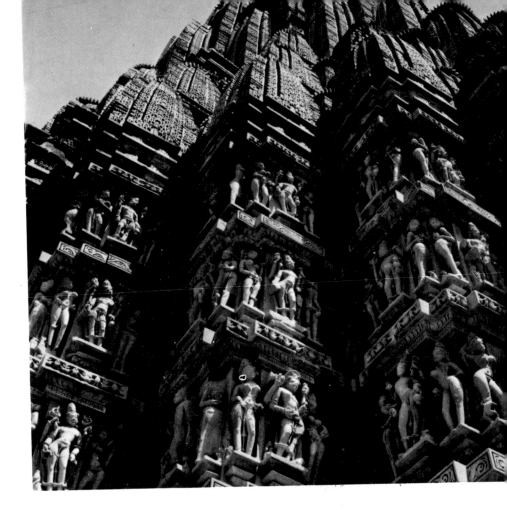

Buddha. Sandstone. Gupta period, fifth century A.D. Indian Museum, Calcutta

Sculptural figures at Lakshmana Temple, Khajuraho. Sandstone. Late Medieval period, tenth century.

of the Hindu pantheon. Each had his shakti, or female counterpart, for Shiva, the beautiful Parvati, the goddess of love and beauty, and for Vishnu, Lakshmi, the goddess of prosperity and good fortune. While the Buddha represents the ascetic ideal of India, the withdrawal from the world and the ultimate fulfillment in the nothingness of Nirvana, Hinduism embodies a very different spiritual ideal, namely, the identification of the soul with the creative energy of the universe symbolized by the gods.

The great artistic monuments of the early phase of the medieval period are the cave temple at Elephanta in Bombay Harbor, the monumental Kailasa temple at Elura in Central India, and the rock temple at Mamallapuram near Madras in the south. Although they serve as sanctuaries, they are not really structures in our sense of the term, but giant sculptures carved out of living rock. At these sites there are thousands of carvings representing the gods and goddesses and the multitude of sacred beings, giving visual expression to the cosmos as conceived of by the Hindus. Here the world of the spirit and the world of the flesh are seen as two aspects of the same reality, for in these carvings the spiritual and the sensuously beautiful are combined in works of great beauty and expressive power.

This tendency is even more evident in the great architectural and sculptural monuments of the later phase of medieval Hindu art, the tenth to the thirteenth century, when thousands of temples were erected all over India. The most celebrated are those at Khajuraho in northern India, and at Bhuvanesvara and Konarak in

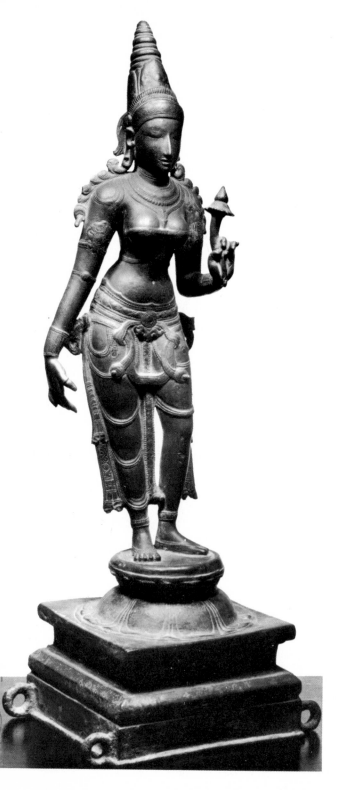

Orissa in the eastern part of the country. Perhaps the most outstanding feature of these temples was their sculptural decoration consisting of thousands of figures and relief carvings representing gods, goddesses, angels, demons, and above all the mithunas, or loving couples, who through their physical union suggest the union of the soul with the deity. Many of these scenes are frankly erotic in character, for to the Hindu mind there was no dichotomy between the spiritual and the sensual. No other civilization has ever produced such an abundance of vital and expressive sculpture. The temple buildings themselves are really gigantic pieces of sculpture which are meant to be magic replicas of the mythical Mount Meru, the World Mountain, or Mount Kailasa, the Hindu equivalent of Mount Olympus where the gods were believed to dwell.

With the Moslem invasions and the conquest of northern India by Islam, this great period of Hindu art came to an end, making way for a very different art which was derived from Iranian sources. Only in the south, which remained relatively free from Islamic influences, did the Hindu tradition survive with huge temple complexes like the one at Madura representing the last important manifestation of Hindu architecture. Another art form which continued to flourish in the south was bronze sculpture which had celebrated its greatest triumphs under the Chola dynasty during the tenth, eleventh, and twelfth centuries, and continued to be produced almost up to modern times.

Painting also flourished, with excellent miniatures being made in northern India as late as the middle of the nineteenth century. The two great centers were Rajputana and

Lakshmi. Bronze. Chola period, twelfth century. Morse Collection, New York

Seated Buddha, from
Thailand. Bronze.
Fourteenth century.
Wolff Collection,
New York

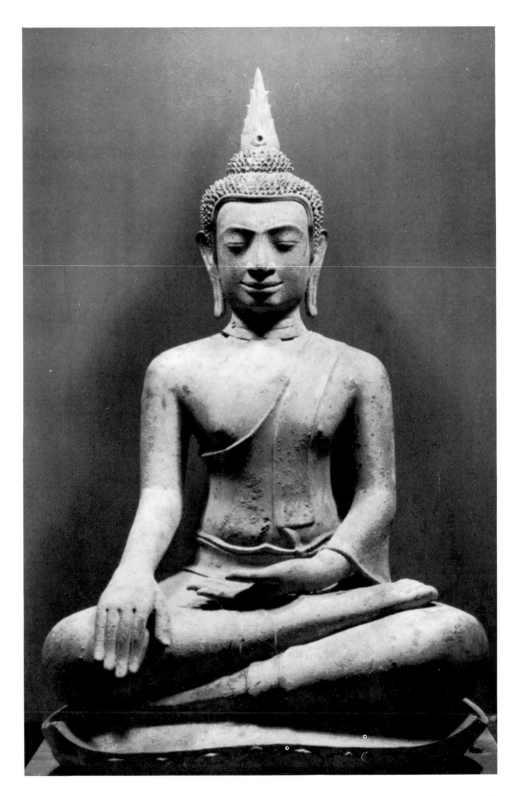

Dancing Apsaras, from Cambodia. Sandstone. Twelfth century. Musée Guimet, Paris

the foothills of the Himalayas. Although usually small in format and for the most part made by anonymous artists, these paintings are often of extraordinary beauty, especially in their color and design. The most common subject is that of Krishna, one of the manifestations of the god Vishnu, who is usually shown with his beloved, the beautiful milkmaid Radha. Other favorite themes are the musical modes, or ragas, and episodes from Hindu legend. Less common were portraits and scenes from contemporary court life. This late flowering of Indian art ended about a century ago, and the story of modern Indian art is that of increasing Western domination.

The influence of Indian art was by no means restricted to the Indian subcontinent but spread throughout an area which has sometimes been referred to as Indian Asia, or Greater India. Buddhist art, due to its missionary nature, spread throughout Asia as far as Indonesia and Indo-China in the south, and China and Japan in the east. In fact the Buddhist art of Asia is ultimately derived from Indian sources and uses an iconography first developed in the homeland of Buddhism. Is is interesting to note that long after Buddhism and Buddhist art

had ceased to be a major force in the cultural life of India, it served as a source of inspiration to peoples throughout eastern and southern Asia.

The first countries outside India which felt the impact of Indian Buddhism were Afghanistan, Central Asia, and Ceylon, but soon Buddhist art was being made in Java, Burma, Thailand, Cambodia, and Viet Nam, as well as Nepal, Tibet, China, and Japan. In fact, in some of these countries Buddhist art is still being produced at the present time. Although deeply influenced by Indian prototypes, this art was by no means only a provincial imitation. Certainly the great stupa at Borobudur, the enigmatic smiling Buddhas at Angkor, and the frescoes from Central Asia, not to mention the Buddhist art of China, Korea, and Japan, are all creations of originality and power which are comparable to the finest Indian work.

Although the influence of Hindu art was never as pervasive, since Hinduism did not spread as widely, its repercussions were also felt throughout Southeast Asia and, strangely enough, Hindu gods and motifs are even found in the art of China and Japan. The single greatest work is no doubt the temple at Angkor Vat, Cambodia, which some critics have called the most outstanding of the artistic creations of the Indian world. Other countries in which fine works of art were created under Hindu inspiration are Ceylon, Java, Bali, and Viet Nam. In all cases the work has characteristics which are indigenous along with features which are clearly derived from Indian sources. In these countries also, the modern art tends to be Western-inspired, and the older traditions, both Buddhist and Hindu, have lost their vitality.

Comparative Chronology

	INDIA	GREATER INDIA	WEST
B.C.			
3000	Indus Valley Civilization (3000–1500 B.C.)		Minoan Art
2000			Mycenaean Art
1000	Vedic Period (1500–500 B.C.)		
500	Sakyamuni Buddha		Greek Art
A.D.	Early Buddhist Art (250 B.C.–A.D. 50)		Roman Art
100	Kushan Art (A.D. 50–300)	Buddhist Art in Ceylon and Afghanistan	
500	Gupta Art (A.D. 300–600)		Byzantine Art
900	Early Medieval Art (A.D. 600–900)	Borobudur (Java) Pagan (Burma)	Romanesque Art
1200	Later Medieval Art (900–1300)	Angkor Vat and Angkor Thom (Cambodia)	
1300	Moslem Conquest and End of Hindu Art in North	Buddhist Art in Thailand	Gothic Art Late Gothic
1400	Late Hindu Art in Southern India	Tantric Art in Nepal	Early Renaissance
1500	Jain Miniatures	Lamaist Art of Tibet	High Renaissance Mannerism
1600	Rajput Miniatures (1600–1800)	Folk Art of Bali	Baroque
1700			Rococo
1800	Kangra Painting (1700–1850)	Later Buddhist Art in Thailand	Neo-Classicism Romanticism Realism
1900	Modern Art Under Western Influence	Modern Art	Modern Art

THE ART OF THE INDUS VALLEY CIVILIZATION

The oldest Indian civilization is the one which flourished in the Indus Valley some four thousand years ago. Due to its marked affinities with Sumerian civilization, it is often referred to as Indo-Sumerian, and scholars have suggested that it may indeed be a provincial extension of the culture of ancient Mesopotamia. Of the artistic monuments surviving from this period, the one which shows this relationship most clearly is the portrait bust of a priest or ruler which closely resembles the stone figures excavated in Mesopotamia, both in the carving itself and in the racial type, which is distinctly Near Eastern rather than Indian.

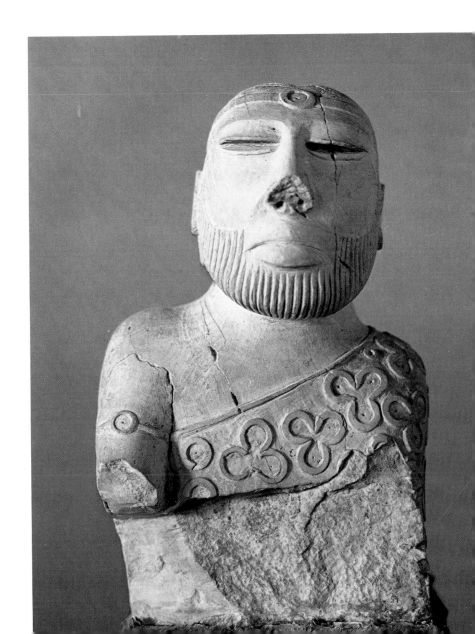

Portrait of a priest. Limestone, height 7″. Indus Valley civilization, third millennium B.C. Museum of Central Asian Antiquities, New Delhi

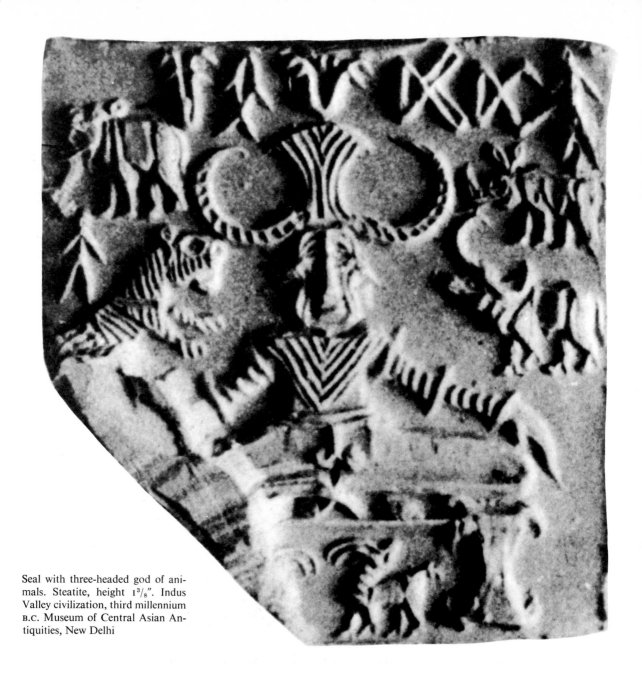

Seal with three-headed god of animals. Steatite, height 1³/₈″. Indus Valley civilization, third millennium B.C. Museum of Central Asian Antiquities, New Delhi

Other cultural features which are found both in prehistoric India and in the ancient Near East are the engraved seal and the written language. Although the Indian script, which unfortunately has not yet been deciphered, does not resemble that of Sumer, it is generally believed that it is most unlikely that these two civilizations would have developed written languages completely independent of one another at approximately the same

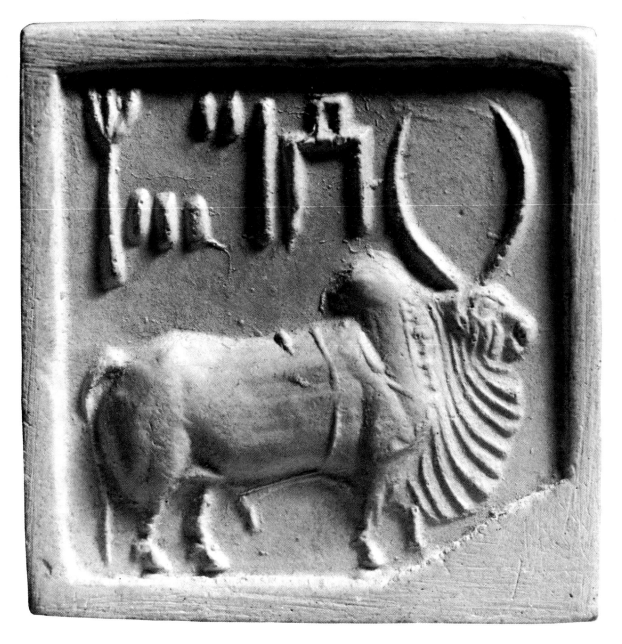

Seal with buffalo. Steatite, height 1¹/₂″. Indus Valley civilization, third millennium B.C. National Museum of India, New Delhi

time. However, it is interesting to note that not only the script itself but the forms represented on the seals are already uniquely Indian, with the horned god seated in the yoga position and surrounded by various animals anticipating the typically Indian image of Shiva as the Lord of the Beasts.

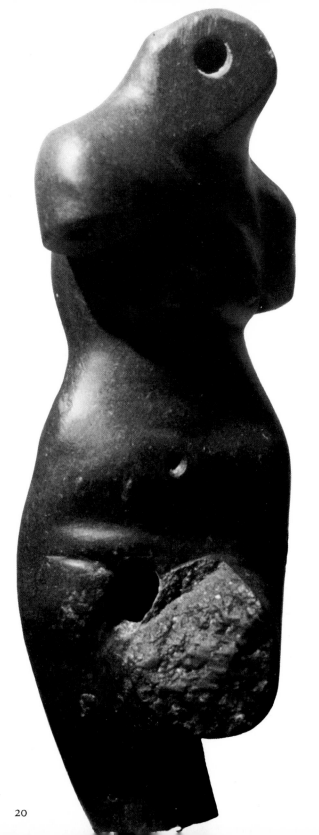

Figure of dancing god (two views). Limestone, height $3\frac{1}{2}''$. Indus Valley civilization, third millennium B.C. National Museum of India, New Delhi

The very Indian nature of the art of the Indus Valley civilization is perhaps best seen by the fact that sculpture, as in all later Indian art, is the most important artistic form and that the carving shows the same kind of vitality so characteristic of Hindu sculpture. While the techniques of metal casting and stone carving may very well have been derived from outside sources, probably Mesopotamia or Iran, there is something in the spirit of the sculptures

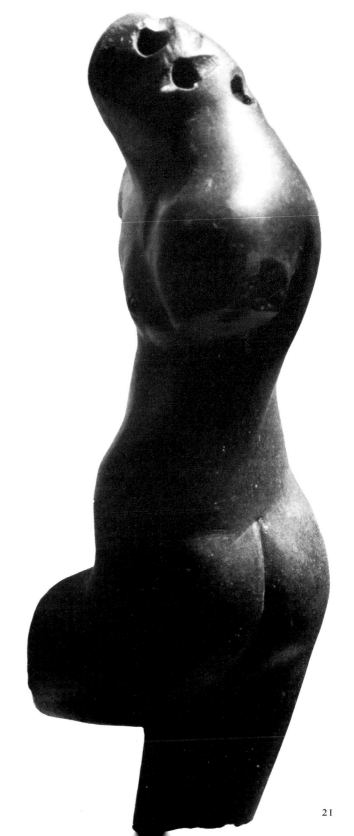

which is already purely Indian, anticipating the kind of work which was to flourish in India in later times. It has been suggested that while the ruling class may have been foreign, with the impetus for the civilization very likely coming from the Near East, the mass of the people were indigenous, probably the ancestors of the Dravidian peoples of southern India.

Next to stone, the most important medium employed by the craftsmen of ancient India was clay. Among the objects made in this material were all kinds of small figurines and ceramic vessels of various shapes and designs. Particularly charming are the clay animal figures which may well have been intended as toys, for they are playful in mood and small in scale. The numerous jars and bowls which have been excavated all over India are typical of the kind of ceramic ware found in the Neolithic civilizations of Asia, but the painted designs covering their bodies are already distinctly Indian with their emphasis on a highly decorative all-over design. The ornamental motifs are usually derived from nature and connected with fertility. There are plants, leaves, flowers, seeds; zigzag lines representing water; sun-birds and the circle with a dot, an emblem which also stands for the sun. All these designs were no doubt symbolical in nature and interestingly enough resemble the fertility emblems used over and over again in later Indian art.

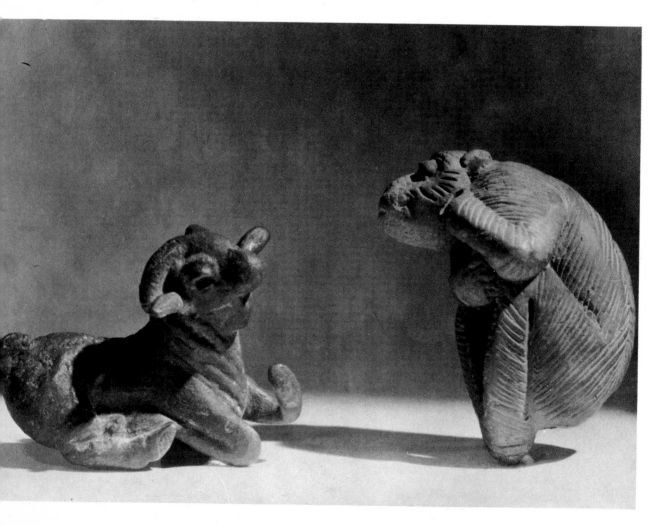

Storage jar with painted design. Clay, height 21³/₄″. Indus Valley civilization, third millennium B.C. Museum of Fine Arts, Boston

◀ Copper ram and clay monkey. Height 2¹/₄″ and 2³/₈″. Indus Valley civilization, third millennium B.C. Museum of Central Asian Antiquities, New Delhi

23

The Indus Valley civilization was followed by a period of more than a thousand years during which virtually no art was produced. During the third century B.C., a new period of artistic flowering occurred under Buddhist inspiration. The most characteristic and important monuments of this time are the Ashoka columns, so named because they were erected by the famous Indian ruler Ashoka who had established an extensive kingdom embracing all of northern India and had become a great patron of Buddhism and Buddhist art. The tall columns, which are inscribed with Buddhist texts and crowned by a lotus capital and symbolical animals, are derived from Iran and resemble those found at Persepolis, but the symbolism is decidedly Indian and Buddhist. The column itself is conceived of as the world axis which is anchored in earth and reaches the sky, uniting heaven and earth; the inverted flower is a symbol of the world which is viewed as a giant lotus with its center in the Himalayas and its petals the four quarters of the universe; and the lion is a royal emblem which is also connected with the Sakya clan to which the historical Buddha Sakyamuni belonged.

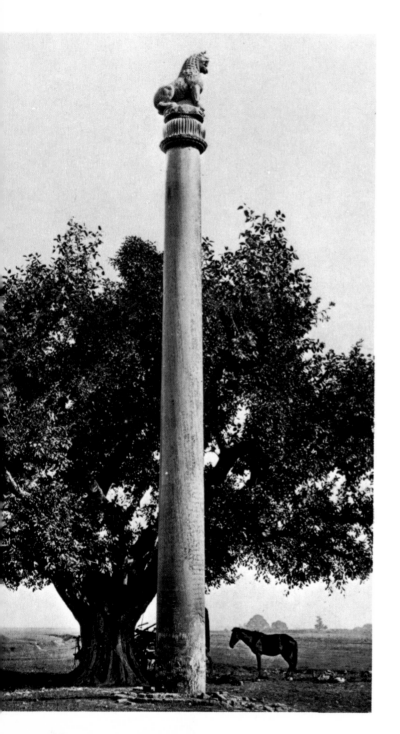

Ashoka lion column, Lauriya Nandangarh. Sandstone. Early Buddhist, third century B.C.

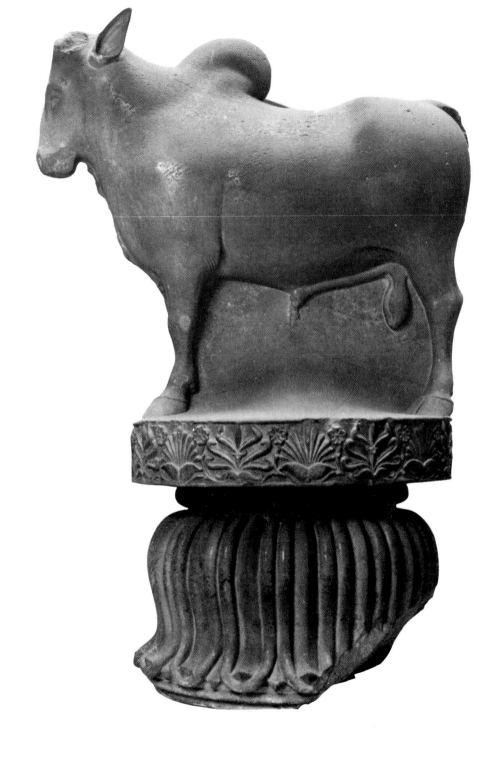

Bull capital, from Rampurva. Sandstone, height 8'8³/₄". Early Buddhist, third century B.C. National Museum of India, New Delhi

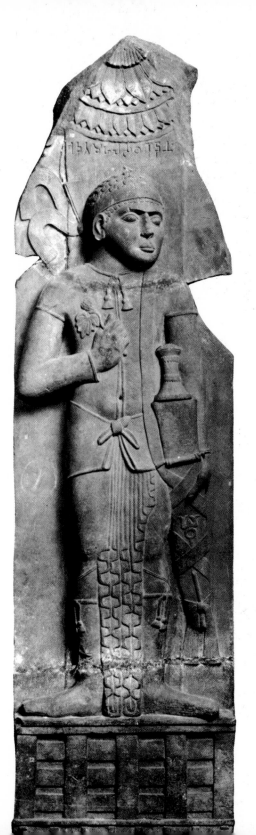

In the early Indian Buddhist sculptures, such as the relief carvings from the great stupa at Bharhut which date from the second century B.C., the style and iconography again show the same mixture of Indian and foreign elements. The stimulus for this art no doubt came from Achaemenid Persia, but the genius of the Indian carvers adapted the Persian forms to new and different purposes. While the yakshi and yaksha figures found among the relief carvings at Bharhut are typically Indian and represent very ancient indigenous nature- and fertility-deities, other figures are clearly derived from Persian prototypes, indicating the source from which this style of monumental stone carving is derived. Yet both style and iconography are now used for Buddhist monuments and embody new and typically Buddhist religious conceptions.

Male figure, on railing pillar from Bharhut. Sandstone, height 78³/₄″. Early Buddhist, second century B.C. Indian Museum, Calcutta

Yakshi, on railing pillar from Bharhut. Sandstone, total height ▶ 83¹/₂″. Early Buddhist, second century B.C. Indian Museum, Calcutta

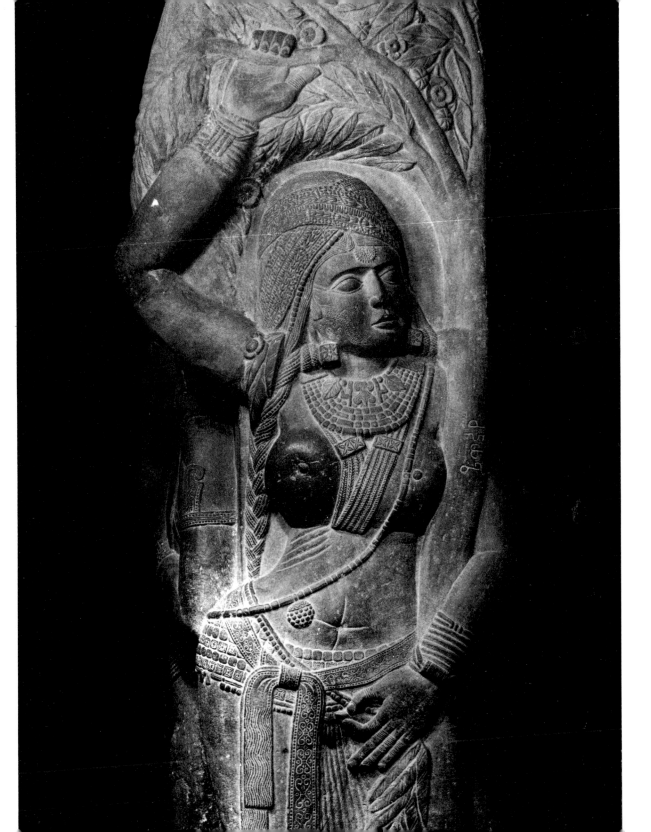

Of the surviving monuments of early Buddhist art, the most impressive are the great stupas, or gravemounds, at Sanchi in Central India. Erected as memorials for the Buddha, they are among the most characteristic of all the Buddhist architectural monuments. Although the form may change and the name applied to these structures may differ from place to place and period to period, the basic concept of the stupa remains the same in all the countries which embrace Buddhism. Here again, as in so much of Indian art, a profound symbolism permeates the entire structure. The base represents the earth, the curved elevation the dome of the sky, the square boxlike shape on top the palace of the thirty-three gods, while the umbrella crowning the whole stands for the royal rule of the Buddha who is supreme over earth, heaven, and the ancient Vedic gods.

The sacred area in which the stupa was enclosed was separated from the outside world by a stone fence or railing with gates, or toranas, opening in four directions, indicating that the peoples of the four quarters of the universe were coming to pay their homage to the memory of the Great Teacher. These gates were usually decorated with sculptural carvings representing the life and legends of the Buddha, as well as figures of Buddhist saints and other heavenly beings. As in the portal carvings of the Christian churches of medieval Europe, these carvings were not so much ornamental as religious, their purpose being to instruct the faithful as they entered the sacred enclosure.

Great Stupa at Sanchi. Massive brick building, encased in sandstone, height 54', diameter 100'. Early Buddhist, second–first century B.C.

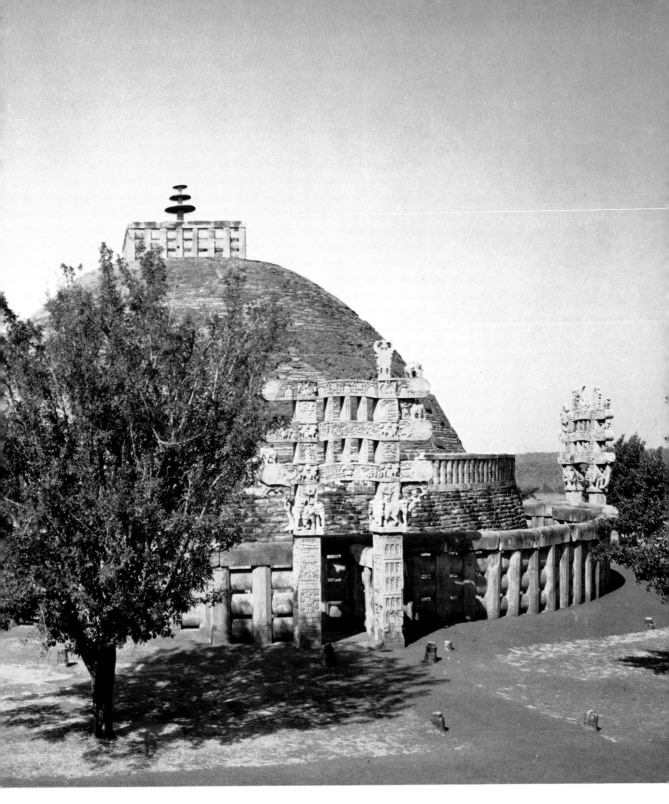

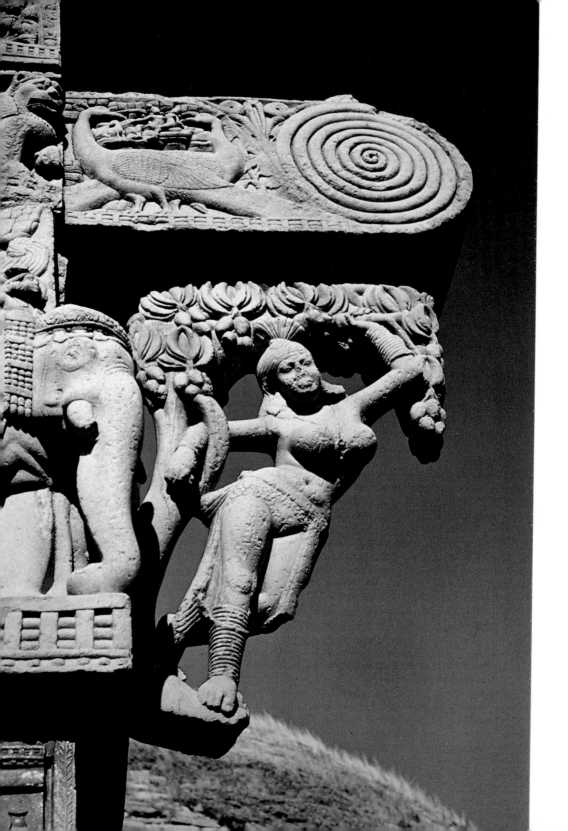

Among the many beautiful carvings found at Sanchi, the loveliest are the portrayals of the yakshis, which were tree-nymphs rather like the dryads of ancient Greece. Their voluptuous bodies symbolize the fecund energy of nature, for their touch makes the tree burst into bloom. Combining the sensuous with the spiritual, they are uniquely Indian, for only in Indian art is there this intimate union between the world of physical beauty and the world of the spirit. To the Indian mind the dichotomy between the flesh and the spirit so deeply ingrained in the Judeo-Christian heritage does not exist; in fact they are seen here as two aspects of the same reality.

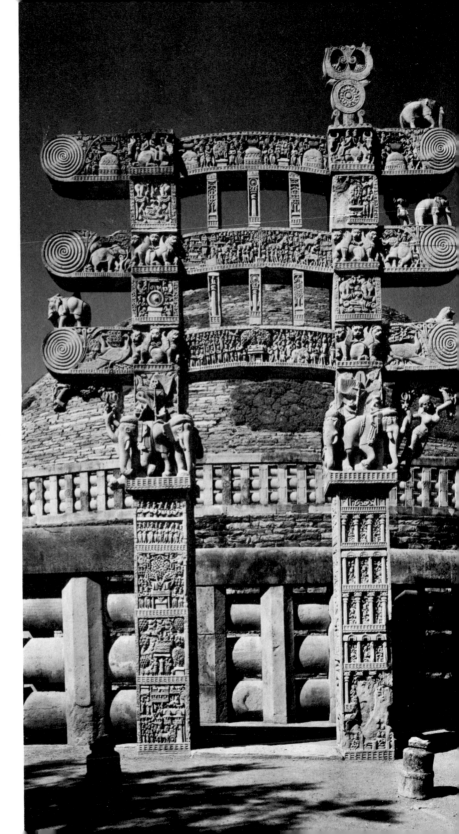

◀ Yakshi, on gate of Great Stupa at Sanchi. Sandstone. Early Buddhist, first century B.C.

Eastern gate of Great Stupa at Sanchi. Sandstone, height 34′. Early Buddhist, first century B.C.

On the panels decorating the pillars and the crossbeams over the gates, there are relief carvings depicting scenes connected with the Buddhist faith. The Buddha himself, however, is never represented. His presence is indicated by religious emblems such as the bodhi tree symbolizing his Enlightenment; the diamond throne of the Buddha; the wheel which stood for his preaching because it was likened to the turning of the Wheel of the Law; the trident symbolizing the Holy Trinity consisting of the Buddha, the Law, and the Buddhist Community; and

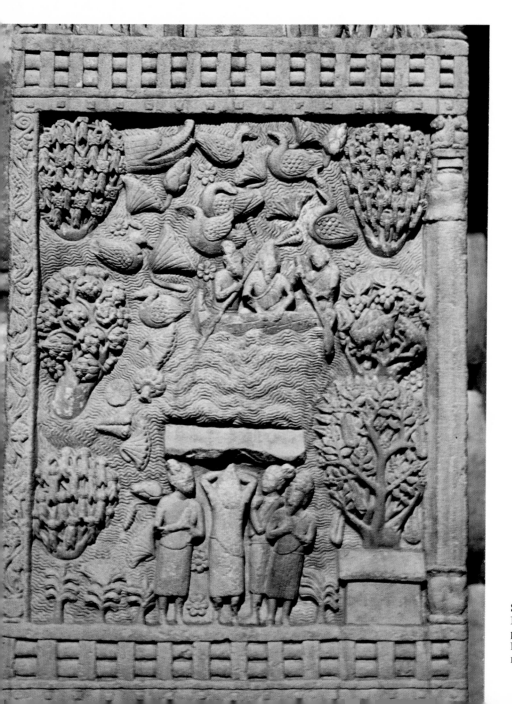

Sculptured panel showing Buddhist miracle, on gate pillar at Sanchi. Sandstone. Early Buddhist, first century B.C.

the stupa which represents his death, or Nirvana. As in so much of Indian art, the forms, although derived from nature, are usually symbolical, expressing religious ideas and concepts.

Particularly lovely are the carvings of flowers, birds, and beasts, reflecting the closeness which the Indians have always felt for the world of nature. Believing in the transmigration of souls where a man may either be reborn as an insect, bird, or animal, or have assumed one of these forms in an earlier incarnation, the Indian finds the difference between human and nonhuman beings is not as pronounced as it seems to be to the Westerner. The forms themselves are always full of life, resembling those of nature but generalized and simplified for the sake of a beautiful design. Here again, as in the decoration of the Neolithic jars, the Indian artist tends to use an all-over pattern, not leaving any part of the surface empty, a feature which is characteristic of Indian art throughout the ages.

Ornamental carving with birds and flowers, on gate of Great Stupa at Sanchi. Sandstone. Early Buddhist, first century B.C.

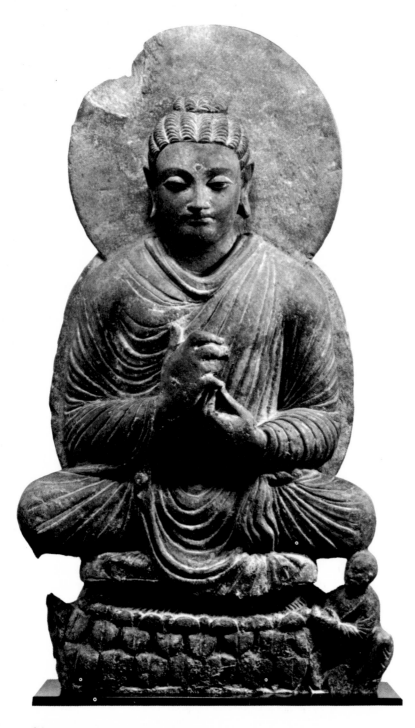

Seated Buddha, from Swat, Gandhara. Schist, height 25″. Kushan period, second century A.D. Boney Collection, Tokyo

Head of Buddha, from Gandhara. Schist. Kushan
period, second-third century A.D. Archaeological
Department of Pakistan, Lahore

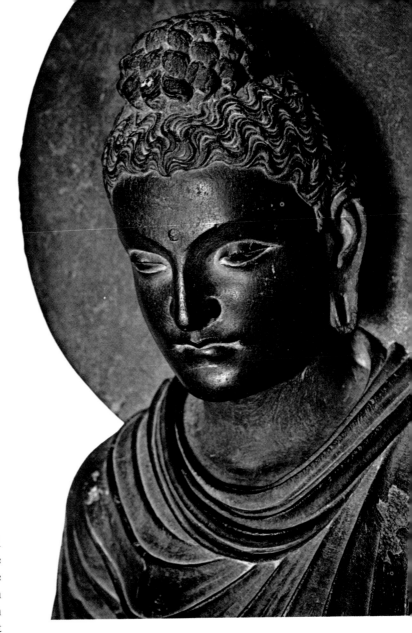

While the early Buddhist artists used
symbols to represent the presence of the
Buddha, beginning with the Kushan rule
during the first century of the Christian
era, Sakyamuni Buddha was depicted in
human form. This practice probably first
occurred in the Gandhara province of
northwestern India, today a part of Paki-
stan, where there had been a marked clas-
sical influence deriving both from late
Hellenistic and Roman sources. The most notable of these Gandharan icons was that of the Buddha seated in
the position of a yogi. Dressed in a monk's garment, his head displays the signs of his supernatural powers—the
large ears; the urna, or third eye, on his forehead; and the protuberance, or ushnisha, on his head. These three
indicate that he hears all, sees all, and knows all. Although the forms are clearly influenced by classical art,
the iconography is strictly Indian, showing that this art represents a fusion of native and foreign elements.

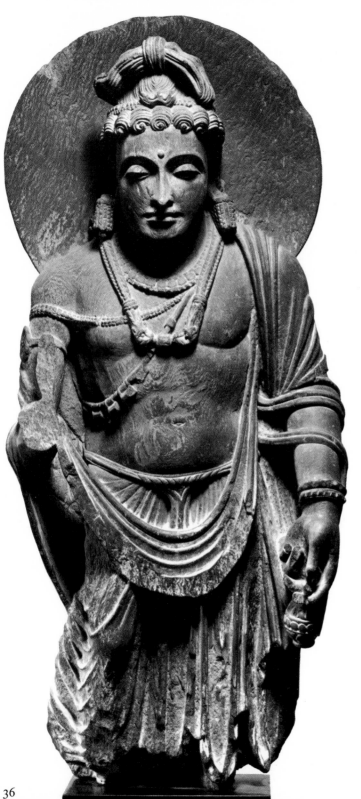

Standing bodhisattva. Schist, height 29″. Greco-Buddhist, second century A.D. Private collection, Geneva, Switzerland

In contrast to the Buddha who is always represented as wearing a monk's garment and having short hair, an iconography which symbolizes the fact that the historical Buddha Sakyamuni renounced the world and became a monk, the bodhisattvas, or Buddhist saints, are shown with a bare

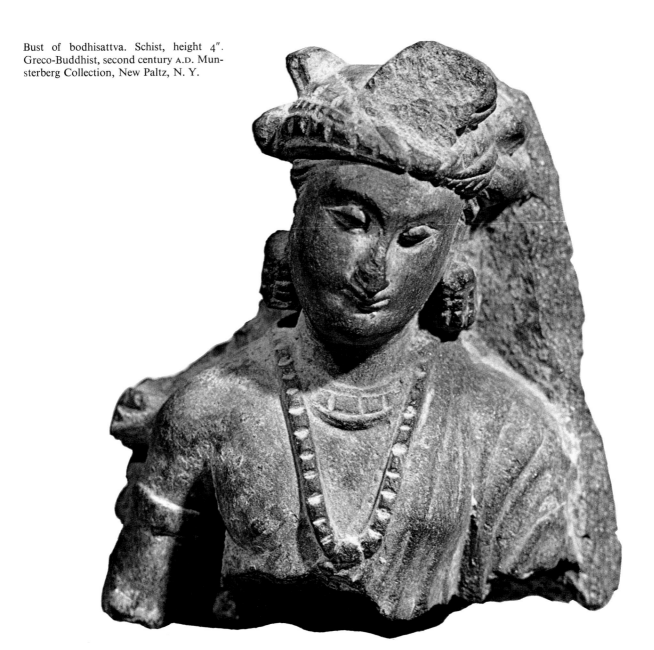

Bust of bodhisattva. Schist, height 4″. Greco-Buddhist, second century A.D. Munsterberg Collection, New Paltz, N. Y.

upper body, skirt, scarves, jewels, and long hair, since Sakyamuni before his renunciation had been a royal prince. This contrast between the Buddha as the sacred being who has achieved Enlightenment, and the bodhisattva who is on the road to this goal but has not yet attained it, is found in all the Buddhist art of Asia, not only in India itself but also in East and Southeast Asia. Many of the loveliest and most moving of the Buddhist images are not of the Buddha but of the great bodhisattvas, for they have a gentleness and warmth not found in the more austere renderings of the Buddha himself.

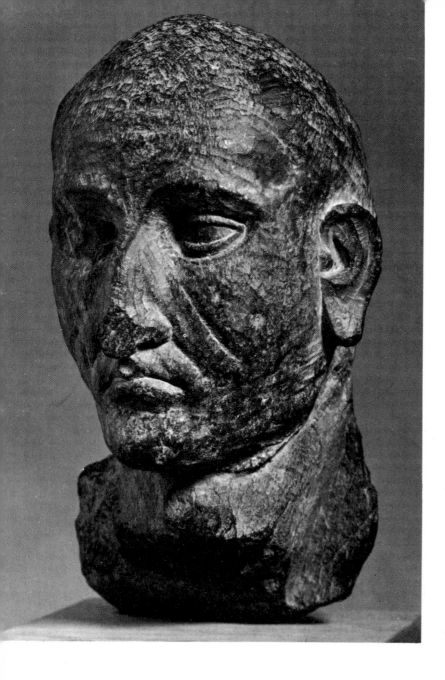

Head of monk, from Gandhara. Schist. Kushan period, second century A.D. Museum für Indische Kunst, Berlin

Head of brahmin, from Gandhara. ▶ Stucco, height 7¹/₈″. Kushan period, third century A.D. Museum für Indische Kunst, Berlin

The great strength of the classical elements in the so-called Greco-Buddhist art of the Gandhara province is best seen in the portrait heads and the representations of classical deities which found their way into the Buddhist art of northwestern India. The inspiration for this art came largely from that of Imperial Rome which

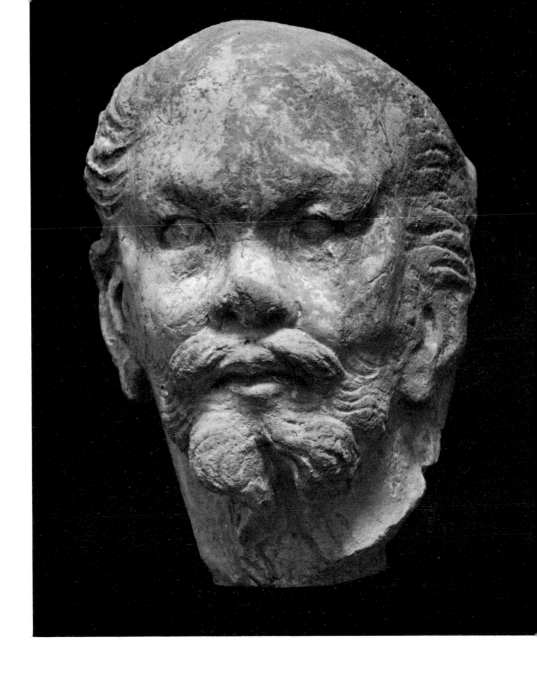

had spread throughout western Asia since Roman garrisons were stationed in many countries of the Near East. In fact some of these sculptures would have been taken for provincial Roman work from Gaul or one of the other Roman provinces had they not been found at Buddhist sites in the Gandharan region.

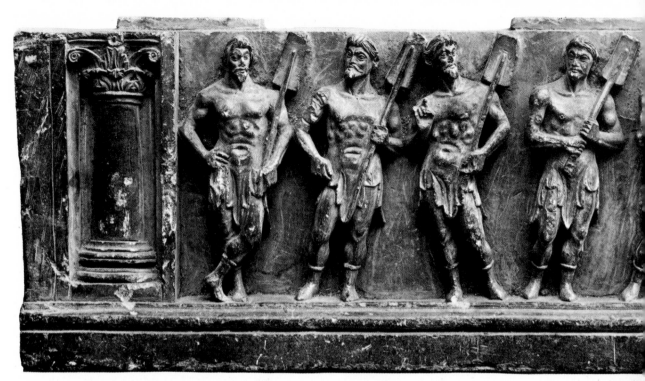

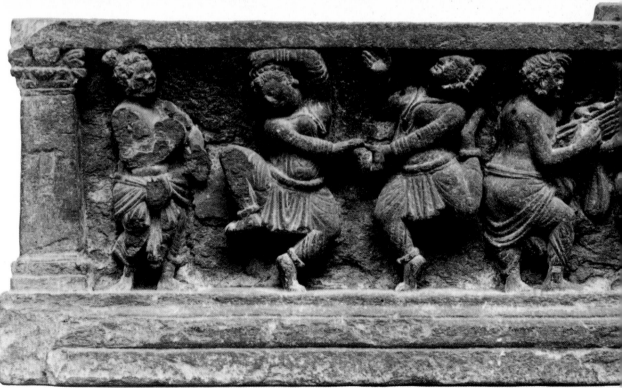

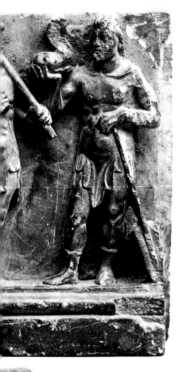

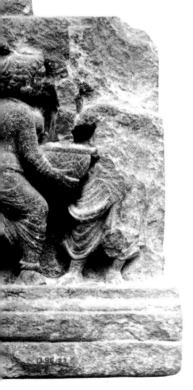

Musicians and dancers. Schist, height 6¹/₂″. Greco-Buddhist, first century A.D. The Metropolitan Museum of Art, New York City

A strong classical influence is also seen in the relief carvings which, both in their artistic style and in much of their iconographical detail, are closely related to Roman relief sculptures of Imperial times. The position of the figures, the treatment of the body, and the architectural forms used are all clearly derived from Roman models, suggesting either that examples of Roman sculpture were known to the Gandharan carvers, or that Roman artisans had come to this part of the world, which, considering the far-flung outposts of the Roman empire, is not at all unlikely. This influence is especially noticeable in some of the subjects treated which are not Buddhist but classical in character.

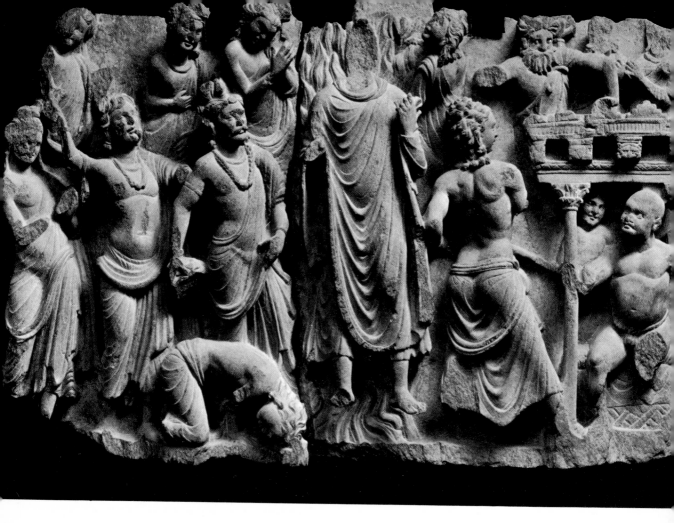

Buddha appearing to Sumagadha. Schist, height 13⅜″. Greco-Buddhist, second century A.D. Central Museum, Lahore

Siddharta being presented with his bride. Schist, height 6¼″. Greco-Buddhist, second century A.D. Rowland Collection, Cambridge, Mass. ▶

Most of the Gandharan reliefs portray episodes from the life of Sakyamuni Buddha or scenes from Buddhist legend. In fact the entire life of the Buddha, his birth, his youth as Prince Siddharta growing up at a North Indian court, his marriage, his renunciation of royal prerogatives, his period as an ascetic, his Enlightenment under the bodhi tree at Bodhgaya, his first sermon in the Deer Park at Benares, his teaching, his miracles, and finally his death, or Nirvana, may be traced in the thousands of relief carvings which decorate the various holy sites of Buddhism.

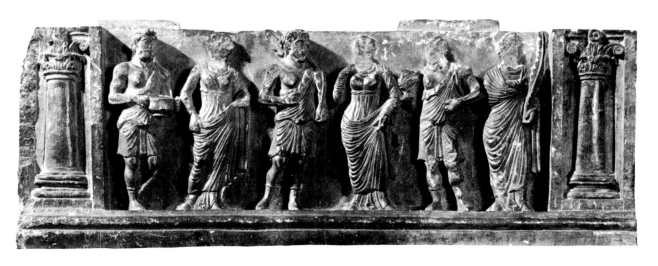

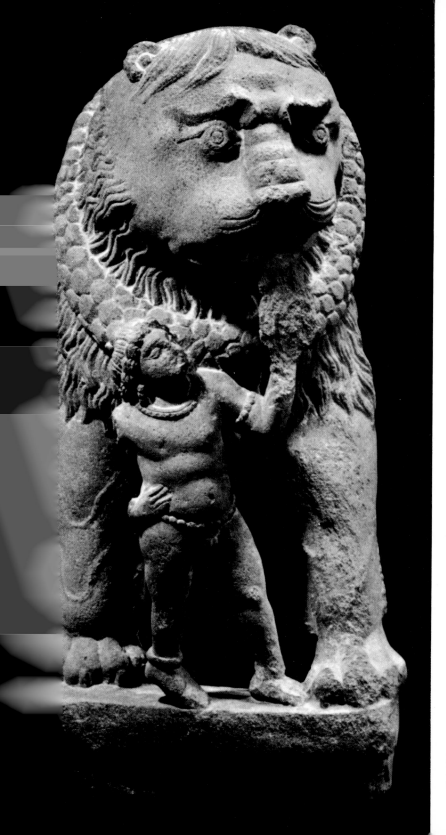

Not only deities and human beings were represented in the Greco-Buddhist art of the Gandharan region; there were also animals, although they never played the prominent role which they had at Sanchi, thus indicating the humanistic, man-centered emphasis characteristic of the classical tradition. Most important among these animals was the lion which

Pair of lions. Schist, height 20". Greco-Buddhist, second century A.D. Boney Collection, Tokyo

from ancient times had been used as a royal symbol and was considered the most powerful of all beasts. In Buddhist art two lions are usually shown flanking the Buddha's throne, symbolizing his kingly position as ruler among men and at the same time serving as the emblem of the Sakya clan to which the historical Buddha belonged.

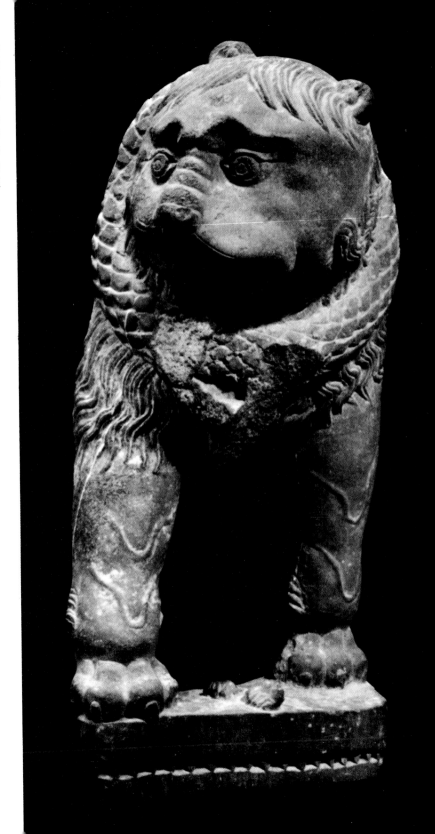

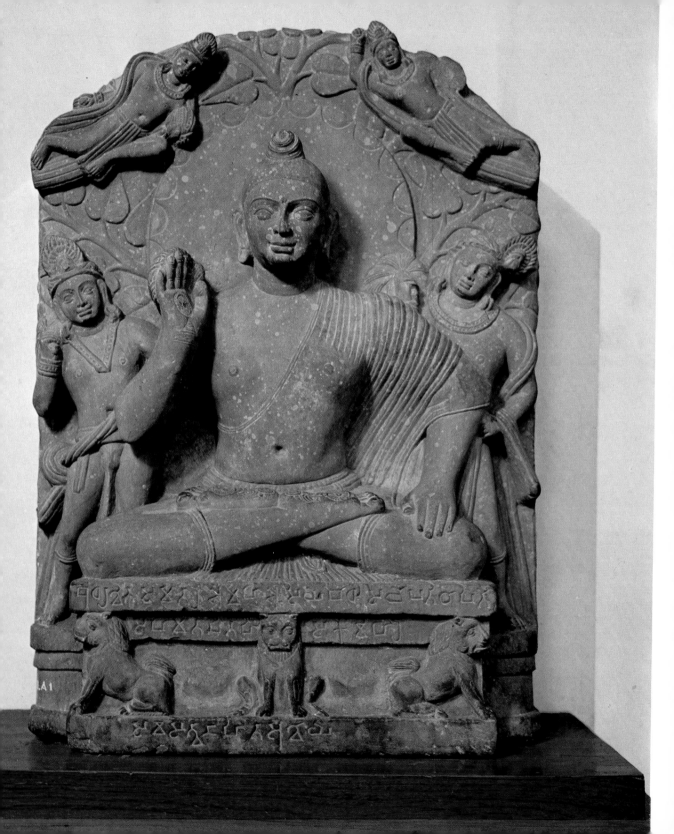

◄ Buddha stele, from Katra. Archaeological Museum, Mathura

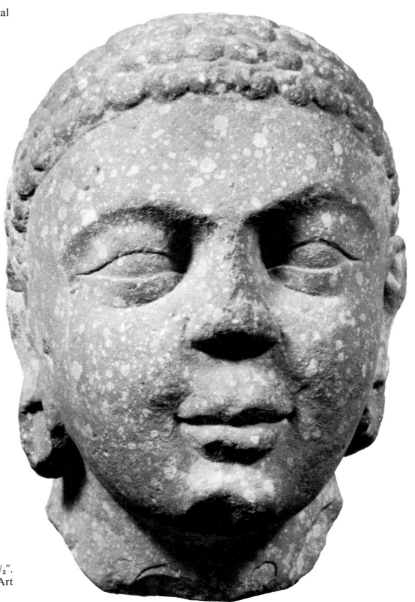

Head of Buddha. Sandstone, height 13$^1/_2$". Mathura School, second century A.D. Art Institute of Chicago

While the Greco-Buddhist school of Kushan art flourished in the North-West Frontier region around the cities of Peshawar and Taxila in present-day Pakistan, another school of sculpture more closely related to the native Indian tradition developed in India proper, at Mathura, not far from Delhi in northern India. There has been considerable debate among scholars as to which of these schools was responsible for the origin of the Buddha image, a question which has not yet been settled conclusively. However, it is certain that this development took place under the foreign, Indo-Scythian, Kushan dynasty and that the impetus came from the outside even though the forms used by the Mathura artists were truly indigenous.

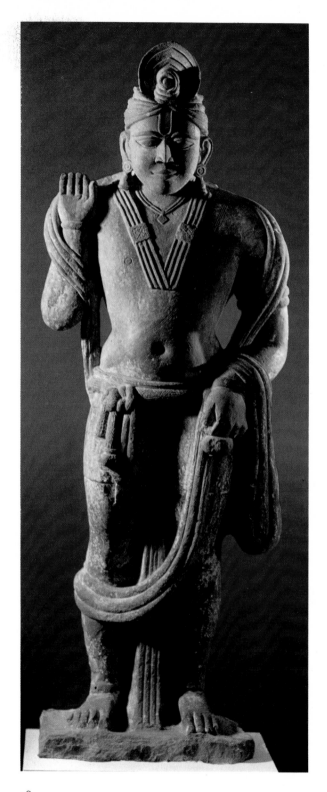

Bodhisattva Maitreya, from Mathura. Sandstone, height 69¼". Kushan period, second century A.D. Archeological Museum, Mathura

The style employed by the Mathura sculptors is a direct continuation of the style found in the early Buddhist art of the pre-Christian era and shows no classical influence whatsoever. Instead of the rather severe and often dry manner typical of the Gandharan artists, the Mathura carvers used softer and rounder forms, showing the warmth and sensuousness characteristic of the native Indian tradition. This is particularly evident in the representations of the bodhisattvas who are clearly derived from the earlier yaksha figures, instead of the orator or Apollo-type images which had inspired the Gandharan statues. Another important difference which also influenced the style is the kind of stone used by the two schools, for while most Gandharan images are of gray schist, the Mathura sculptures are made of soft red sandstone.

Bodhisattva. Sandstone, height $69^5/_8''$.
Mathura School, second century A.D.
Curzon Museum of Archaeology,
Mathura

49

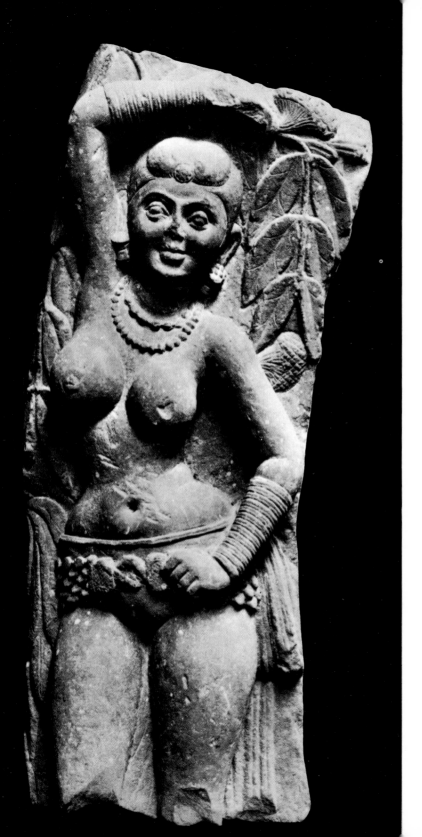

Of all the subjects treated by the Mathura artists, the most traditional as well as the most appealing as works of art are the numerous representations of the yakshis, or tree-nymphs, which continued to enjoy great popularity. In contrast to the Buddha who represents the ascetic ideal, these fertility-deities are

Yakshi. Sandstone, height 20½″. Mathura School, second century A.D. Victoria & Albert Museum, London

an expression of a far more ancient Indian folk religion which had become incorporated into Buddhism. Here the peculiarly Indian union of the spiritual and the sensual finds its most beautiful manifestation in the swelling, voluptuous forms of the yakshis' bodies reflecting the teeming energies of nature.

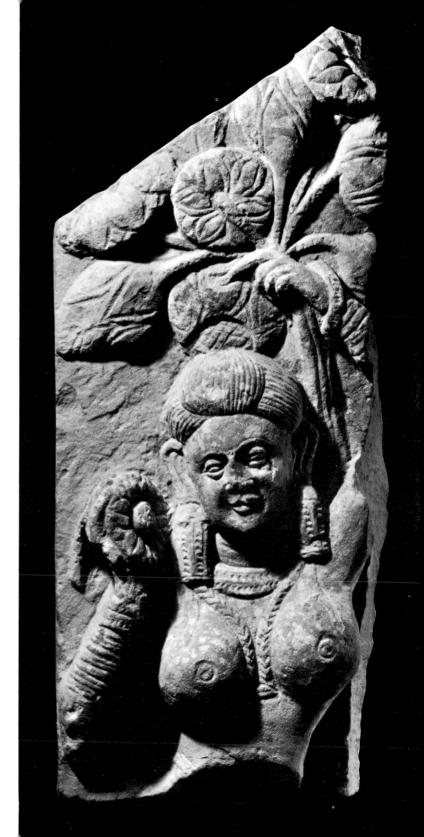

Yakshi. Sandstone, height $18^{1}/_{2}''$. Mathura School, second century A.D. Private collection, New York

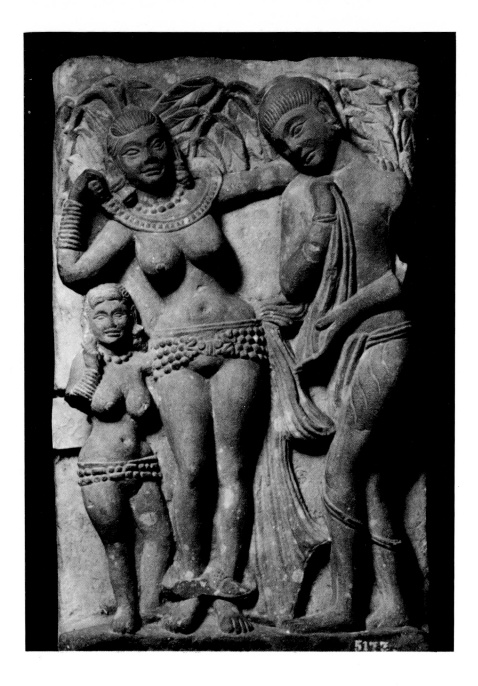

Genre scene. Sandstone, height 14¹/₈″. Mathura School, second century A.D. Indian Museum, Calcutta

The emphasis upon sensual beauty is by no means restricted to the yakshis but may be found in many Mathura sculptures, some of them religious, others purely secular in character. For example, the representations of donors at the entrances to the great cave temples as well as the couples in the genre scenes show this same

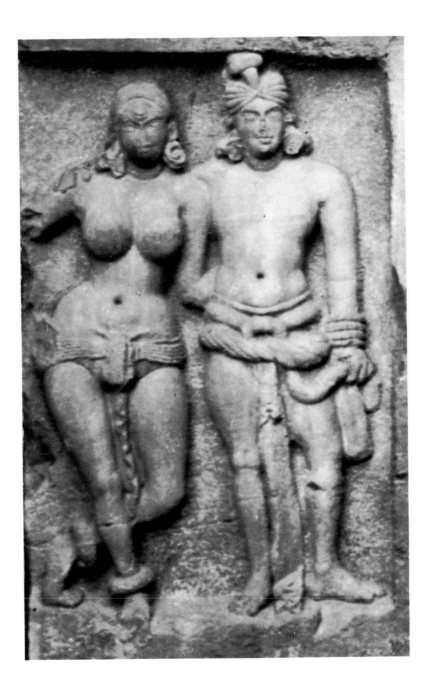

accent on the beauty of the female form rendered with a wonderful feeling for the softness and sensuousness of female flesh. Ornamented only with a girdle and jewels, these women display the curves of their bodies and the swelling globes of their breasts with an unselfconsciousness and a natural grace which is beautiful indeed.

Stupa relief, from Amaravati. Marble, height 48″. Andhra period, second century A.D. The Metropolitan Museum of Art, New York City

Relief showing Great Departure and Temptation of Buddha. Marble, height 56³/₄″. Andhra period, second century A.D. The Metropolitan Museum of Art, New York City

In addition to Gandhara in the northwest and Mathura in the north, there was a third important artistic center during the first centuries of the Christian era, and that was Amaravati which was in the south near Madras where the Andhra dynasty ruled. The main artistic monument was a huge stupa which unfortunately has not survived, but many of the relief carvings that decorated the drum and the railing of the stupa have come down to us. Particularly interesting are those which show this structure as it must have looked in ancient times, with the surface of the burial mound decorated with images of all types depicting the Buddha surrounded by worshipers, guardians, and lions, as well as showing scenes from his life and legend.

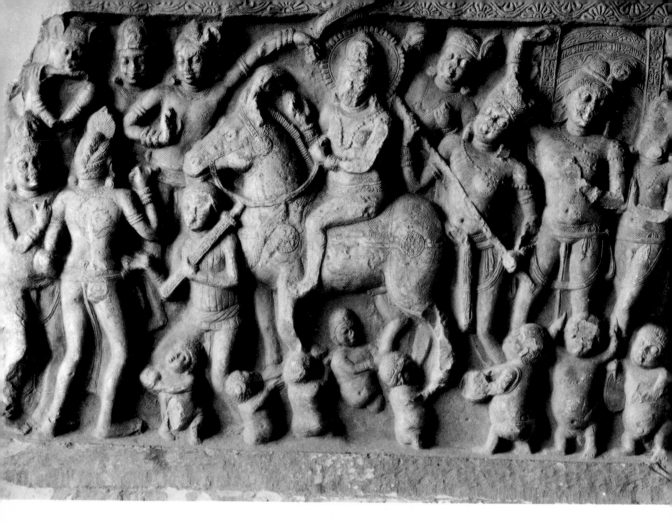

Scenes from the Life of the Buddha. Limestone, height 97¹/₄″. Andhra period, second century A.D. British Museum, London

The style employed by the South Indian artists at Amaravati differs from that used by their contemporaries both at Mathura and Gandhara. In a way it is perhaps more closely related to that found at Sanchi with its wealth of detail and its passion for covering every inch of the surface. An inscription at Sanchi suggests that some of the artisans belonged to the guild of ivory carvers, and it may indeed have been the origin of this style in ivory or wood which accounts for the meticulous manner in which the forms are carved, as well as the strong sense of decorative all-over design which characterizes these sculptures. Another difference between these southern carvings and those of the northern schools is the material, which is limestone or marble in the south in contrast to the schist and sandstone of the north.

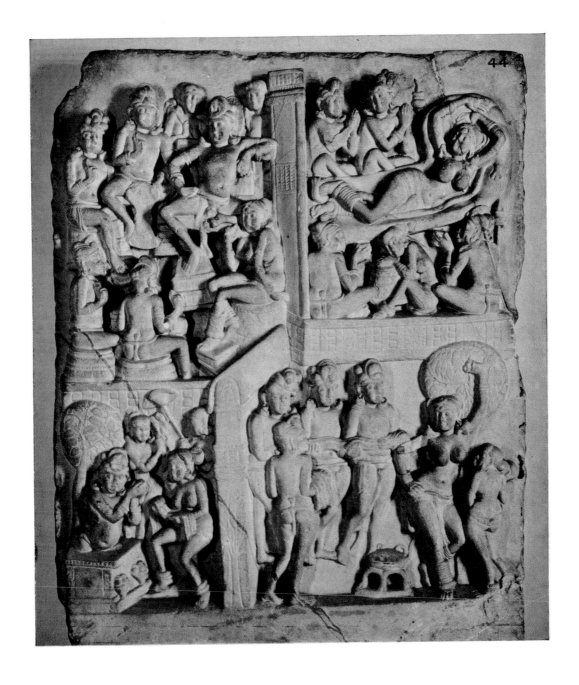

Relief carving depicting the Birth of the Buddha, from the Great Stupa at Amaravati. Marble, height 63″. Andhra period, second century A.D. British Museum, London

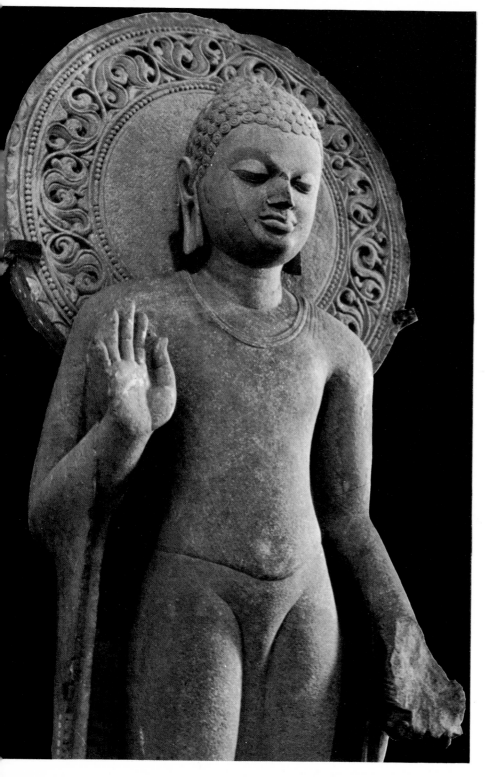

Detail of figure on facing page

The climax of Indian Buddhist art, when all the previous tendencies were synthesized into a classical statement which was to inspire much of the art of the entire Buddhist world, came under the rule of the Gupta dynasty. This period lasted from the fourth to the sixth century, although the style continued somewhat longer than the actual rule. The Gupta period is rightly considered the golden age of Indian culture, for not only art flourished but also literature, drama, and music. In the Gupta images, the Buddhist ideal of serenity finds its noblest expression, with the forms of the Buddha's body, the expression of his face, and the smile hovering over his lips suggesting the ultimate harmony which had been achieved by the Enlightened One.

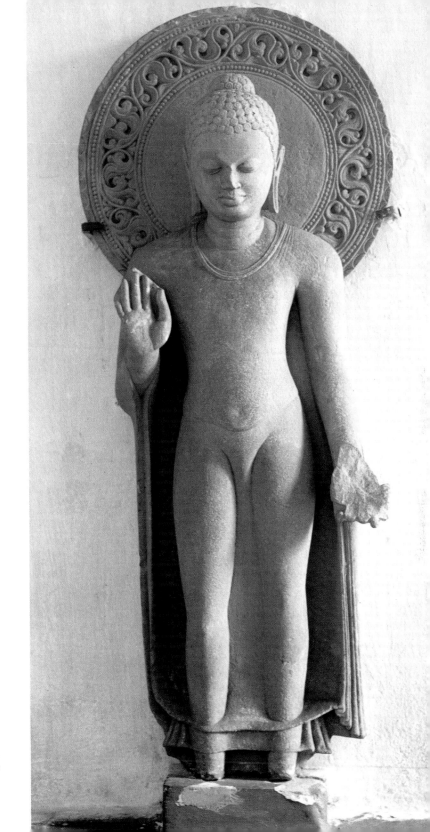

Standing Buddha. Sandstone, height 85³/₈″. Gupta period, fifth century A.D. Indian Museum, Calcutta

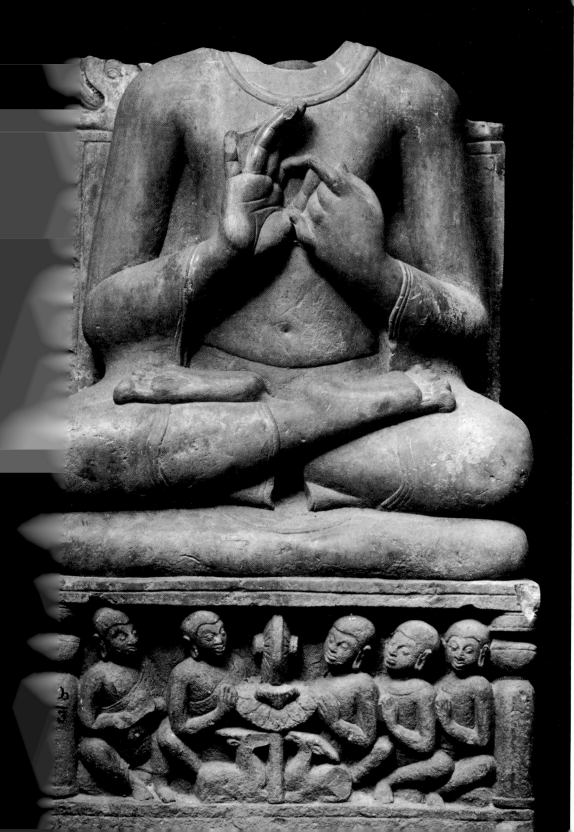

Seated Buddha preaching sermon. Sandstone, height 61³/₄″. Gupta period, fifth century A.D. Archaeological Museum, Sarnath

Preaching Buddha. Sandstone, height 61³/₄″. Gupta period, fifth century A.D. Archaeological Museum, Sarnath

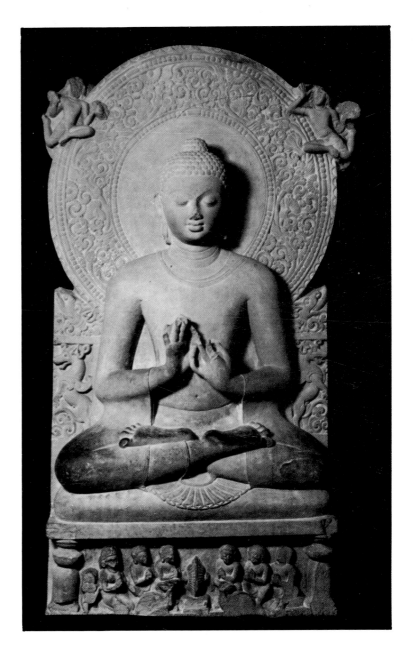

In these images every aspect is fashioned according to prescribed canons of beauty and meaning. The position of the body, the hand gestures, called mudras in Sanskrit, and the attributes are all symbolical in nature, and indicate which deity is represented and what qualities are associated with him. In fact, the shapes of the different parts of the body are prescribed in the sculptor's manual, with the head in the form of an egg, the eyebrows like an Indian bow, the eyelids resembling lotus flowers, the lips with the fullness of the mango fruit, the shoulders rounded like the trunk of an elephant, the waist like that of a lion, and the fingers like flowers.

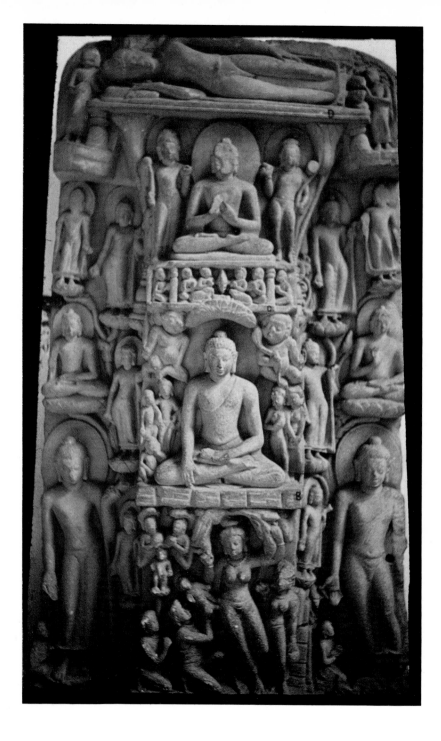

Scenes from the Life of the Buddha. Sandstone, height 41″. Gupta period, fifth century A.D. Archaeological Museum, Sarnath

Particularly interesting from an iconographical point of view are the Gupta relief carvings which represent the main events of the Buddha's life. The series of episodes shown usually starts with the birth of the royal prince Siddharta from the side of his mother Maya, who is portrayed as a kind of yakshi, and ends with his death and

Relief carving depicting scenes from the Life of the Buddha. Sandstone. Gupta period, fifth century A.D. National Museum, New Delhi

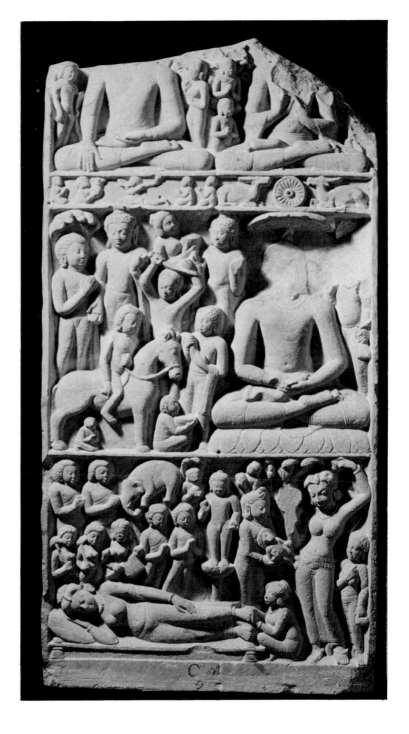

entrance into Nirvana. The other scenes vary, but they usually include his Departure from his ancestral palace, his Temptation, his Enlightenment, his first sermon in the Deer Park at Benares, as well as various scenes showing the acts of charity and the miracles he performed.

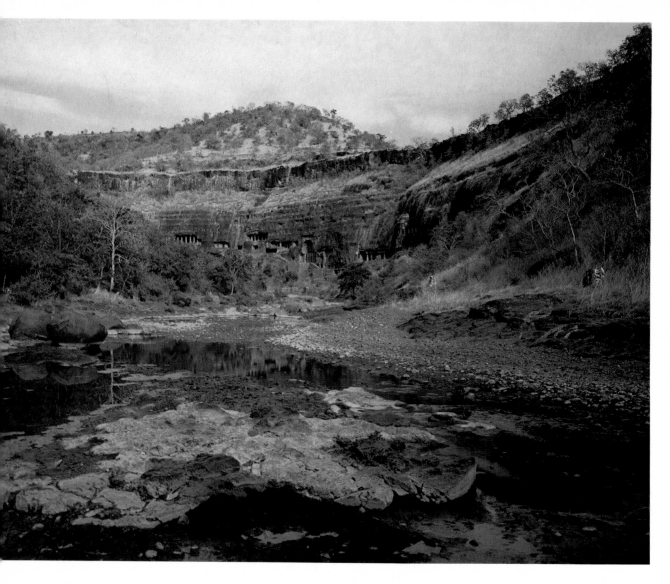

General view of caves at Ajanta. Gupta period, largely fifth–seventh century A.D.

Of all the Buddhist sites in India, the most impressive is Ajanta which is located in the Deccan region of the modern state of Hyderabad. Here, in a river valley, a whole series of cave temples has been hollowed out of the rock of the hill side, and because of their relatively isolated location, they have not only survived, they are also quite well preserved. In fact, this is the only place in India where large numbers of ancient wall paintings still exist. Although a few of the caves date back to pre-Christian times and there are some fragmentary remains of very early paintings, most of the frescoes and carvings at Ajanta date from the Gupta period, largely the fifth and sixth centuries.

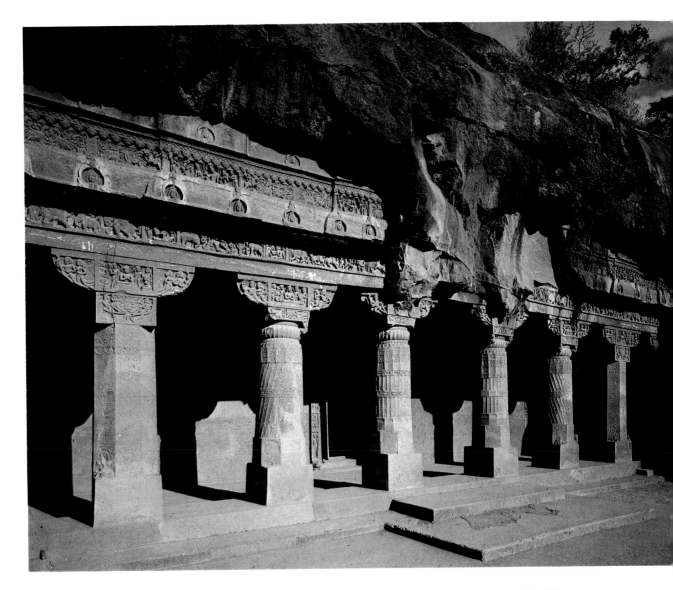

Entrance to Cave I at Ajanta. Sandstone. Gupta period, sixth century A.D.

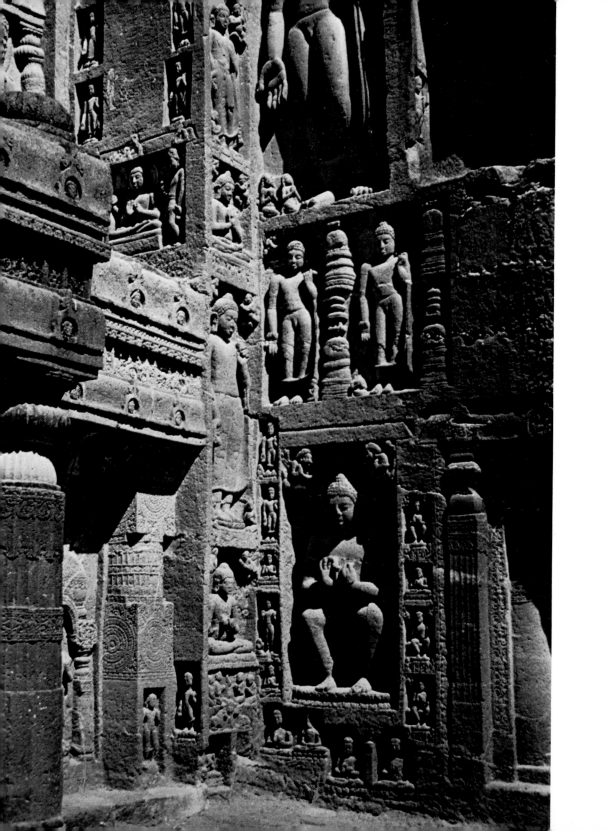

◄ Sculptures from facade of Cave XIX at Ajanta. Sandstone. Gupta period, sixth century A.D.

Naga king and queen, from exterior niche of Cave XIX at Ajanta. Sandstone. Gupta period, sixth century A.D.

Although the frescoes are the most important works at Ajanta, the architecture of the cave temples and the carvings decorating the entrance portals are also outstanding. In these temples, forms which were originally developed in masonry or wood are carved out of living rock. The sculptures, both numerous and varied, cover the entrance facades without any unified iconographical plan. Their arrangement probably depended upon the desires of the pilgrims and monks who had these images carved for the glory of the Buddha and for their own salvation.

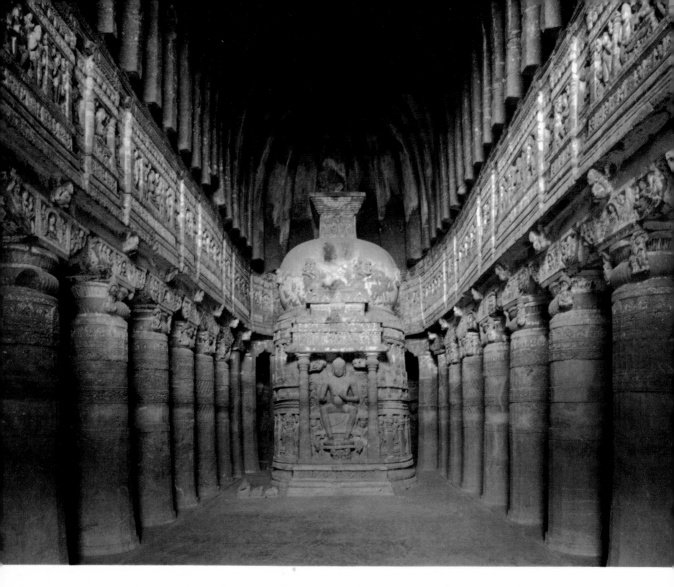

Interior of caitya hall, Cave XXVI at
Ajanta. Gupta period, seventh century A.D.

Seated Buddha preaching, Cave I at Ajanta. ▶
Sandstone. Gupta period, sixth century A.D.

Passing through the portals of the cave temples, the worshiper entered the caitya halls with their rows of
columns which divide the interior into a central nave and side aisles not unlike the division found in the Chris-
tian basilica churches. However, at the far end where the altar would be in a church there is a stupa commem-
orating the Nirvana of the Buddha. In other caves, there are giant images of the Buddha which loom myster-
iously out of the depth of the cave and are among the most impressive of all Buddhist images. Although
executed by anonymous craftsmen, probably Buddhist monks living at the cave sites, these works are among
the great religious sculptures of the world.

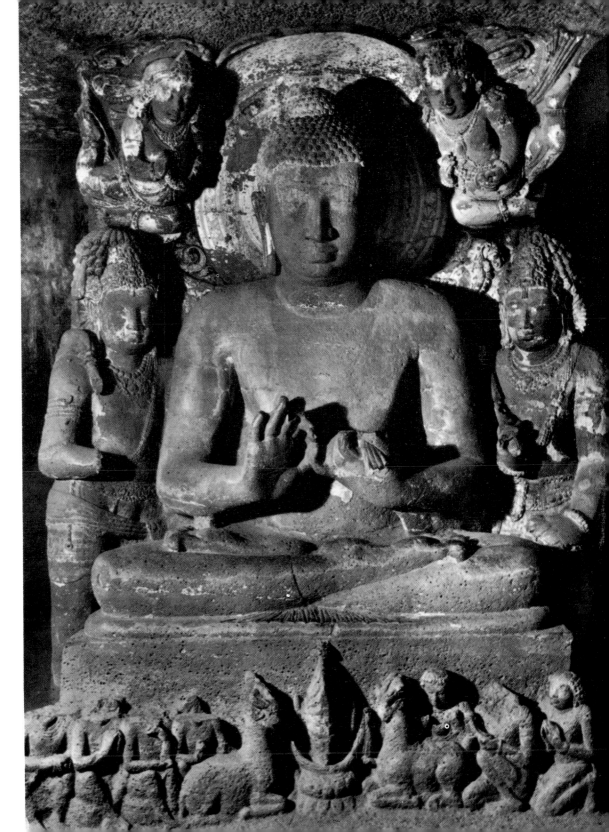

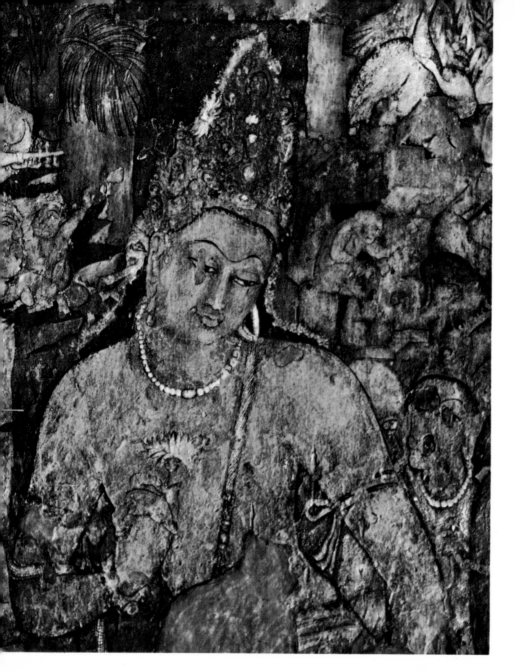

Bodhisattva Padmapani, wall painting in Cave I at Ajanta. Gupta period, sixth century A.D.

Even more remarkable, at least for us since so few ancient Indian paintings have survived, are the frescoes which decorate the walls of many of the caves. When they were rediscovered in the nineteenth century, they were rightly hailed as among the greatest of all wall paintings, and certainly they are the finest frescoes surviving from this period anywhere in the world. No doubt at the time they were less unique, for we are told of

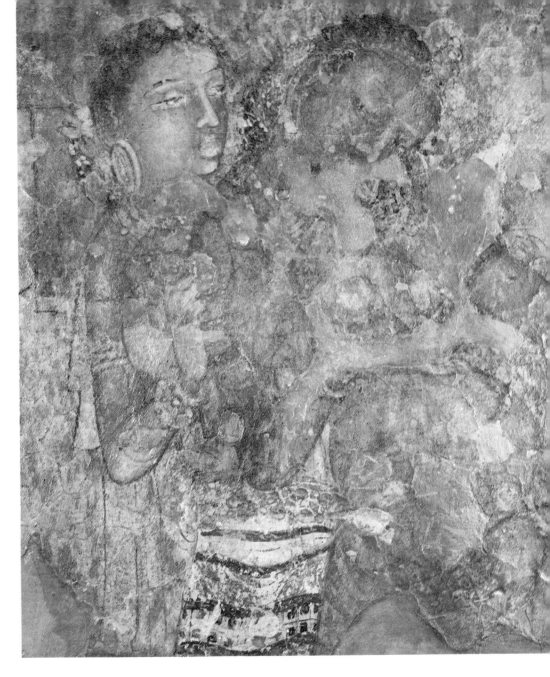

numerous paintings which once decorated the temples and palaces of the Gupta period. Outstanding among the many magnificent paintings at Ajanta is the beautiful representation of Avalokitesvara, the Bodhisattva of Mercy and Compassion, who is shown in a dancelike position with a lotus in his hand.

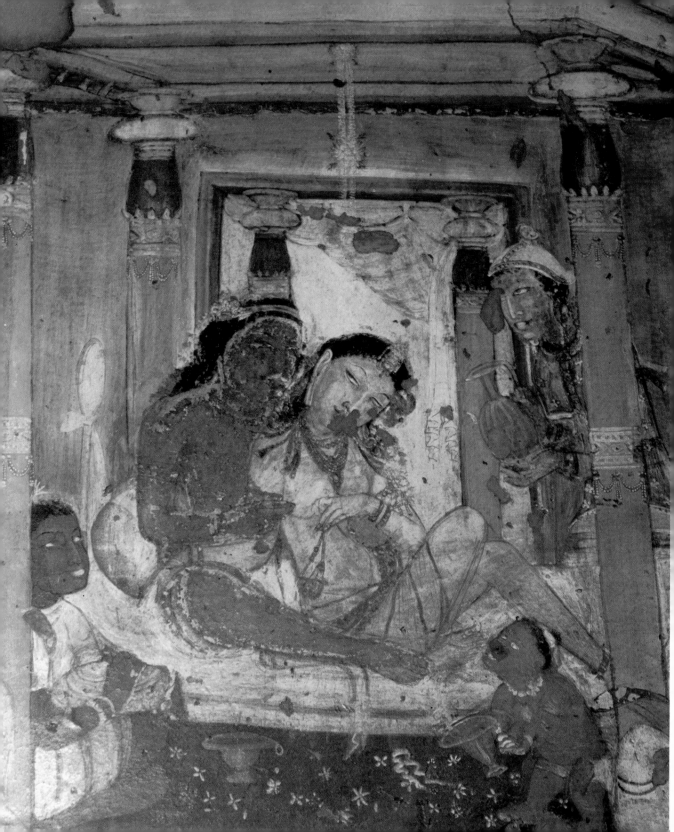

Though the subjects treated are Buddhist, many scenes from contemporary life are depicted on the walls of the Ajanta caves, usually in the form of episodes from the legends and early life of the Buddha. In these paintings, as in the sculptures, there is the same combination of the physically beautiful with the spiritual which is so characteristic of the Indian conception of reality. The result is that here, at this Buddhist site, the voluptuous beauty of the female body and the joys of palace life are rendered with a warmth and lyrical feeling seldom equaled and never surpassed in world art.

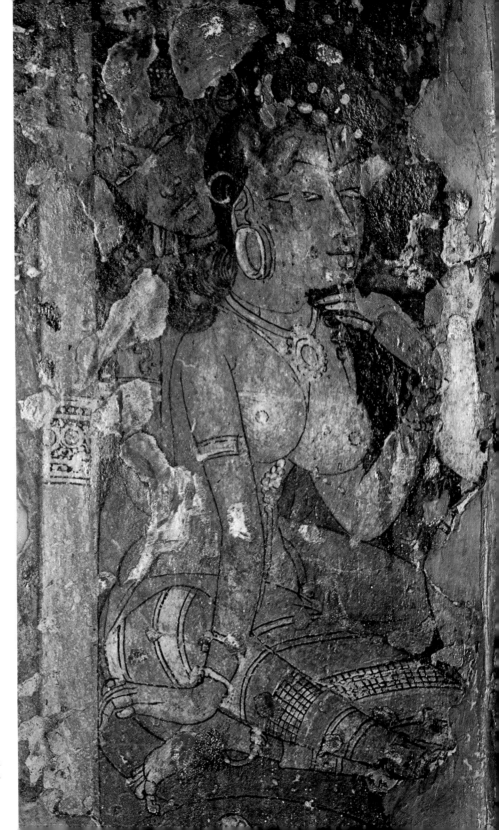

◀ Lovers in palace interior, wall painting in Cave XVII at Ajanta. Gupta period, fifth century A.D.

Court ladies, wall painting in Cave XVII at Ajanta. Gupta period, fifth century A.D.

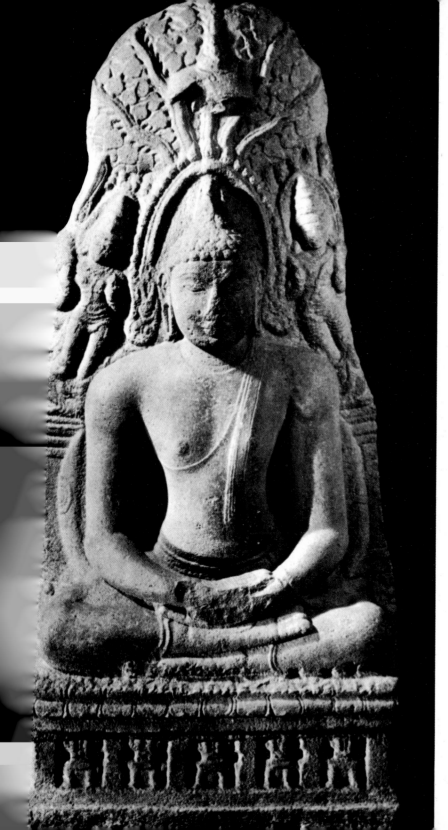

With the end of the Gupta period and the revival of Hinduism during the seventh century, the great age of Buddhist art in India came to an end. Buddhism itself sank into a decline, losing its hold on the Indian people as a resurgent Hinduism began to replace it. Only in the eastern sections of the country, notably Bengal and Bihar, and in the north in Kashmir and Nepal did Buddhism survive for any length of time. Yet even in these areas the art produced no longer had the vitality and expressive power of the Buddhist art of earlier periods. The craftsmen employed the same iconography and even imitated the same stylistic conventions, but they became drier and more mannered, and their work lacked the religious conviction which had suffused the earlier images.

Seated Buddha, from South India. Limestone, height 71″. Early Medieval period, ninth century A.D. Boney Collection, Tokyo

Standing Buddha. Black stone, height ▶ 33¹/₂″. Early Medieval period, ninth century A.D. Boney Collection, Tokyo

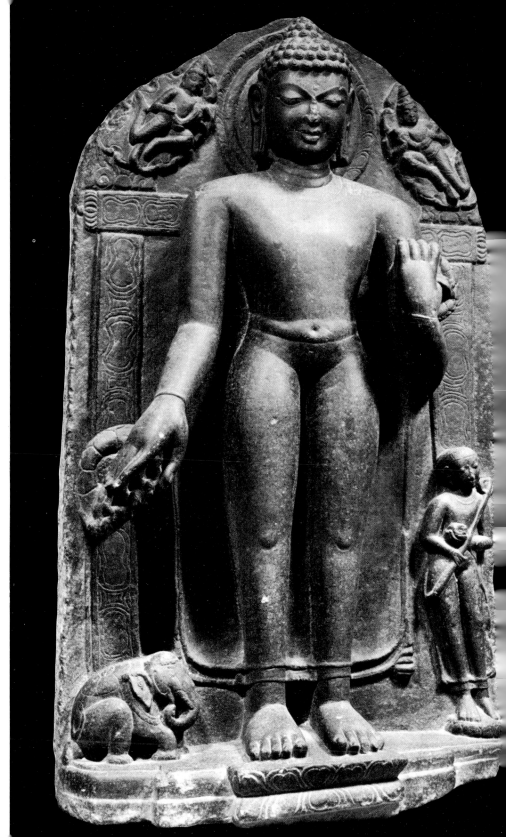

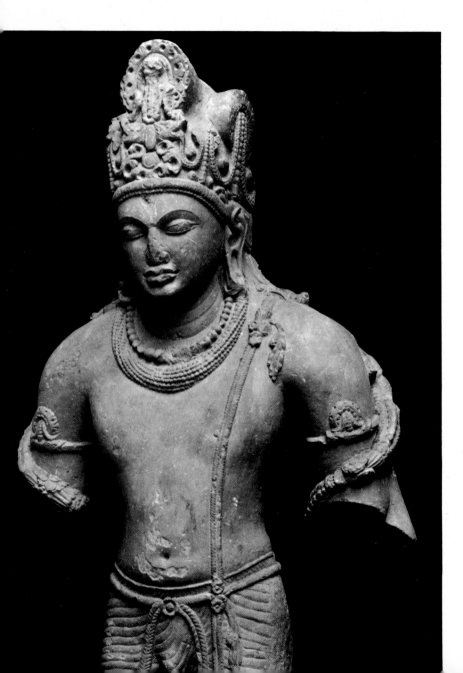

Vishnu. Sandstone, height 40$^1/_8$". Gupta period, fifth century A.D. Curzon Museum of Archaeology, Mathura

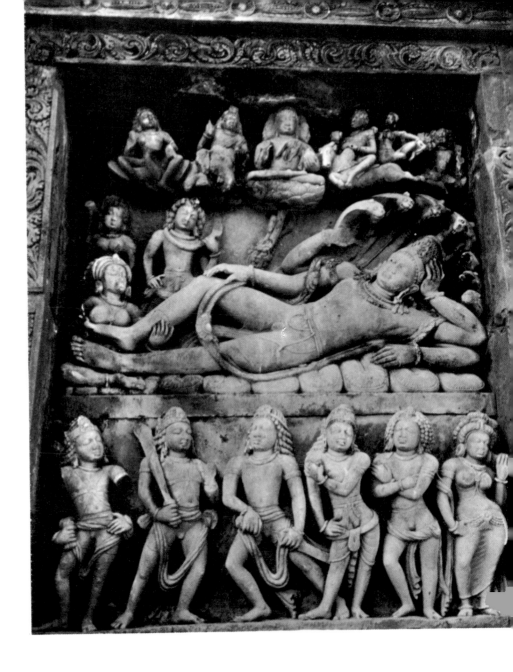

Vishnu lying on World Serpent. Sandstone, 59 × 46″. Gupta period, sixth century A.D. Vishnu Temple at Deogarh, Central India

Hinduism had already had a great revival during Gupta times, and in the following era, which is usually called the Medieval period of Indian art, almost all of the artistic production was devoted to Hindu themes. Initially, the forms were not very different from those used by the Buddhist artists; in fact in some cases it is very difficult to tell if a work is Hindu or Buddhist, especially if there are no specific attributes which can be associated with either of the great religions. Yet as Hinduism asserted itself more and more, a new iconography and style were developed to give expression to the very different spiritual concepts embodied in the Hindu faith.

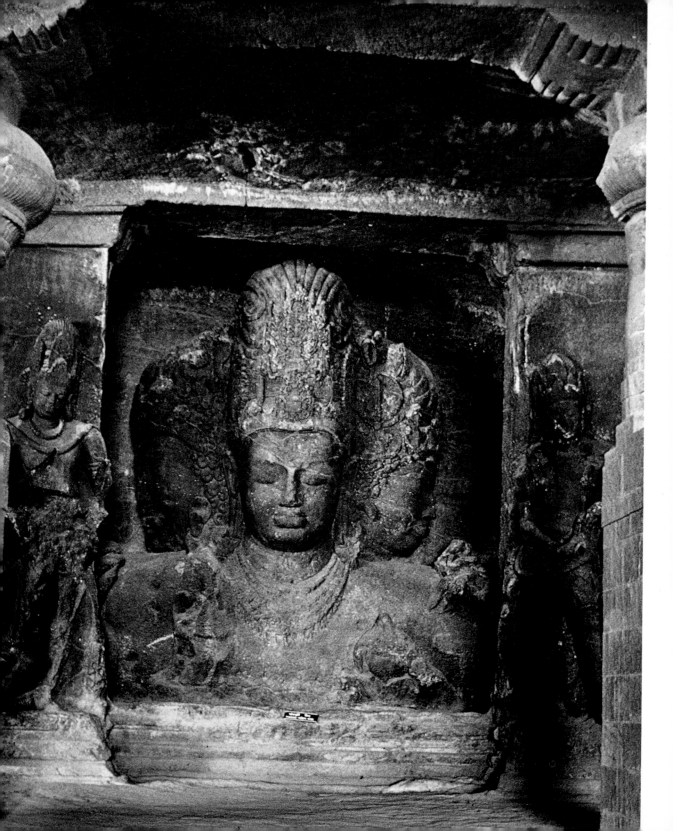

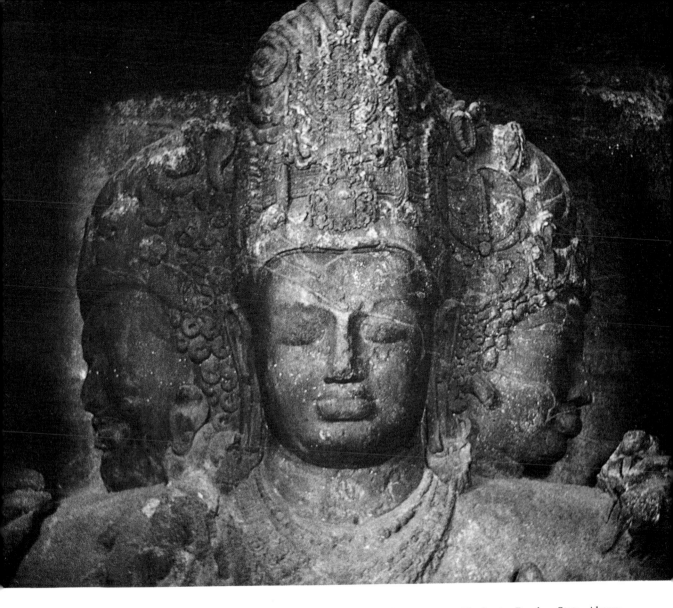

Shiva as Mahesvara. Sandstone, height 10′10″. Early Medieval period, seventh century A.D. Elephanta, Bombay State. Above: detail of same

The gods who were most commonly represented in Hindu art were Shiva, the Destroyer, and Vishnu, the Preserver, while the third great god of the Hindu trinity, Brahma, the Creator, was only rarely depicted. To their devotees, Shiva and Vishnu became the gods par excellence who embodied all the creative and destructive elements of the universe. One of the most powerful renderings of the multiple nature of the deity is the main icon at Elephanta where Shiva is seen as the three-headed Mahadeva whose heads represent three different aspects of the god, the center one his creative self, the left his destructive nature, and the right the gracious, feminine manifestation of the deity.

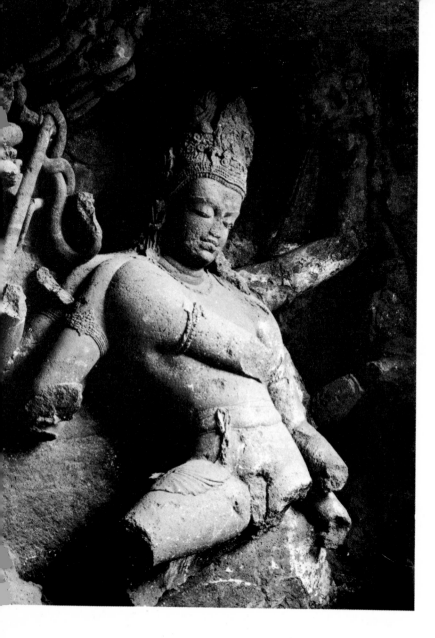

Dancing Shiva. Sandstone. Early Medieval period, seventh century A.D. Elephanta, Bombay State

Shiva and Parvati. Sandstone. Early Medieval period, seventh century A.D. Elephanta, Bombay State ▶

Other sculptures at Elephanta represent different aspects of the god, always stressing the multiple nature of Shiva who, although manifesting himself in various ways to his worshipers, is ultimately always the same deity. Among the most important and popular of these manifestations are Shiva as the Lord of Dance, or Nataraya, to use the Sanskrit term, who is performing the cosmic dance, and Shiva with his consort Parvati, the goddess of beauty and love who is Shiva's female counterpart, or shakti. In contrast to the repose and harmony of Buddhist art, these Hindu works are charged with a dynamic energy which reflects the very different Hindu outlook on life.

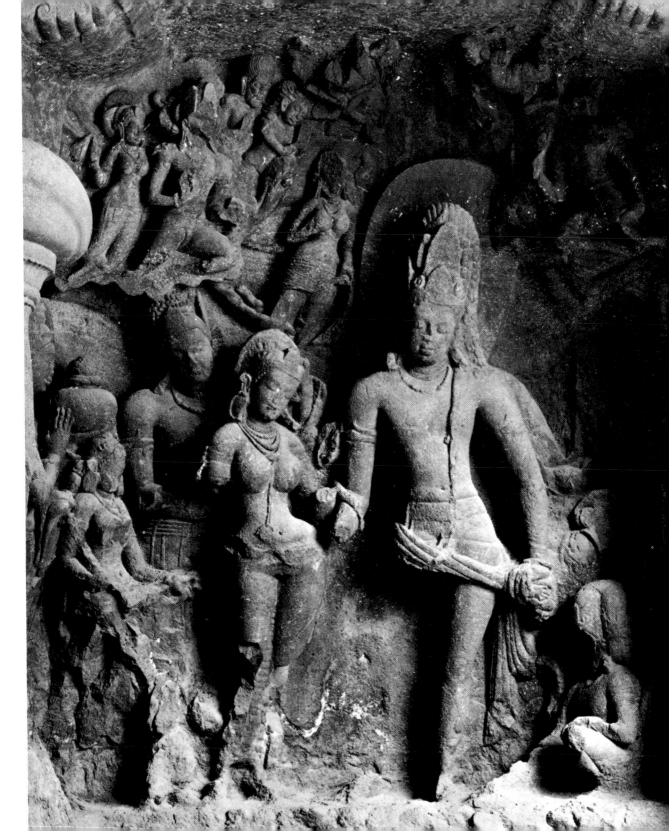

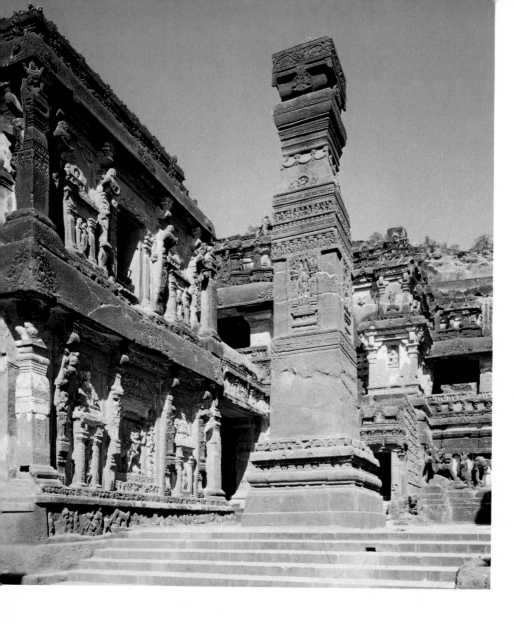

Ramesvara Temple at Elura. Early Medieval period, eighth century A.D.

View of mandapa. Kailasanatha Temple at Elura. Early Medieval period, eighth century A.D. ▶

If there is one monument which can be singled out as the most remarkable creation of the Early Medieval period, it would probably be the great Shiva temple at Elura not far from Ajanta in Central India. Although it is an immense structure, whose silhouette is supposed to resemble Mount Kailasa where the gods were believed to dwell, it is actually not a building in the conventional sense but a piece of monumental sculpture which was literally carved out of the rock of the hillside. Even as a technical feat, this huge temple is an extraordinary achievement, but above all it is remarkable as a great work of art, for it combines some of the most impressive architecture of Hindu India with sculpture of great beauty and expressive power.

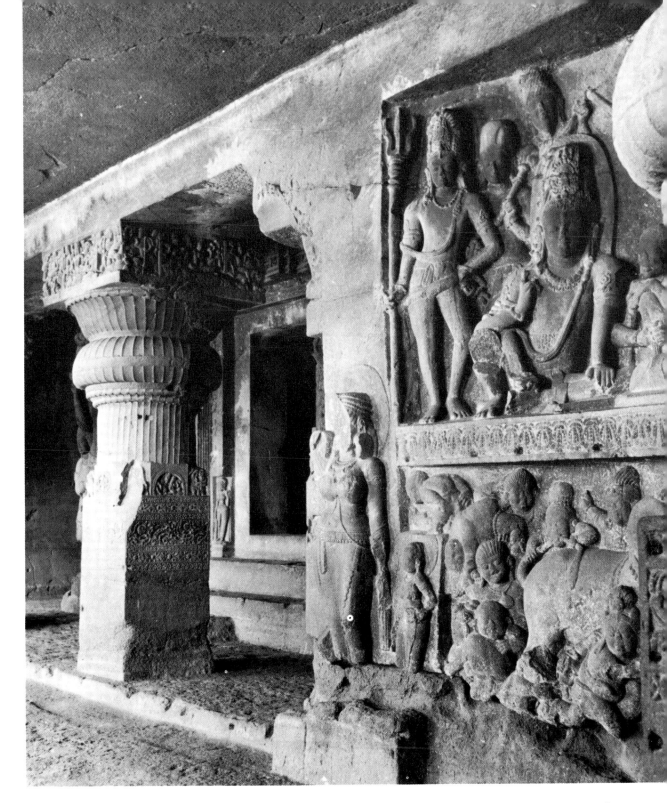

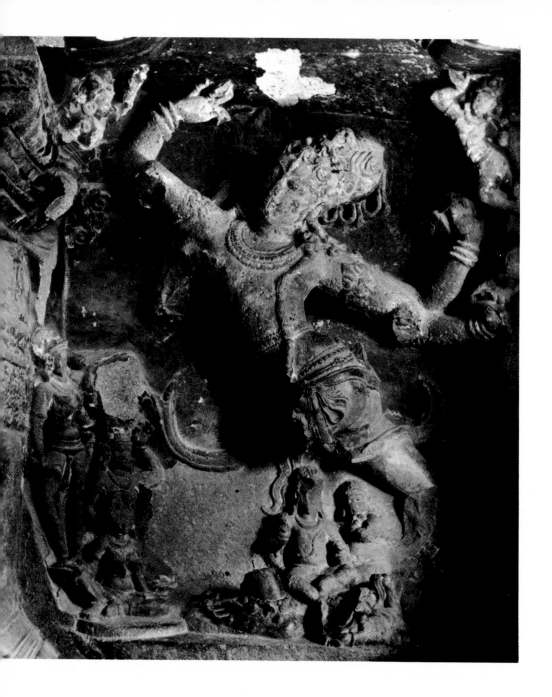

Prominent among the thousands of images carved out of rock at Elura are the representations of Shiva, for it is to him that this huge temple is dedicated. He is represented in his many incarnations as Creator, Destroyer, Lord of the Dance, Divine Lover, and Slayer of Titans, and with him are shown his consort Parvati and his elephant-headed son Ganesha, the god of wisdom and learning.

Just as the beautiful yakshis had played an important role in Buddhist art of earlier times, so female deities

◄ Dancing Shiva, Lokesvara Temple at Elura. Early Medieval period, ninth century A.D.

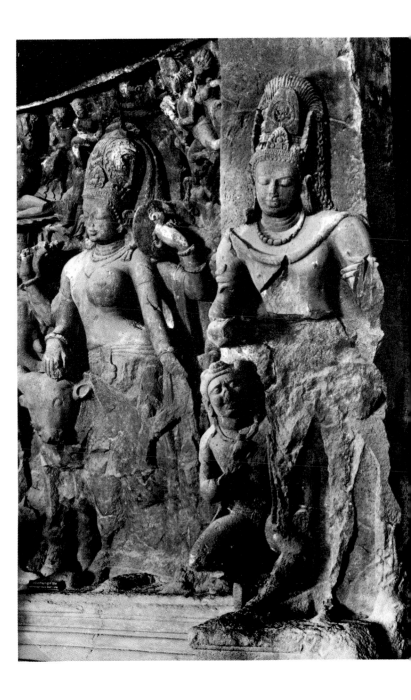

Shiva Ardhanarisvara in half-male and half-female form, Elura. Early Medieval period, eighth century A.D.

of all kinds are prominent in the Hindu art of this period. Whether they are the female counterparts of the gods, or goddesses in their own right, such as the numerous river and nature deities, or merely women embracing men as in the loving couples, or mithunas, so often represented on the facades of Hindu temples, the sensuous beauty of the female form is glorified with a fervor and joy in the senses which are typical of Indian art throughout the ages.

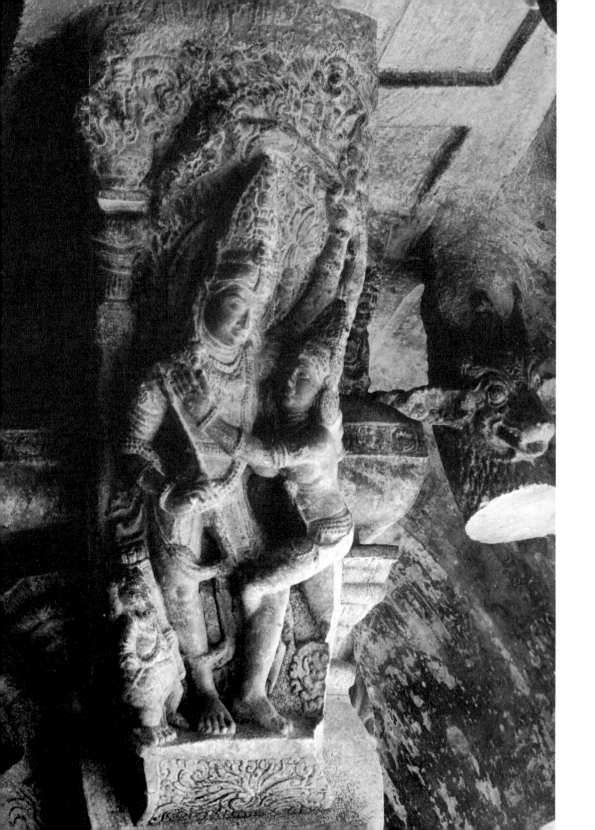

What is always astonishing about works such as the sculptures at Elura and other Hindu religious sites is that the innumerable carvings decorating the facades of the temples and the walls of the caves were not the creation of some uniquely gifted man of genius, some divine Michelangelo of medieval India, but merely part of the vast artistic output produced by medieval Hindu society, and that they were not created by self-conscious artists for their own fame and satisfaction but for the greater glory of the god and for the spiritual merit of the carver and the donor. Who these artists were we do not know, for their work was not signed and no Vasari has recorded their lives, yet the sculptures they created are among the masterpieces of mankind.

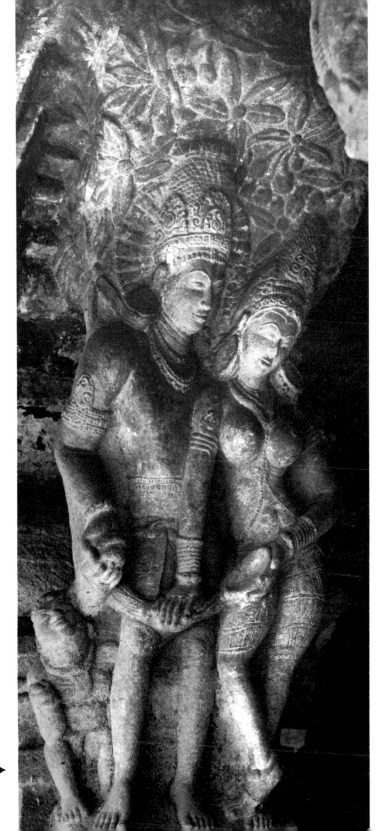

◀ Mithunas, Vaishnava Temple at Badami. Early ▶
Medieval period, sixth century A.D.

In the south the outstanding temple complex of the Early Medieval period is without doubt Mamallapuram which is located just south of Madras on the east coast. Here along the shore are a number of sanctuaries which are considered among the finest of Indian temples. The largest and most impressive is the Shore Temple, so named because it was built by the sea so that it could be seen from a distance by the ships which sailed past. Its form is that of Mount Meru, the World Mountain. Its seven steps rise to heaven and it is not unlike the pyramids of Egypt, the ziggurats of Mesopotamia, and the step pyramids of ancient Mexico which embody the same idea of a magic replica of a World Mountain.

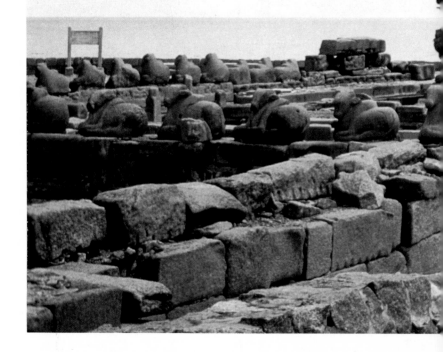

Shore Temple at Mamallapuram. Early Medieval period, eighth century A.D.

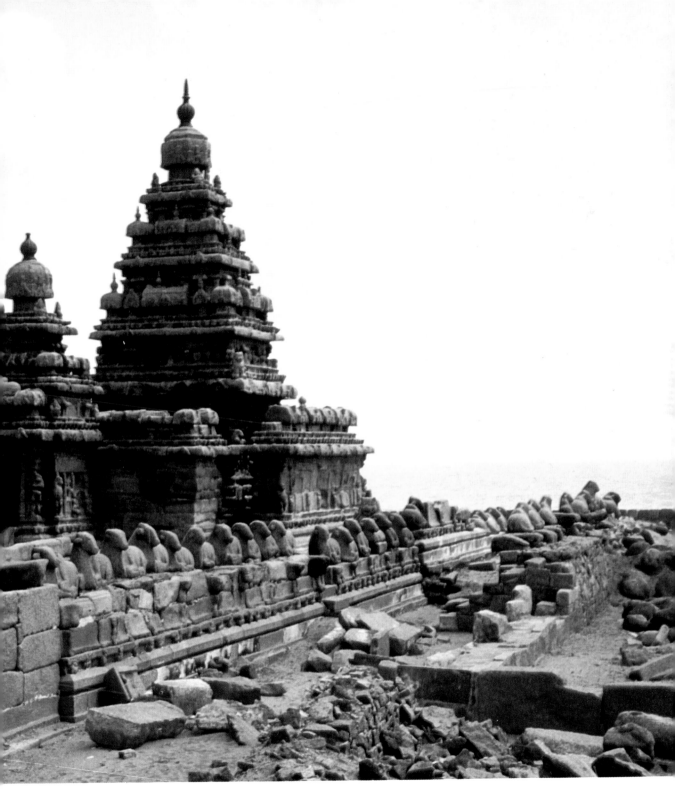

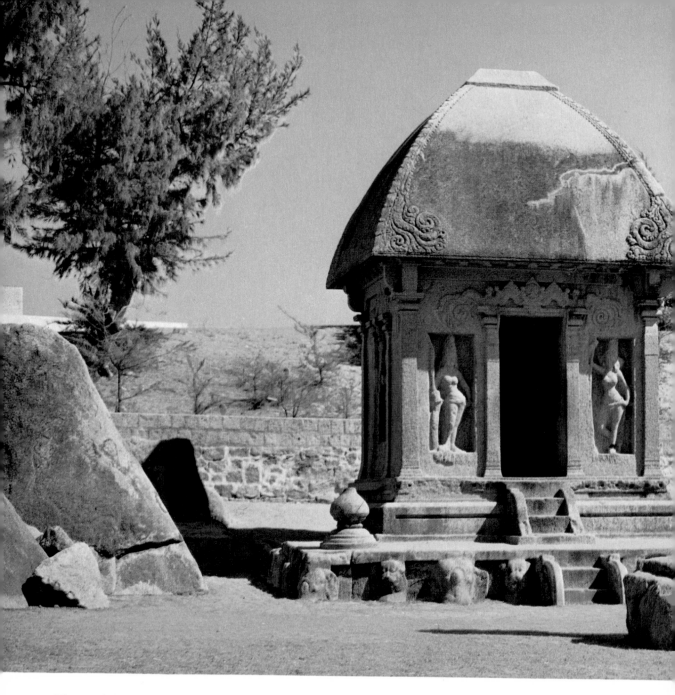

Dharmaraja Rath at Mamallapuram. Early Medieval period, seventh century A.D.

A series of smaller temples at Mamallapuram are carved out of huge boulders instead of being built up like the Shore Temple, yet they no doubt represent the kind of architectural construction which was being used in southern India at the time. Some of the buildings found here probably reflect very ancient types of shrines constructed in wood and no longer surviving today. In addition to the Mount Meru-type building, there are

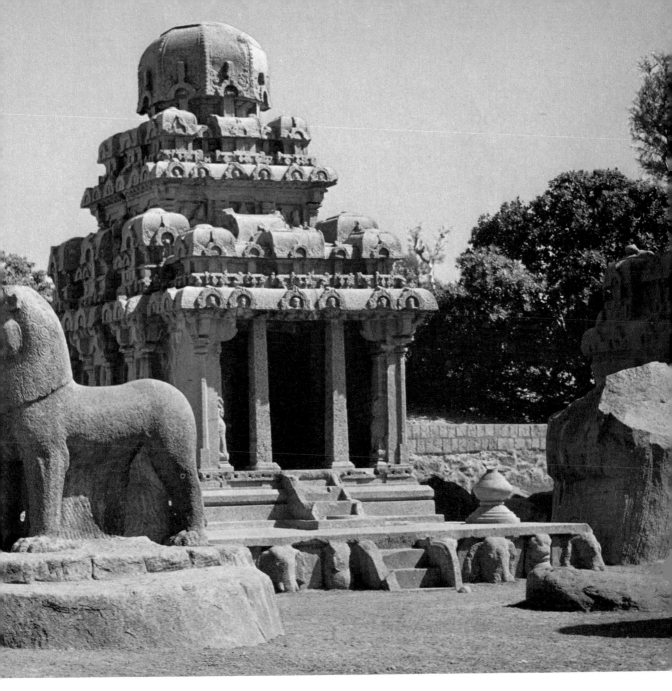

Durga Sanctuary at Mamallapuram. Early Medieval period, seventh century A.D.

longitudinal halls with curved roofs as well as small shrines built to contain sacred images. In fact all Hindu temples, like those of the Greeks, were meant to serve as houses for the gods rather than places for congregational worship.

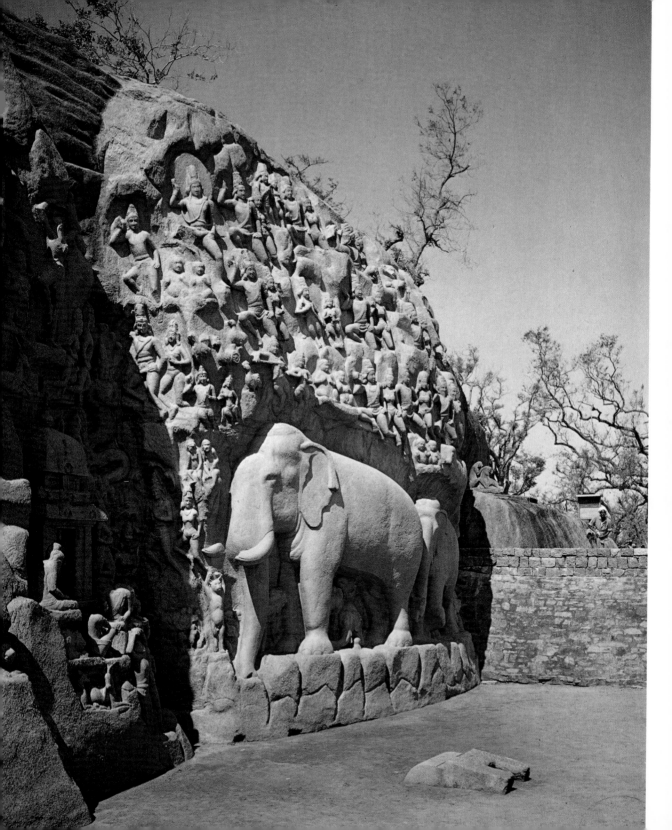

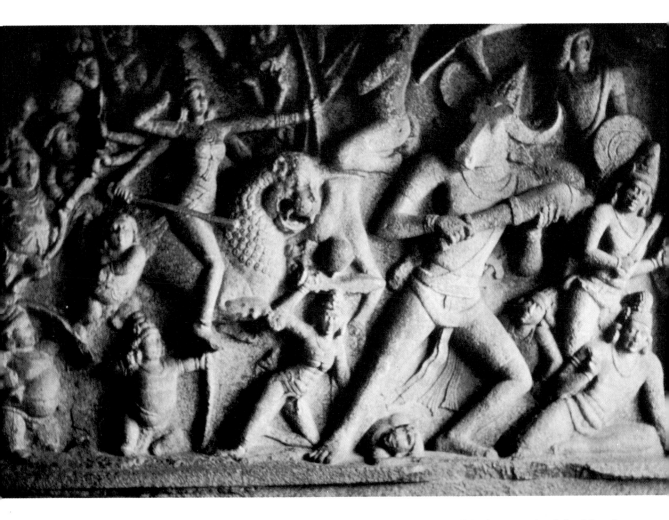

Durga battling buffalo-demon, rock relief at Mamal-
lapuram. Early Medieval period, seventh century A.D.

In addition to its temples, Mamallapuram is also famous for its sculptures, especially the relief of the Descent
of the Ganges which is carved into the side of a huge boulder and represents the Hindu legend of how Shiva
saved the world from being flooded by letting the river first fall on his head before coming down to earth. The
relief shows the river's descent and the many beings—animals, humans, and divinities—paying their tribute
to Shiva for his gift. Another famous relief shows Shiva's female counterpart in her incarnation as the Durga,
the fierce Slayer of the Titan Buffalo, which is rendered with strong contrasts of light and dark and an emphasis
on dramatic movement.

◀ Descent of the Ganges, rock relief at Mamallapu-
ram. Early Medieval period, seventh century A.D.

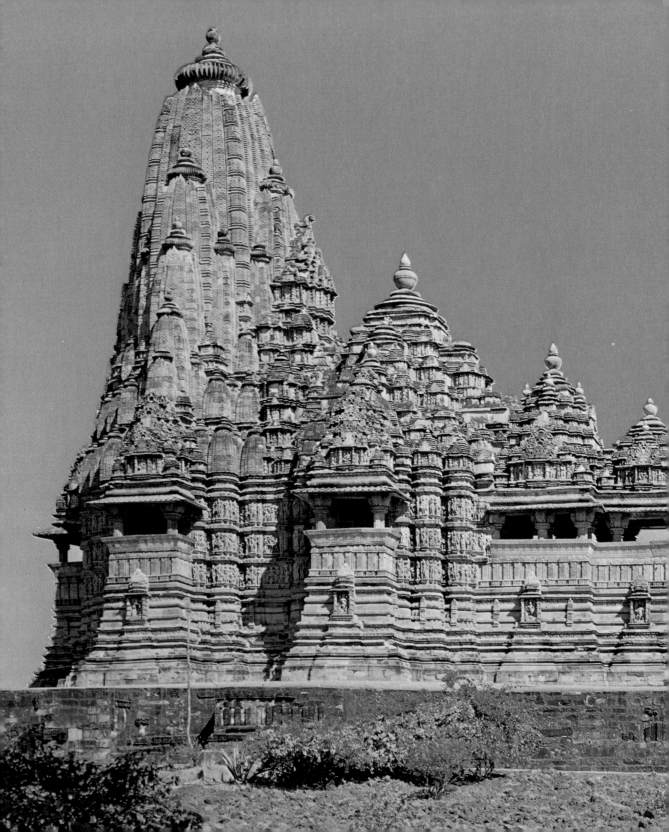

CULMINATION OF HINDU ART DURING THE LATER MEDIEVAL PERIOD

Interestingly enough, the culmination of Hindu medieval art comes during the very same period when the medieval religious art of the West reached its climax, and that is during the tenth to the thirteenth century. Just as the art in Europe was dedicated to Christianity and the most outstanding monuments were the cathedrals, so in medieval India the art was devoted to Hinduism and the finest artistic creations were the temples which were erected all over India. Among the temple sites, one of the most famous was Khajuraho located just west of Allahabad in northern India. The most celebrated of the temples here is Kandarya Mahadeva whose silhouette resembles Mount Kailasa, the sacred mountain in the Himalayas.

Kandarya Mahadeva Temple at Khajuraho. Late Medieval period, tenth century

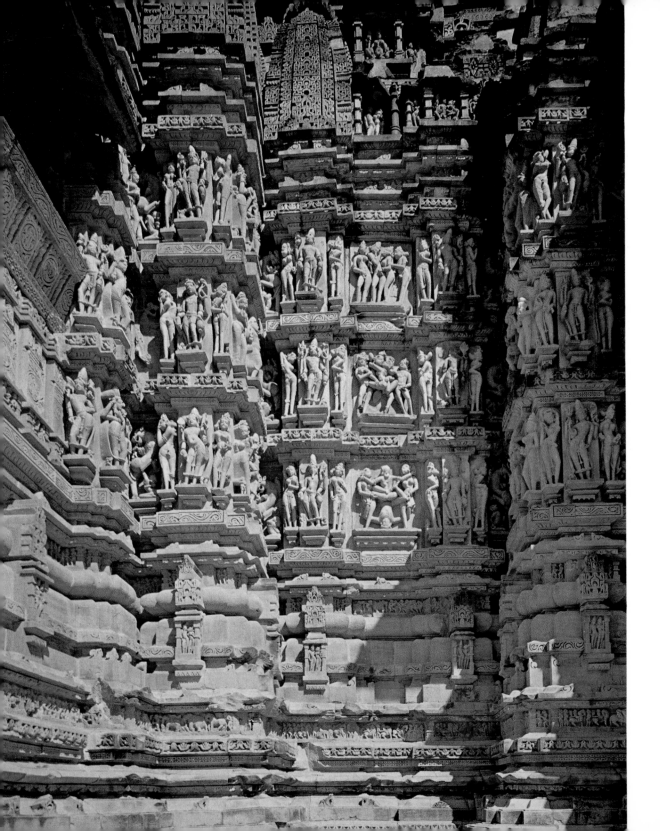

Even more impressive than the massive forms of the temple structures, which consist of sanctuaries containing the images of the gods, and porches in which the devotees perform their acts of worship, are the innumerable sculptural carvings which decorate the facades of the temples. The theme most common at Khajuraho is that of the mithunas, or divine lovers, who are shown in a passionate embrace symbolizing the union of the worshipers with the deity. The forms, although sensuous and full of life, are generalized and abstracted, thereby achieving a marvelous sense of both physical and spiritual beauty.

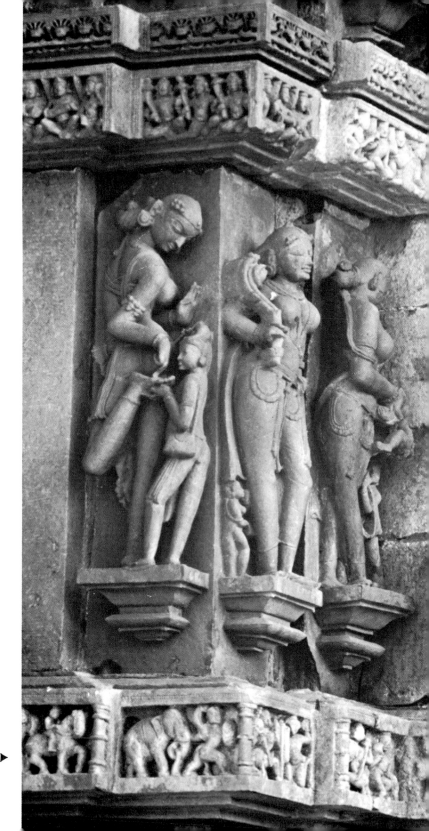

◀ Sculptural decoration of Kandarya Mahadeva ▶
Temple at Khajuraho. Late Medieval period, tenth century.

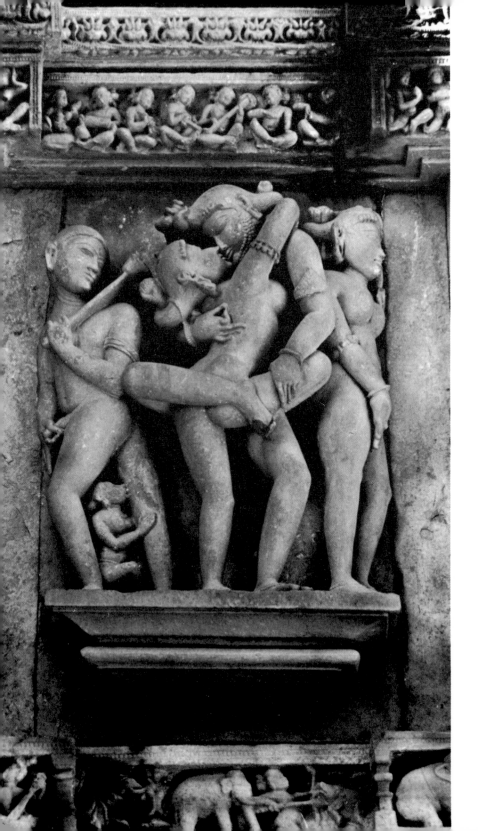

Many of the scenes portrayed in the sculptures at Khajuraho are frankly erotic, showing lovers performing the sex act in various positions, many of which are described in the famous Hindu manual of love, the Karma Sutra. To the Westerner, imbued with the puritan ethics of the Christian tradition, such subjects seem highly unsuitable for a sanctuary designed for religious worship, but to the Hindu no such objections exist, since every aspect of life is looked upon as a revelation of the god who may often manifest himself as a lingam and is frequently thought of as being accompanied by his female counterpart, or shakti.

Erotic scene, from Kandarya Mahadeva Temple at Khajuraho. Late Medieval period, tenth century.

No other religious art has given erotic love the prominence which it assumed in the art of Hindu India where themes such as the lover longing for his beloved are looked upon as religious expressions. Even the statues of Greek goddesses seem restrained and cool compared to the voluptuousness of the female figures produced by the Indian sculptors. These bodies with their dancelike, rhythmic movement, their breasts like ripe fruit, their bellies and thighs of rounded fullness are the very incarnation of sensuous beauty. Although derived from nature, they transcend mere naturalism and thus create a beauty worthy of the gods.

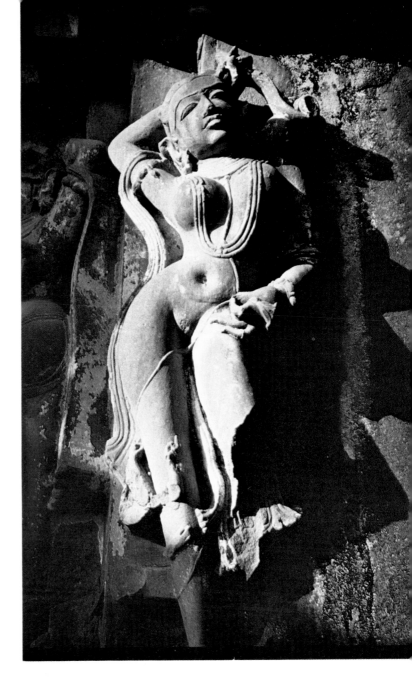

Female figure, from Citragupta Temple at Khajuraho. Late Medieval period, tenth century

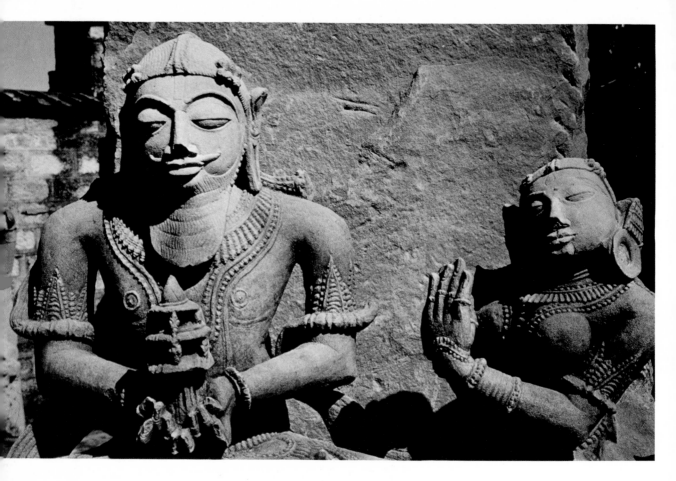

Hindu ruler and his queen, at Khajuraho. Late Medieval period, tenth century

Although most of the images decorating the temples represent either the gods or divine lovers, other figures portray the life of contemporary India, indicating how closely the sacred and the secular, the divine and the human were related in Indian thought. In fact the ruler and his queen were often looked upon as the incarnation of the god and his consort, and a mother holding her child was thought of as a manifestation of the life-giving process of nature. These representations were never realistic likenesses of the persons portrayed, but idealized portraits of kings and queens which corresponded to the spiritual ideals of Hindu thought.

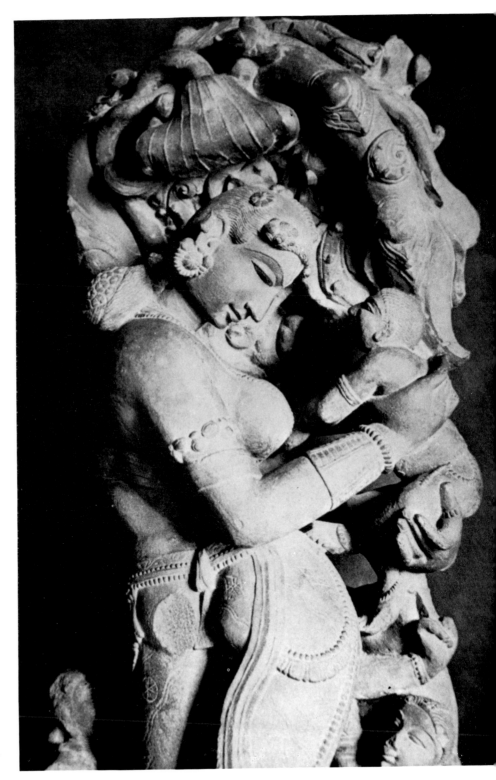

Mother and child, from Khaju-
raho. Height 36¹/₄″. Late Me-
dieval period, tenth century. In-
dian Museum, Calcutta

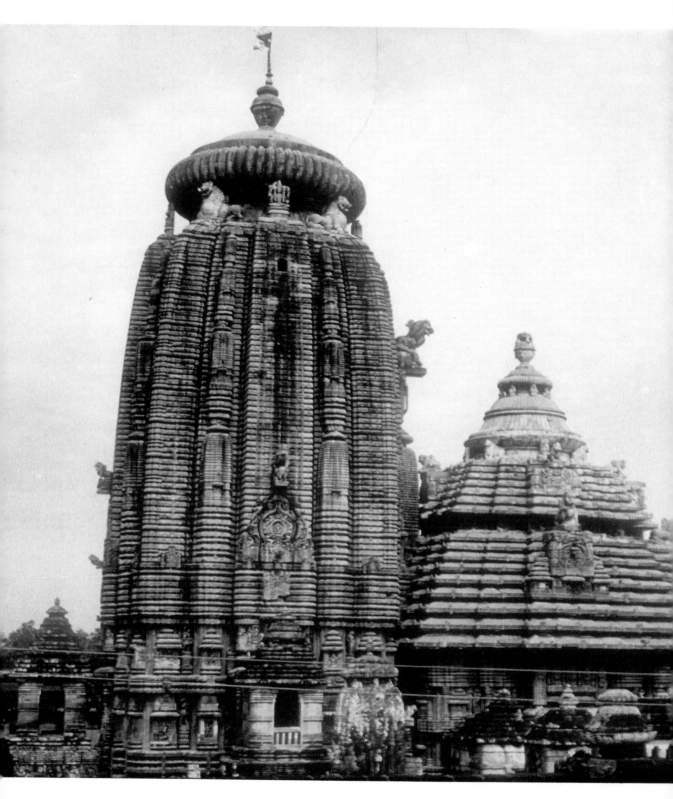

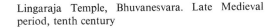
Lingaraja Temple, Bhuvanesvara. Late Medieval period, tenth century

The second of the great temple sites of medieval India is Bhuvanesvara which is located in Orissa in the eastern part of the country. At this sacred pilgrimage center, literally hundreds of sanctuaries were erected so that the whole forms a city of temples. Outstanding is the great Lingaraja Temple dedicated to Shiva as the Lord of the Lingam, the idea being that the phallus embodied the creative power of the deity. Viewed from a distance, all these many temples seem to sprout from the plains like some fantastic growth. They are more like giant sculptures than architecture in the usual sense. Indeed, the creation of inner space, which in the West is usually thought of as the chief function in architecture, plays a very minor role here, the massive masonry and the sculptural decorations being all-important.

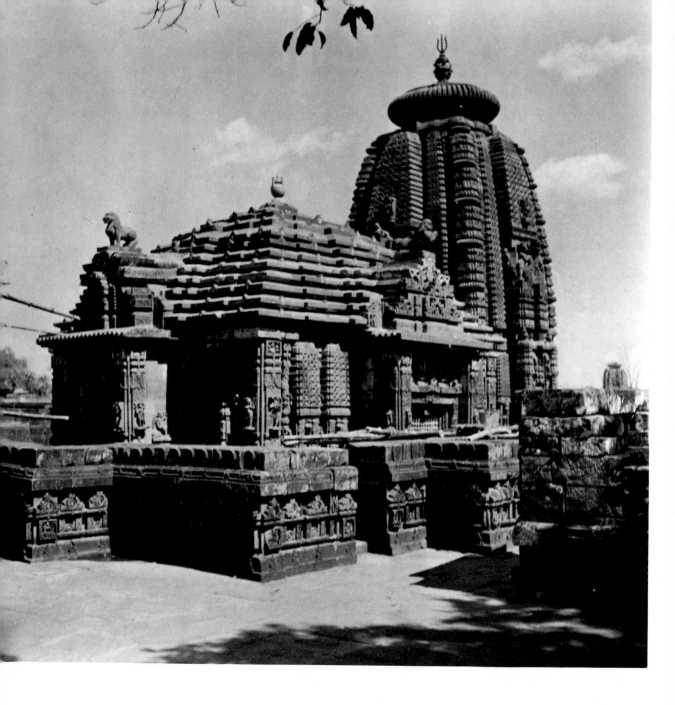

Muktesvara Temple, Bhuvanesvara. Late Medieval period, tenth century

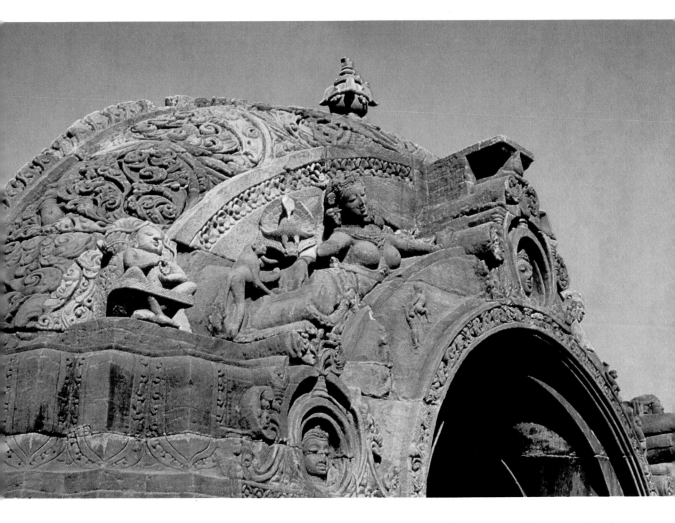

Detail of gate of Muktesvara Temple

A smaller but particularly lovely shrine also located at Bhuvanesvara is the Muktesvara Temple which is outstanding for the carvings decorating its facade. The two main elements of this building are the tower, or sikkhara, with its bulbous finial, and the porch, or mandapan, where the worshiper says prayers and performs his rituals. Beneath the sikkhara is a small chamber known as the womb, or gharba, which contains the inner sanctum in which the image of the deity is kept. Here at the Muktesvara temple a wall, its beautiful gate decorated with ornamental carvings, surrounds the entire complex, separating the sacred area from the outside world.

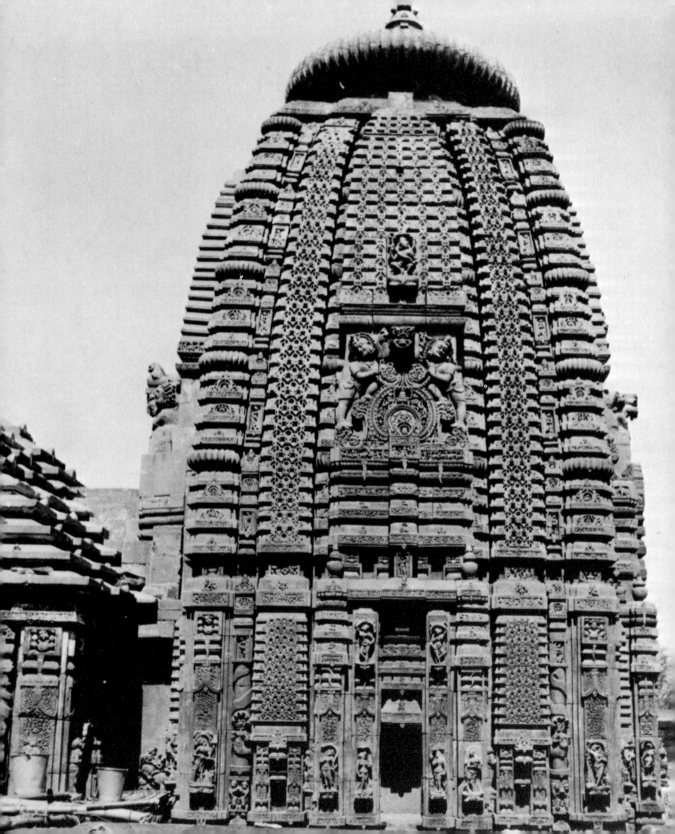

At Bhuvanesvara as at Khajuraho, it is not only the architecture but also the sculptural carvings which make up the total artistic effect. Actually, it is impossible to make a clear distinction between the two, for like the medieval Christian church, the Hindu temple must be experienced as a single entity in which architecture, sculpture and painting are merely parts of a unified whole. The master builders, carvers, and painters were all pious craftsmen who, guided by manuals, or shastras, worked together under the direction of the Hindu priests.

◀ Sculptural decoration on Muktesvara Temple, Bhuvanesvara. Late Medieval period, tenth century

Detail of sculpture on Rajarani Temple, Bhuvanesvara. Late Medieval period, eleventh century

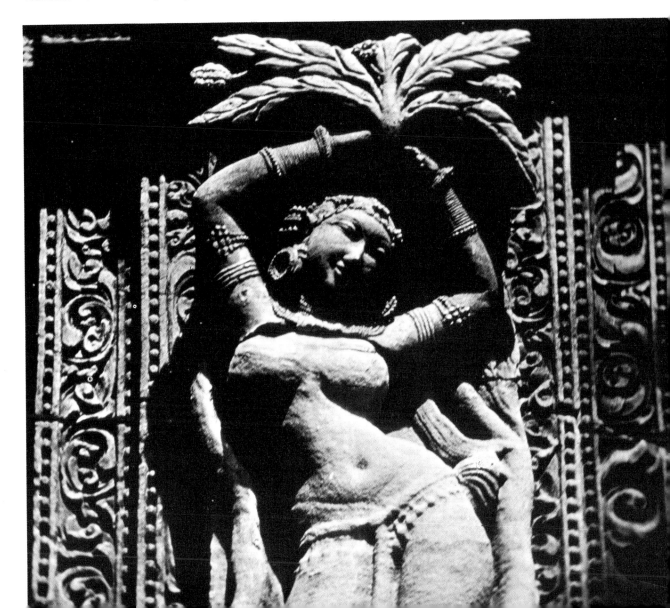

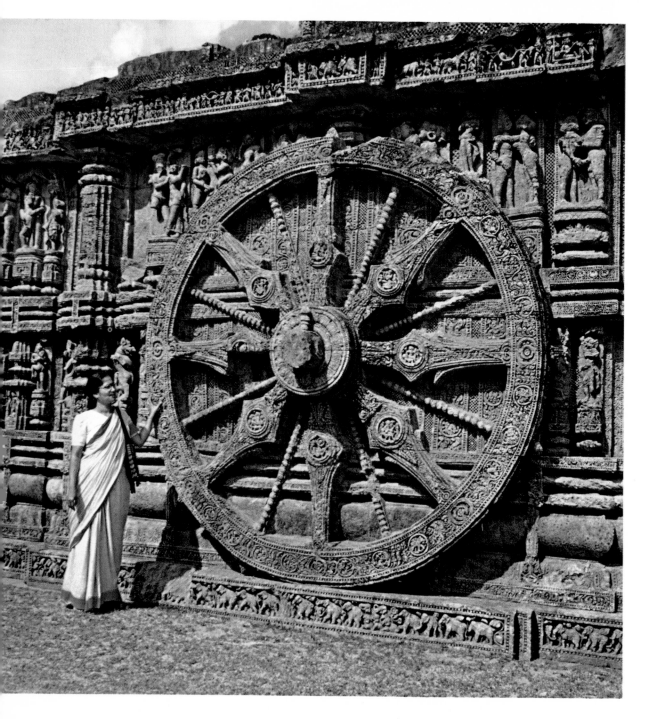

Giant wheel of "Sun-chariot," Surya Temple, Konarak. Late Medieval period, thirteenth century

Horse, Surya Temple, Konarak. Late Medieval period, thirteenth century ▶

The third of the famous temple sites dating from this period is Konarak, also in Orissa, not far from Puri and somewhat south of Bhuvanesvara. This is the last and perhaps the most remarkable of all the great Hindu temples of northern India. Even today when the great Sun Temple is in ruins, it is still one of the most impressive structures of Hindu India. The entire temple was designed to resemble a processional cart of the type still being used in sacred festivals. The giant wheels covered with intricate carvings and the huge forms of the horses ready to pull the cart indicate that the structure was meant to be a replica of the chariot of the sun-god Surya.

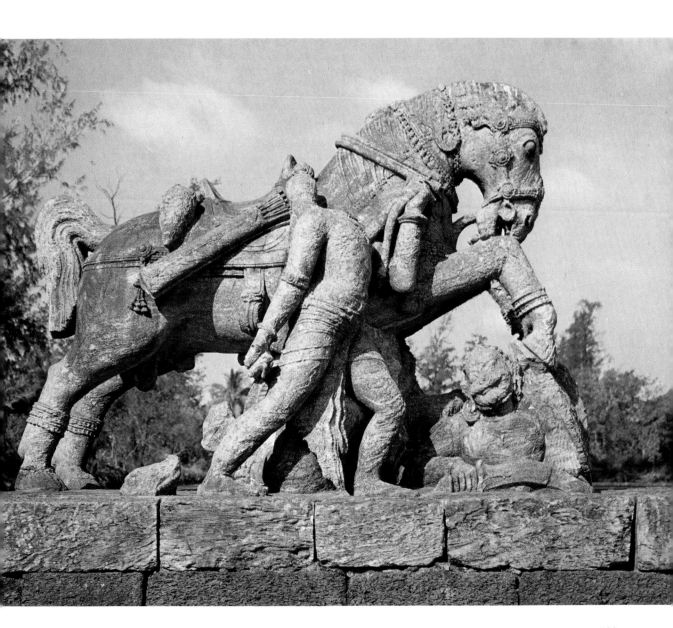

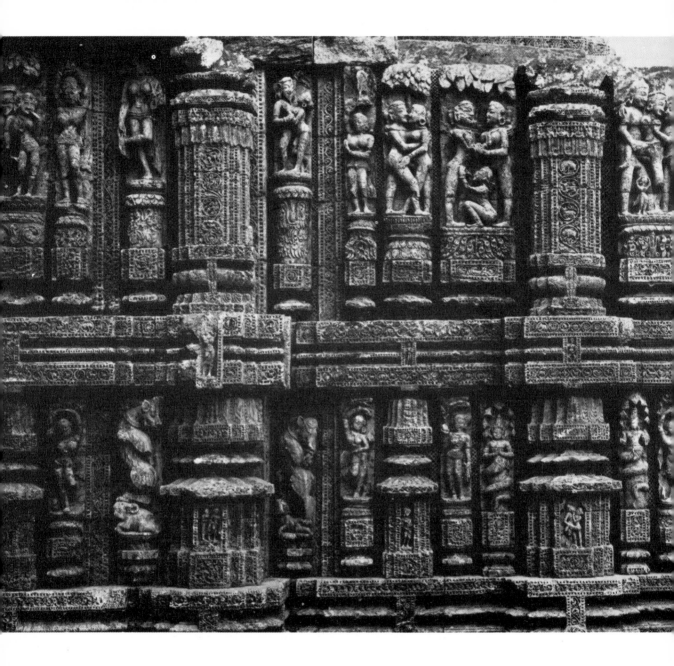

Prominent among the scenes portrayed at Konarak are the loving couples, or mithunas, whose joyful fulfillment of their carnal desire mirrors the rapture of the soul in its mystic union with the god. Although produced in great numbers by anonymous craftsmen, these carvings, like those at Khajuraho, are among the masterpieces of Indian art, indicating the high level both of technical performance and artistic inspiration which

◀ Erotic sculptures on base of manda- ▶
pa of Surya Temple, Konarak. Late
Medieval period, thirteenth century

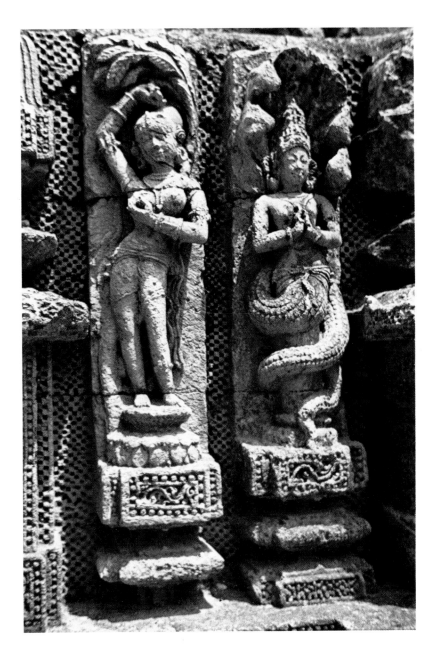

must have existed in India at this time. Here again, the parallel between the art of medieval India and medieval Europe is very striking, for these two remarkable traditions both produced first-rate sculptures in conjunction with great religious architecture.

THE HINDU ART OF SOUTHERN INDIA

The great period of Hindu temple architecture in northern India came to a close in the thirteenth century, largely because of the gradual conquest of the entire north by Moslem invaders who not only put an end to the erection of new temples but were also responsible for destroying many existing structures. In the south, however, Hindu temples continued to be built right into modern times since Islam never became so dominant in that part of the country. Among the southern temples built during the medieval period, one of the finest, especially superb in its sculptures, is the Rajrajesvara Temple in Tanjore which is contemporary with the temples at Khajuraho.

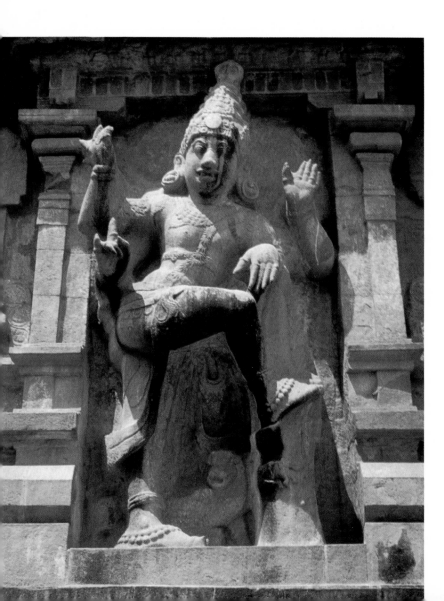

Rama, Great Temple, Tanjore. Late Medieval period, eleventh century ▶

Dancing Shiva, Great Temple, Tanjore. Late Medieval period, eleventh century

The most unique of the southern temples is the Hoysalesvara Temple at Halebid in Mysore which dates from the thirteenth century, the same period as that of the Sun Temple at Konarak. What is so different about this sanctuary is the style of the facade sculptures which is quite unlike that found at other sites, showing that although Hindu sculpture conformed to a general pattern, there were marked variations among many of the local schools. The style employed by the carvers at Halebid is perhaps best described as manneristic, with an emphasis on intricate detail and ornamental design rather than sensuous beauty.

Sculptures on base of Hoysalesvara
Temple, Halebid. Height 39″. Late
Medieval period, thirteenth century

Ganesha, from Minakshi Temple, Halebid. ▶
Height 35″. Late Medieval period, thirteenth
century. Brundage Collection, San Francisco

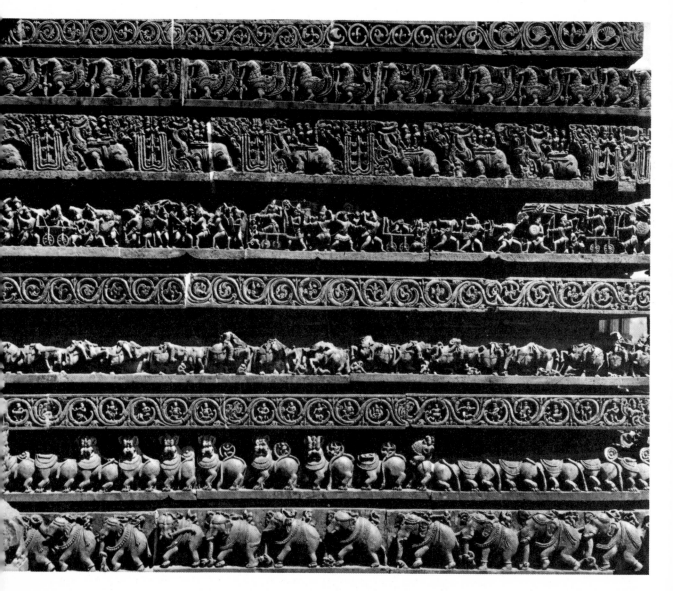

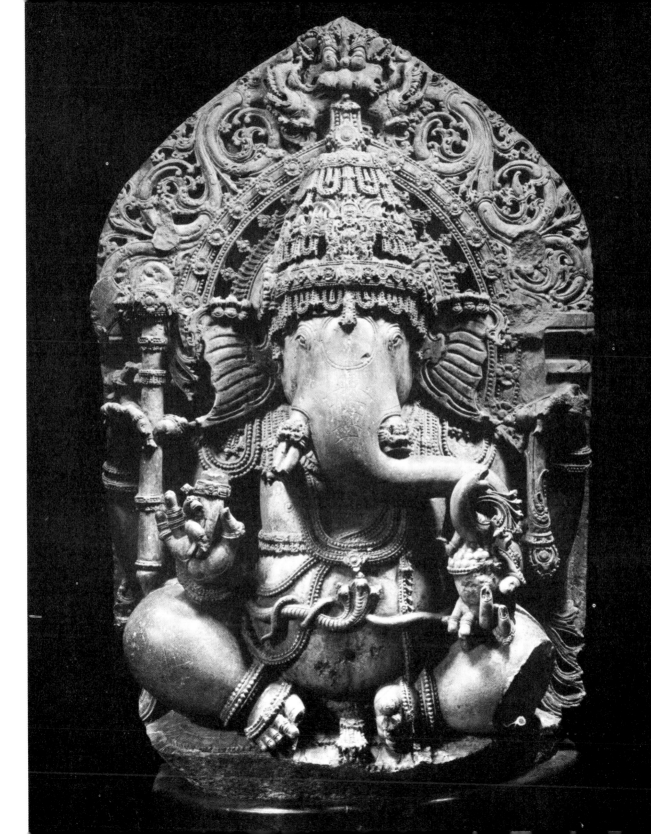

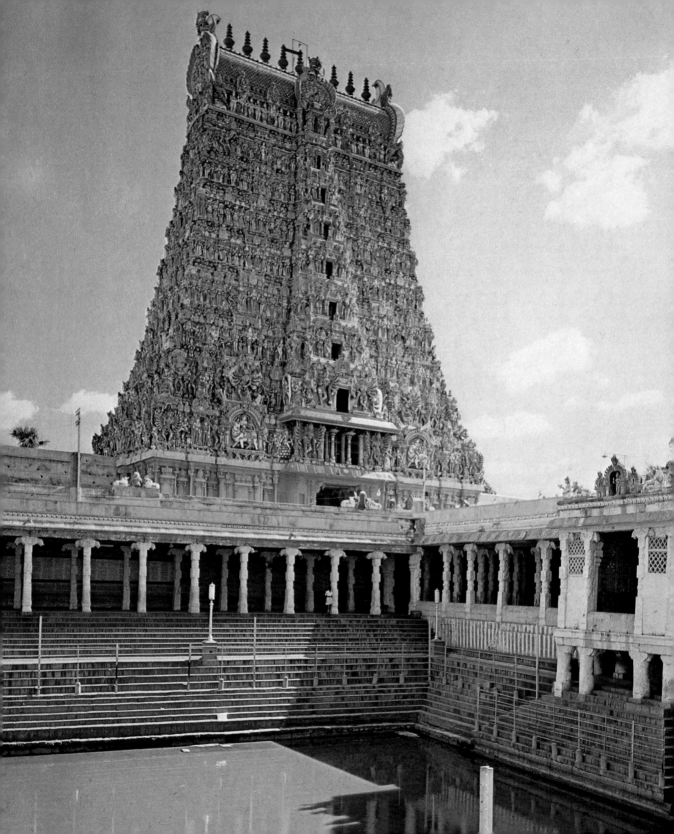

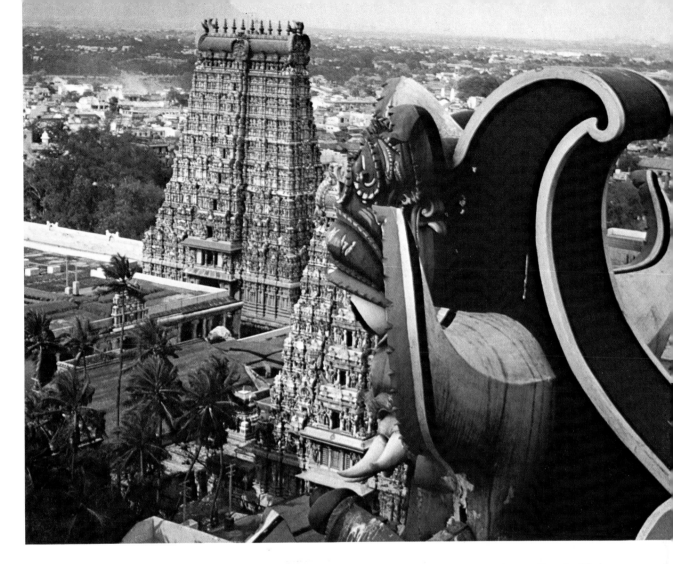

◀ Pool and gopura of Great Temple, Madura.
Late Medieval period, seventeenth century

View of gopuras of Great Temple, Madura.
Late Medieval period, seventeenth century

The most famous of the southern temples is the one at Madura which dates from the seventeenth century and is the last artistically significant Hindu monument. A vast temple area surrounded by a wall which encloses its many buildings, it is impressive as a whole even if the detail is artistically inferior to earlier structures. The most distinctive features are the four huge towers, or gopuras, which face in four directions and mark the entrances to the sacred enclosure. At the center of the complex is the main sanctuary and the sacred pool in which the worshipers bathe. Although the size of the buildings dwarfs anything which had previously been erected, the aesthetic quality of the temple shows a marked decline, and by the eighteenth century, even in the south, the great tradition of Hindu art had come to an end.

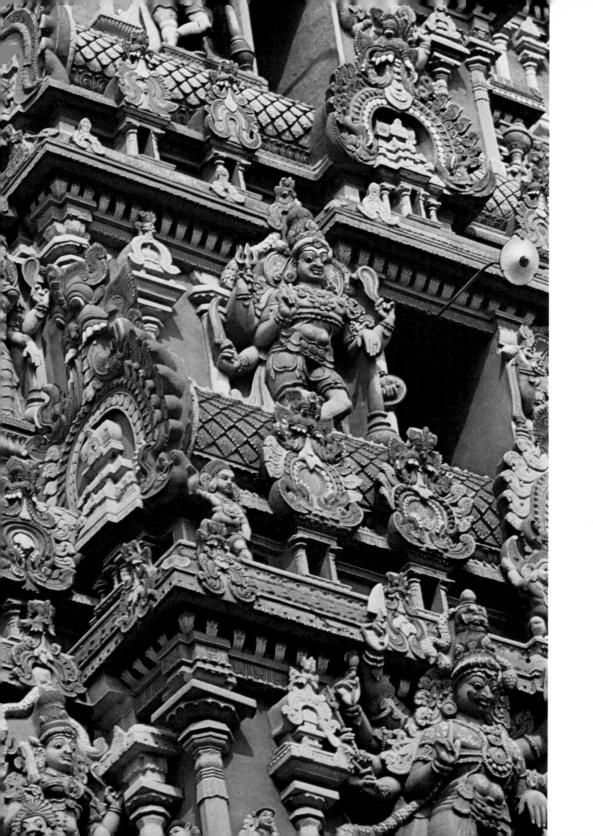

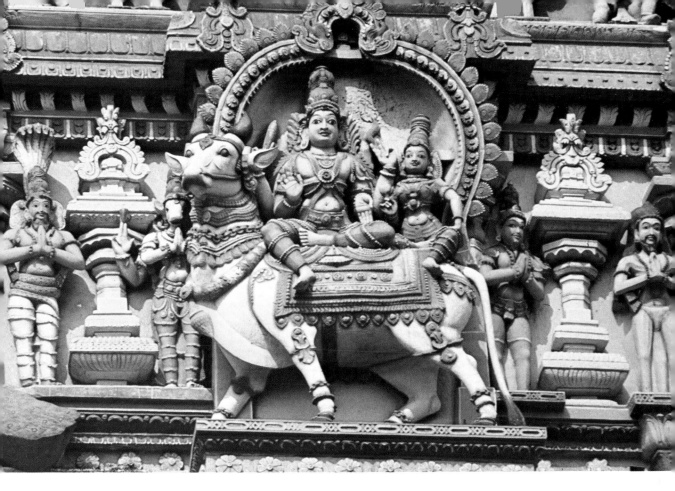

Shiva and Parvati seated on sacred bull Nandi, from gopura of Great Temple, Madura. Late Medieval period, seventeenth century

The late and decadent nature of the Madura temples is most clearly seen in the elaborate sculptural decorations of the huge towers over the entrances to the temple compound. They show a lessening both of spiritual feeling and of quality of artistic performance. The forms of the gods and goddesses portrayed are at the same time more naturalistic than those used in the earlier carvings and highly mannered so that the effect is artificial and often ugly. In fact the late temple sculptures lack all the depth of religious inspiration and aesthetic excellence which had marked the temple carvings of the Hindu Medieval period. Only in the wood carvings of the folk sculptures of rural India does something of the beauty and sensitivity of the earlier work survive during the later centuries.

◀ Detail from sculptural decoration on gopura of Great Temple, Madura. Late Medieval period, seventeenth century

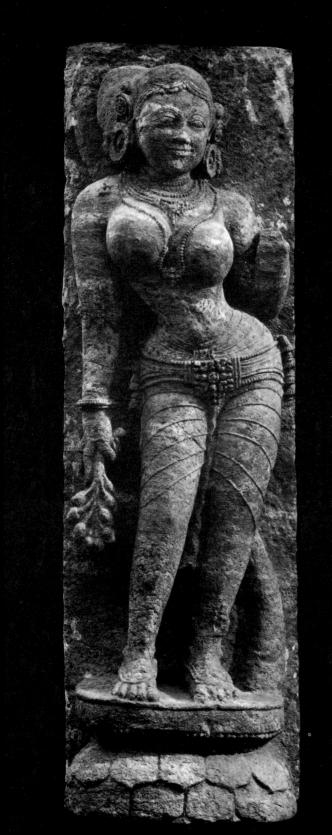

Female figure, from Bhuvanesvara. Height 42½". Late Medieval period, twelfth century. The Metropolitan Museum of Art, New York City

Although most of the stone sculpture of Hindu India was meant to be a part of the temple architecture, many of these carvings can be looked at as individual works of art. In fact numerous sculptures in museums and private collections in the West were once a detail of a temple's decoration, yet they can be viewed independently. That they were ripped from their settings is deplorable, yet it must be said that the great beauty of these carvings can often be more fully appreciated when they are viewed as separate works of art.

Female torso, possibly from Khajuraho. Height 9". Late ▶
Medieval period, tenth century. Munsterberg Collection, New Paltz, N. Y.

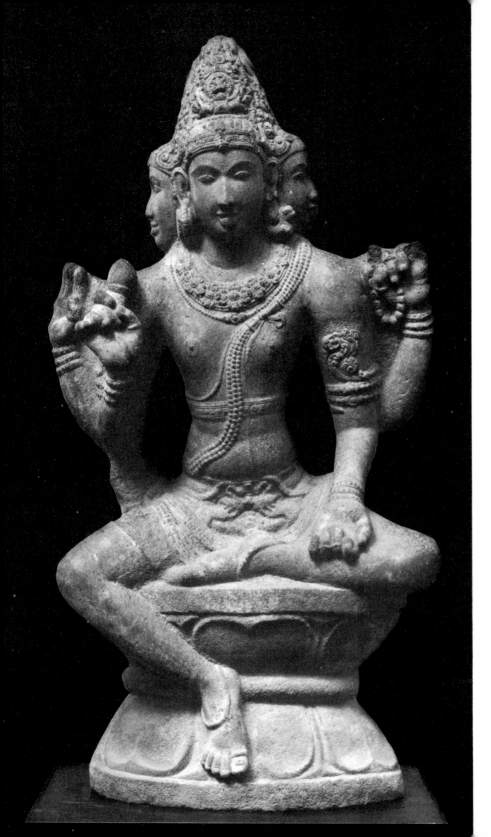

Seated Brahma, from South India. Height 58″. Late Medieval period, eleventh century. The Metropolitan Museum of Art, New York City

While most of the surviving sculpture is architectural, there were many other works which were intended as separate objects. Among these were representations of Shiva and Vishnu, the two most popular deities, as well as a host of other gods and goddesses who make up the Hindu pantheon. Prominent among them was Brahma, the Great Creator, who can be recognized by his four heads, one facing in each of four directions, and Surya, the sun-god, whose attribute is the horse-drawn chariot which he drives across the sky. These are but a few of the many sacred beings represented in Hindu sculpture.

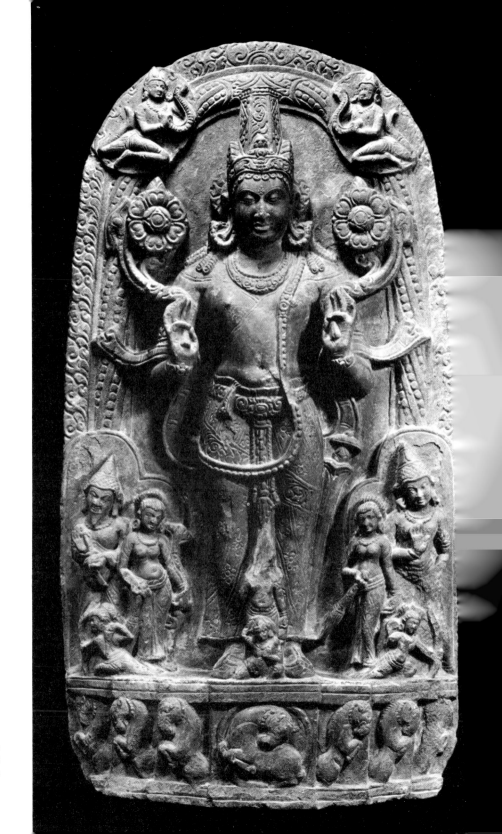

Surya, from Bengal. Height 23″.
Late Medieval period, twelfth
century. Boney Collection,
Tokyo

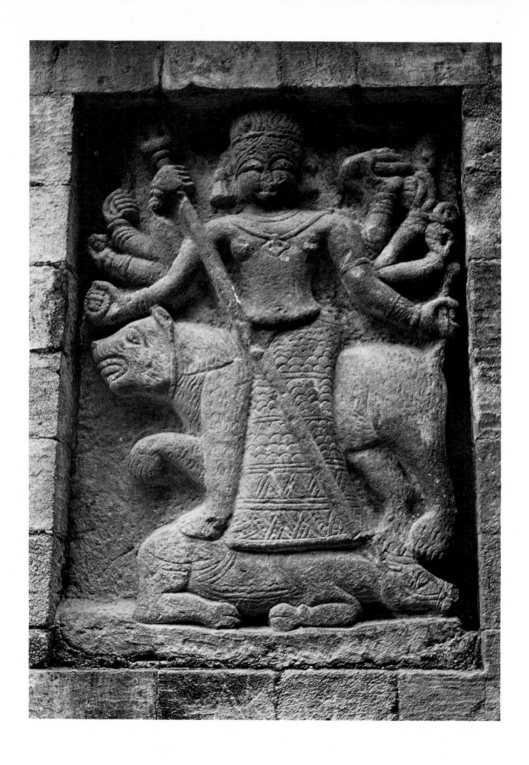

Durga as slayer of the buffalo-demon, from Kangra Fort. Late Medieval period, tenth century

Other images portray the female deities, also legion in number, some of whom revealed themselves in many different forms. Durga the Demon Slayer, for example, is an incarnation of the gracious Parvati, the wife of Shiva, who may also manifest herself as Kali, the terrifying goddess of pestilence. The identification of a specific deity is often very difficult, especially when there are no attributes which can definitely be associated with a given god or goddess. However, the iconography was not dependent upon the whim of the artist making the image, but followed the rules set forth in the shastras and sanctified by tradition. This complex and elaborate system of iconography, although not always clear to the modern viewer, was no doubt deeply meaningful to the medieval worshiper.

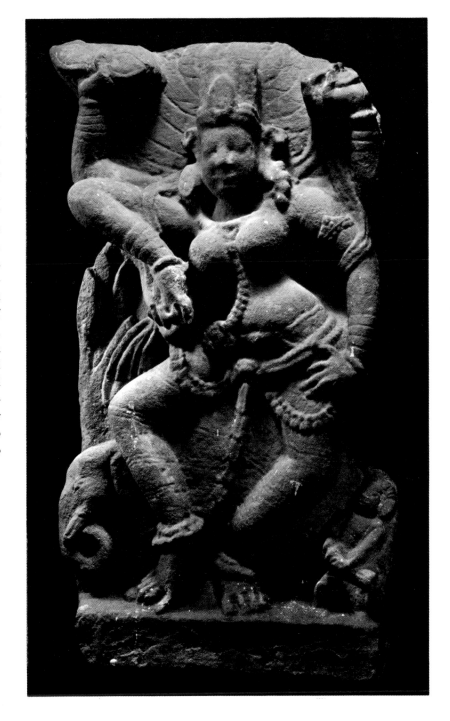

Indrani dancing before an elephant. Height 25″. Early Medieval period, ninth century A.D.

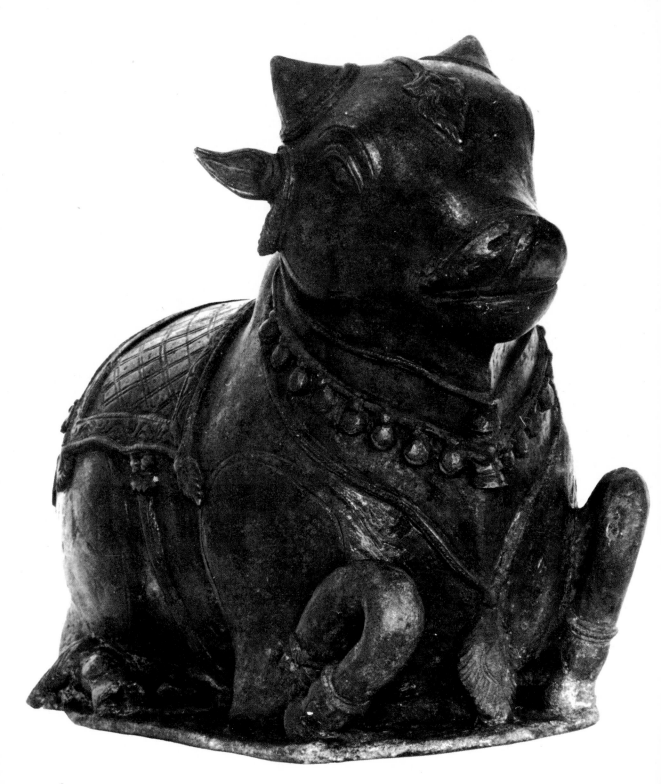

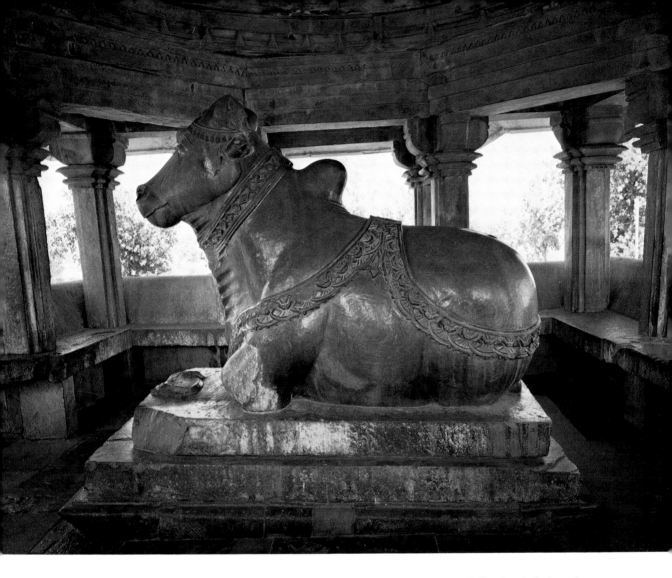

Sacred bull Nandi, at Khajuraho. Sandstone. Late Medieval period, eleventh century

Of the many animals represented in Indian art, the most popular as well as the most sacred was probably the bull which in the form of Nandi was associated with the god Shiva and therefore enjoyed special veneration. In fact temples were often dedicated to Nandi and images of the bull appear both as parts of larger compositions and as separate carvings. Just as the lion had been a common subject in Buddhist art where it symbolized royal power and was associated with the Buddha Sakyamuni, so the bull is very frequently rendered in Hindu art where it is associated with Shiva and represents the creative principle.

◄ Sacred bull Nandi, from South India. Bronze, height $10^{5}/_{8}$″. Late Medieval period, sixteenth century. Formerly Belmont Collection, Basel

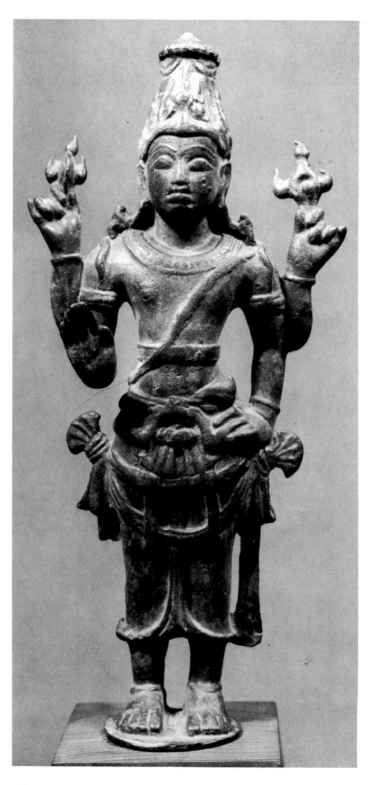

Although the bulk of the sculpture which survives is made of stone, other mediums, such as bronze, copper, silver, gold, ivory, and wood, were also employed. The most outstanding are the bronze images which were particularly popular in southern India. Beginning in the seventh century, a school of metal sculpture evolved in the southern part of the country, a region which, especially under the Chola dynasty, produced some of the greatest works of Hindu sculpture. These images, made by the lost-wax process in a mixture of bronze and tin, are not only technically superb, they are also outstanding from an aesthetic and religious point of view.

Vishnu (front and rear views). Bronze, height 10″. Early Medieval period, seventh century A.D. Wolff Collection, New York

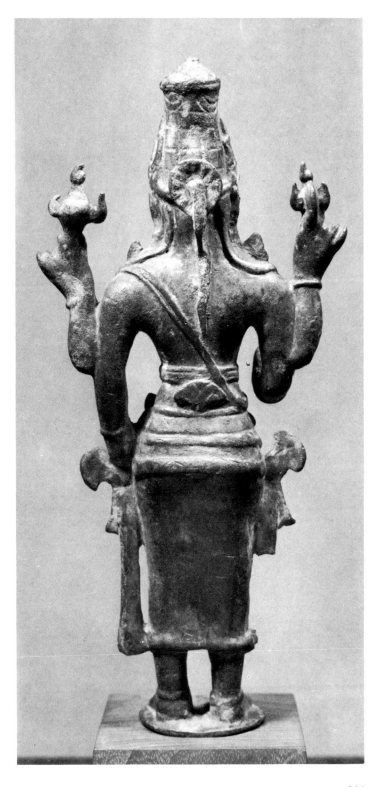

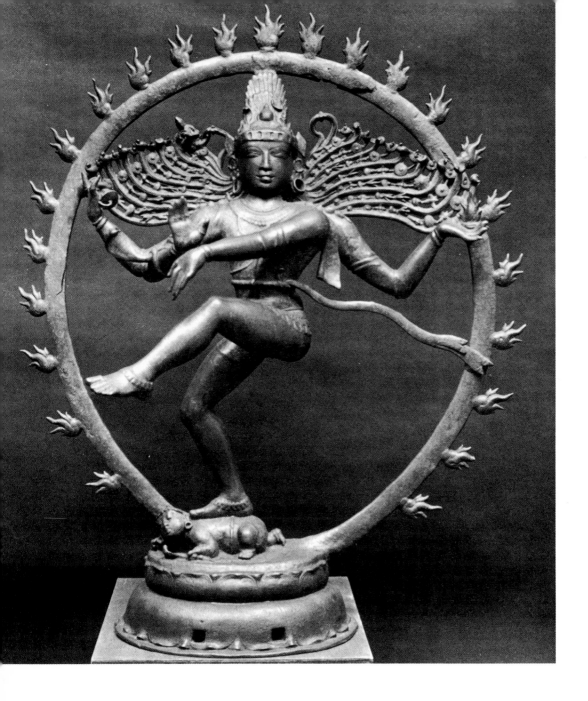

Among the numerous gods represented in the bronze images, the most popular was Shiva, especially in his manifestation as Nataraja, or the Lord of Dance. In these statues of the dancing Shiva, Hinduism finds one of its most profound and characteristic expressions. The cosmic dance mirrors the very essence of the Hindu concept of life, with the dynamic movement of the god expressing the eternal process of the creation, destruc-

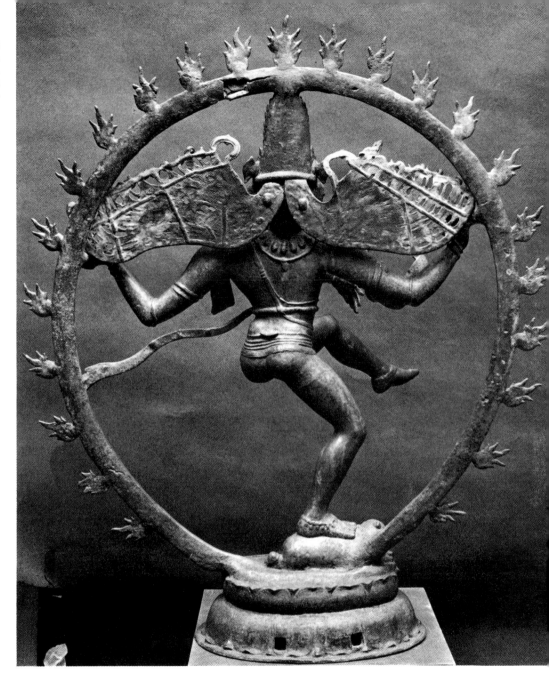

Shiva as Nataraja (front and rear views). Bronze, height 35″. Chola Dynasty, tenth century. Wolff Collection, New York

tion, and re-creation of the universe. His foot crushing the dwarf which represents evil, the god performs the rhythmic dance, one hand holding the flame symbolizing destruction, and the other raised in the abhaya mudra, the gesture of fearlessness, indicating that the worshipers should not be afraid but should come to Shiva.

In other images, Shiva is shown with his female counterpart Parvati, the gracious goddess of love and beauty, or with his wife and the baby Skanda, the latter group being known as Somaskanda. Emblems associated with Shiva and often found in these images are the ax and the deer, while the wheel and the conch shell are com-

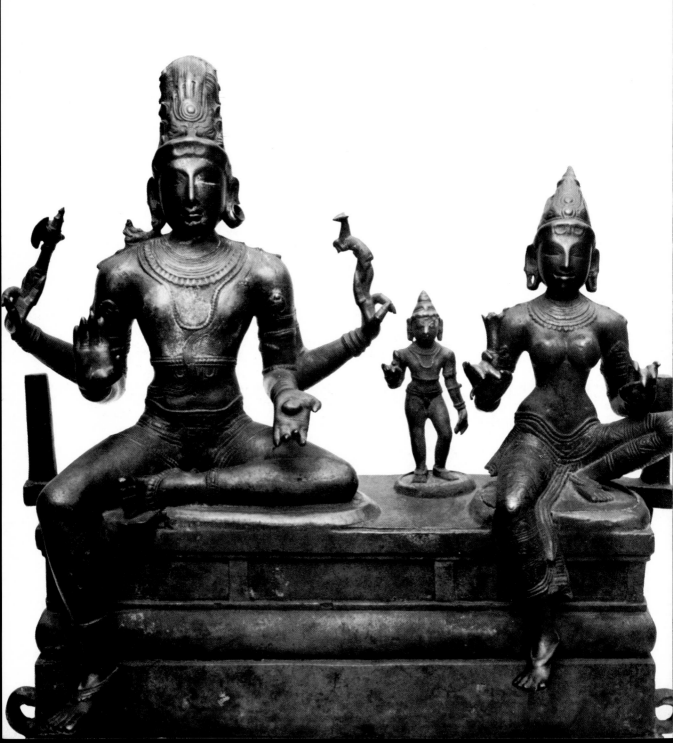

monly associated with Vishnu. Another characteristic of Shiva is the tall phallic headdress which indicates that he is also worshiped as the Lord of the Lingam. Shiva's wife in her incarnation as Parvati is seen as the very essence of female beauty, thus becoming a fit companion for the god.

Shiva with Parvati and Skanda (front and rear views). Bronze, height 20⁷/₈″. Chola Dynasty, eleventh century. Formerly Belmont Collection, Basel

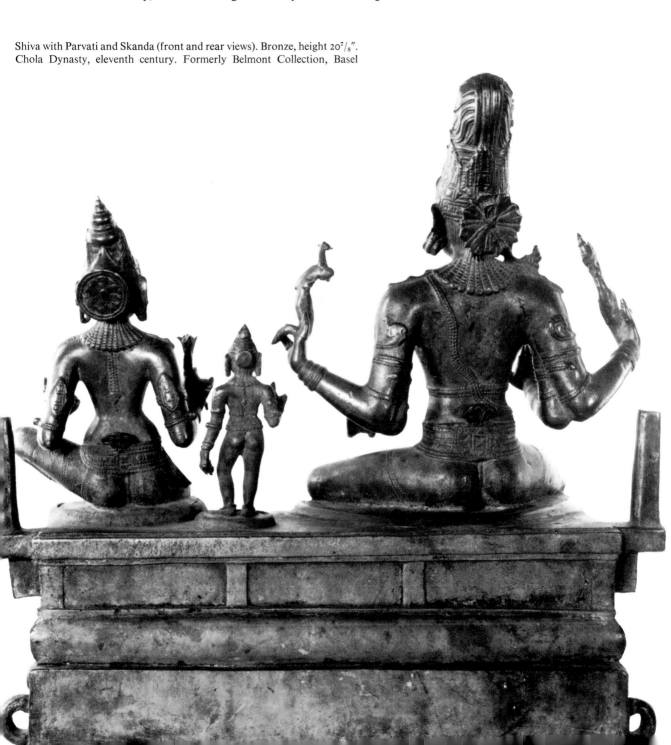

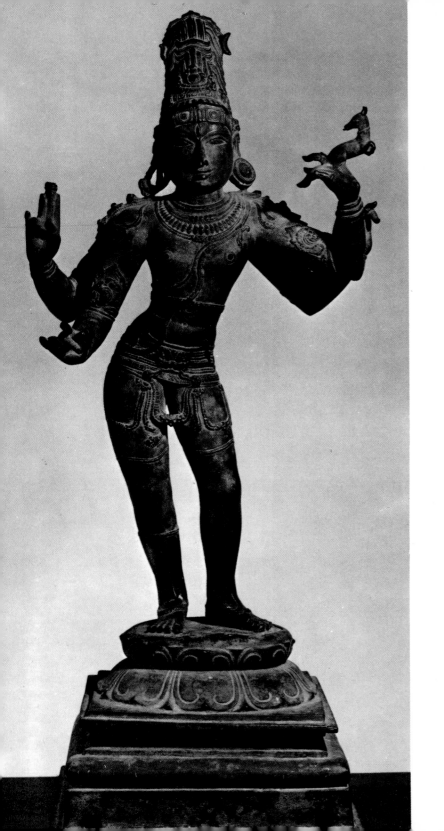

Shiva as Vinadhara. Bronze, height 30".
Chola Dynasty, eleventh century. Private
collection, New York

Shiva. Bronze, height 14″. Chola Dynasty, twelfth
century. Morse Collection, New York

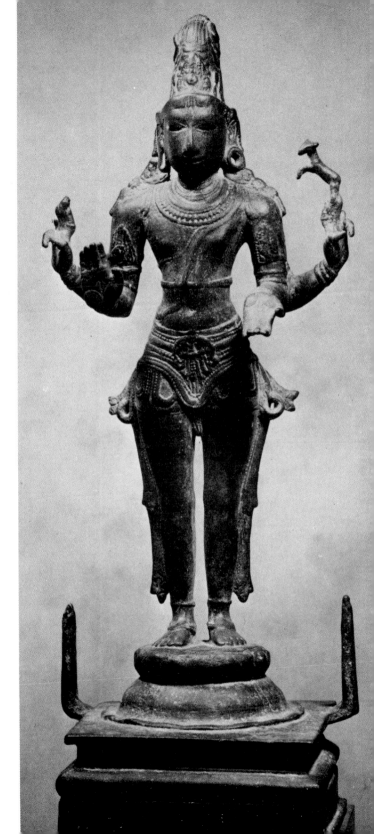

Other bronze statues show Shiva as Vinadha-
ra, the god of music, with his body in a dance-
like position and one hand holding the flute
which is associated with the god in this role.
Here again, every detail of the iconography
was carefully prescribed by the manuals of
instruction used by the craftsmen who made
these images. Although the style changed
over the centuries and the quality of individ-
ual sculptures varied enormously, the gener-
al style remained much the same over a pe-
riod of almost a thousand years during which
these icons were produced. In the eyes of most
critics, the best bronzes were made under the
Chola dynasty during the tenth, eleventh, and
twelfth centuries, but excellent works were
also produced in the following Vijayanagar
period.

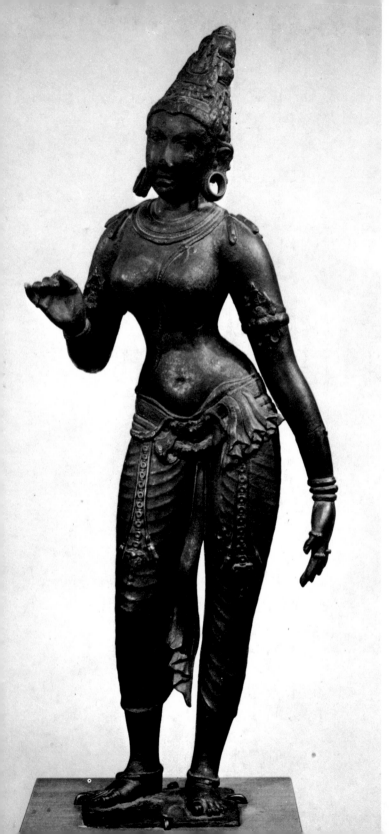

Parvati. Bronze, height 27¹/₂″. Chola Dynasty, tenth century. The Metropolitan Museum of Art, New York City

Next to the images of the dancing Shiva, the most outstanding bronzes are the numerous statues of the goddesses, usually either Parvati, the consort of Shiva, or Lakshmi, the female counterpart of Vishnu. Many other deities are represented in bronze, among them Rukmini, the wife of Krishna, and Sita, the consort of Rama, as well as various other

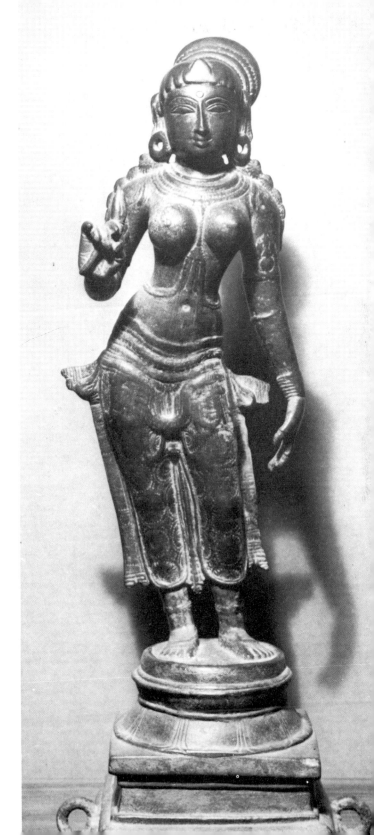

Rukmini. Bronze, height 21½″. Chola Dynasty, twelfth century. Wolff Collection, New York

goddesses of the Hindu pantheon. In these images the typically Indian ideal of feminine beauty finds its most perfect expression. The body has a graceful, dancelike sway, the breasts are protruding yet firm, and the figure slender with a narrow waist, full hips, long legs, and delicate hands.

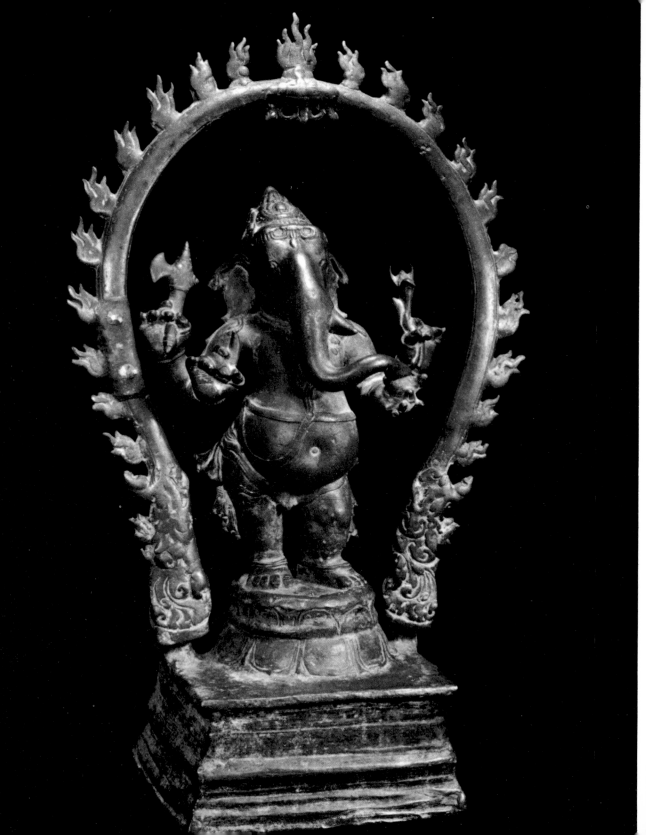

Ganesha (front and side views). Bronze, height 21″. Chola Dynasty, twelfth century. Boney Collection, Tokyo

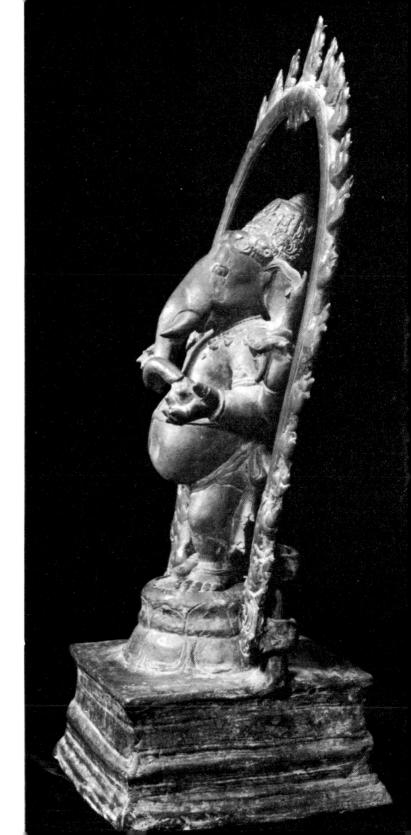

The strangest yet in some ways the most appealing images are those of Ganesha, the god of wisdom and learning who is the son of Shiva and Parvati. He is always represented as a potbellied figure with an elephant head, which reflects the ancient Indian tradition that the elephant is the wisest of all animals, an idea also implicit in the legend that prior to the birth of Buddha his mother dreamed of a white elephant which was taken to mean that her son would be a sage. Ganesha's animal head is the subject of various Hindu legends which try to explain the reasons for this strange phenomenon.

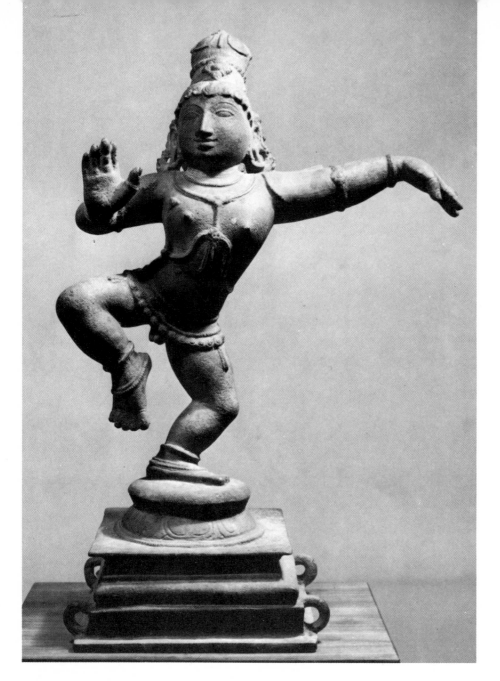

Dancing Krishna (front and rear views). Bronze, height 14½". Chola Dynasty, thirteenth century. Wolff Collection, New York

Another charming figure frequently represented in the southern bronzes is that of Krishna, the divine cowherd, who is one of the many manifestations of Vishnu. He is usually represented as a young boy who in the legends dances and plays with the milkmaids whose butter he steals. Like the dancing Shivas, the emphasis in these

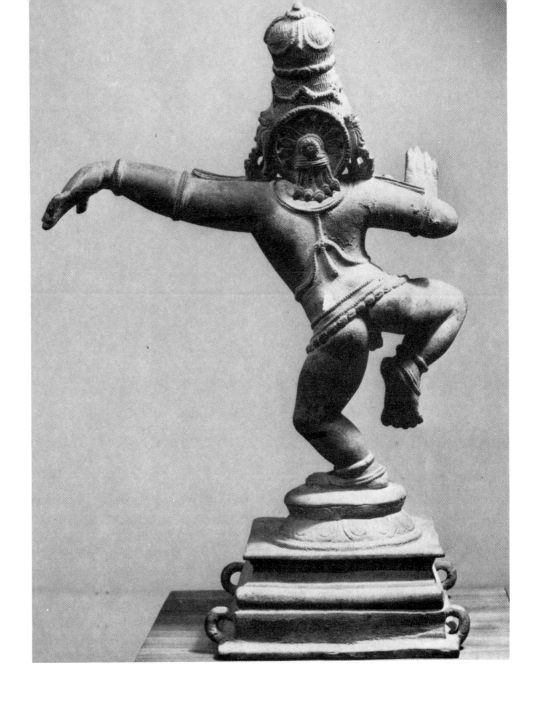

bronzes is on the rhythmic movement of Krishna's body and the graceful gestures of his hands. Dance has always played an important part in India—in fact, in no other civilization does this art form have such as central role as in India and the countries influenced by Indian culture.

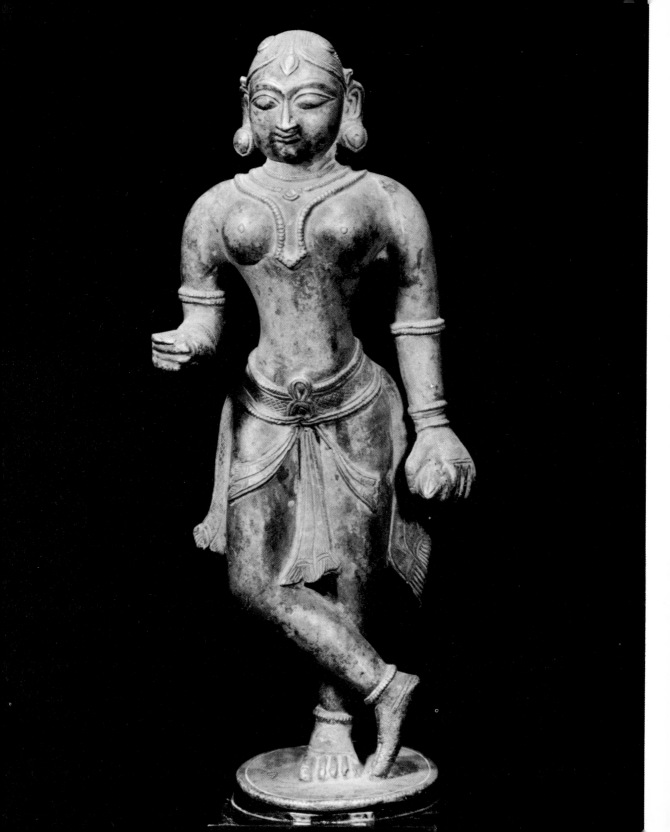

Female figure. Brass, height 11″. Late Medieval period, sixteenth century. Boney Collection, Tokyo

Elephant with rider. Bronze, height 6¹/₈″. Late Medieval period, seventeenth century. Schwindler Collection, Athens, Ohio

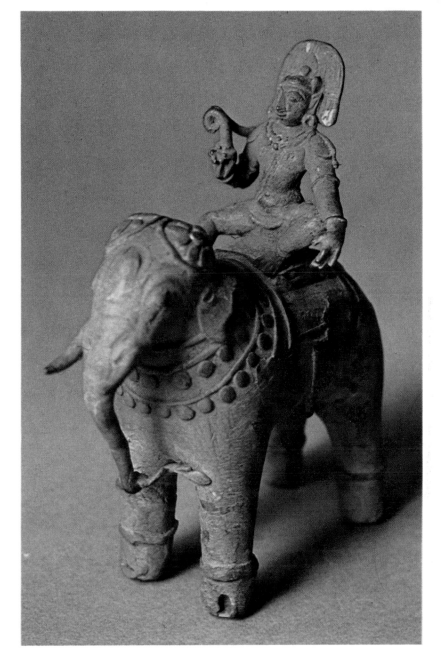

The sophisticated style of the bronzes intended for the major temples began to deteriorate by the end of the fifteenth century, giving way to a rigidity and mannerism with a consequent loss of vitality. However, on the folk-art level good work was done right up to modern times. In their crude and unpretentious way, some of these folk sculptures, often made of brass or copper rather than bronze, are works of great charm and freshness. The forms are usually far simpler and the iconography less complex, but the total effect of these images is naive and straightforward unlike the rather dead, somewhat sterile effects created by later works made for important temples.

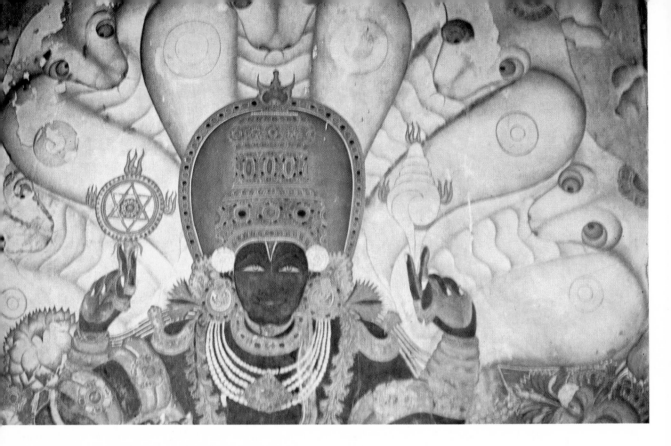

Vishnu, wall painting. Late Medieval period
eighteenth century. Dutch Palace, Cochin, Kerala

Hindu painting, which must have been a major art form in medieval India, has unfortunately not survived very
well. No site like Ajanta exists, and it is most unlikely that one will ever be discovered. Remains of Hindu paint-
ings do exist at Elura and Tanjore; and wall paintings from the Late Medieval period have been found at
various southern sites. Literary accounts tell of flourishing schools of painting all over medieval India, but
since most of these works were executed on walls or on fragile materials such as wood, paper, and palm leaves,
only a few fragments have survived. The subjects treated were the familiar ones, with Shiva and Vishnu most
commonly represented.

Rama, wall painting. Late Medieval period, eight- ▶
eenth century. Padmanabhapuram Palace, Kerala

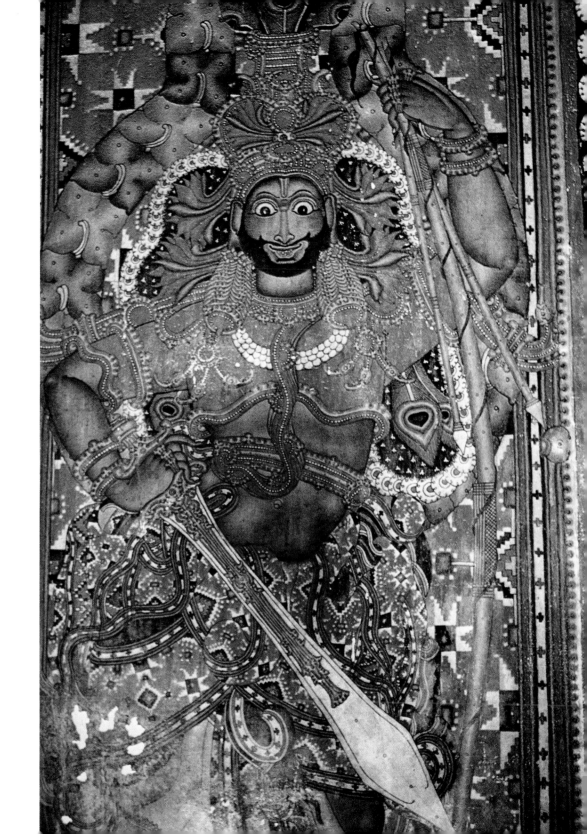

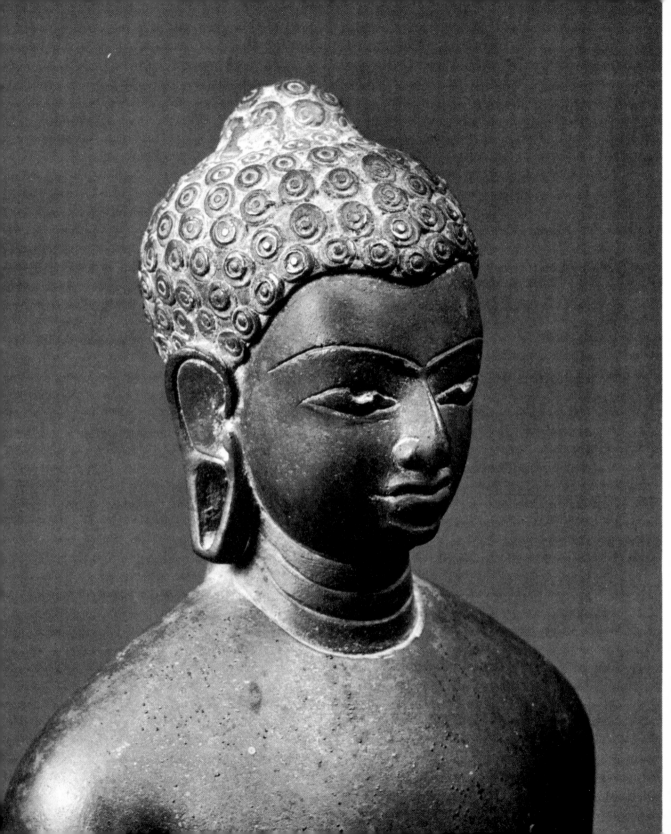

INDIAN ART UNDER JAIN INSPIRATION

Although most Indian art was inspired either by Buddhism
or Hinduism, religious art was also produced by Jainism,
the third of the great religions of India. Jain sculpture, on
the whole, is closely related to Buddhist sculpture from
which it was probably derived. Indeed, it is often difficult
to tell if a given work was made for one or the other of
these faiths. However, there is one aspect in which Jain
sculpture differs noticeably from the Buddhist, and that is
that the Jain savior is shown in the nude with his male
organ prominently displayed, while the Buddha wears
monk's robes which conceal his sex, indicating that he has
overcome the desires of the flesh.

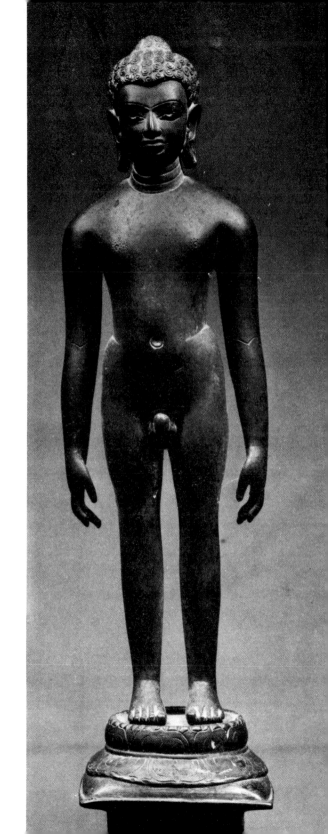

Jain figure. Bronze. Early Medieval period, eighth century A.D.
Cornell University, Ithaca, N. Y. Facing page: detail of head

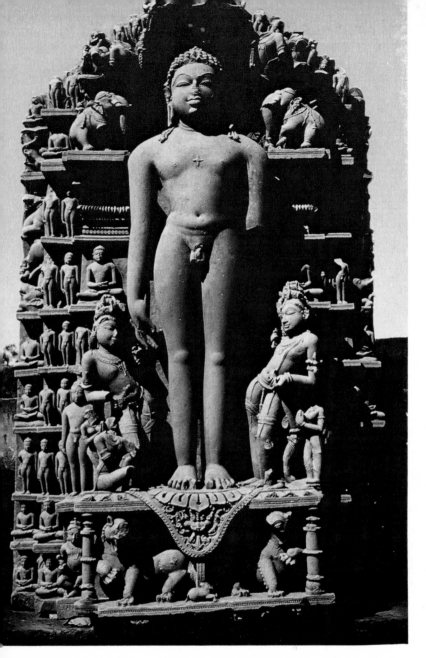

Jain Savior, at Khajuraho. Sandstone. Late Medieval period, tenth century

Basically Jain sculpture is very similar to Buddhist sculpture, for the artistic forms and the iconography are almost identical. The Jain savior, or Jina, is shown either standing or seated with his legs crossed in the same yoga position in which the Buddha was traditionally portrayed. Some scholars have suggested that the Jain images actually preceded the Buddhist ones and are derived from a common source, namely, the yaksha

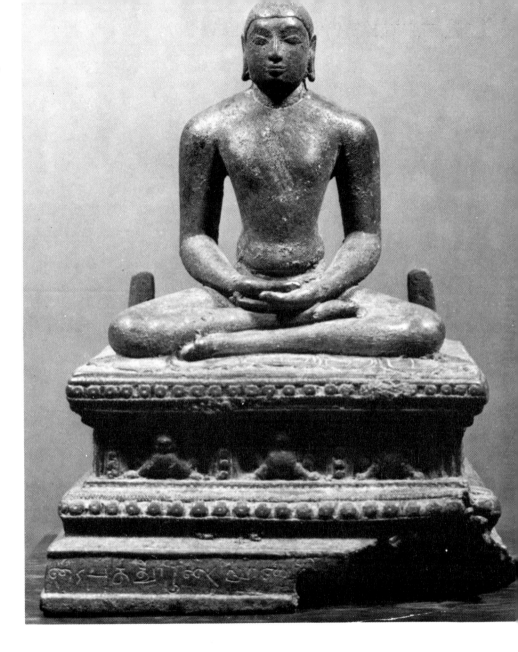

Jain saint. Bronze, height
7¹/₂″. Late Medieval period,
eleventh century. Sackler
Collection, New York

images of the Maurya Period, but this seems most unlikely since Buddhist art can be traced back to an earlier time and is so much more developed. The stylistic evolution which Jain sculpture underwent also followed the Buddhist pattern except that the Jain images tended to be harder and drier than the Buddhist ones.

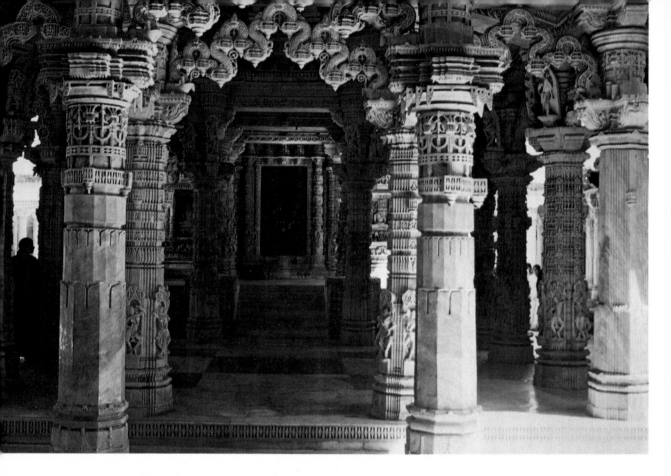

Interior of Jain sanctuary at Mount Abu, Rajputana.
Marble. Late Medieval period, thirteenth century

Of all the artifacts created by the Jain sect, by far the most famous is the great Jain sanctuary on Mount Abu in Rajputana. From a technical point of view, the thirteenth century Tejpal Temple is one of the most remarkable structures in world architecture. Carved of white marble, the interior creates an intricate, filigree effect which is almost unbelievable, representing as it does the endless labor of thousands of craftsmen who carved, filed, and polished the stone until the lacelike forms emerged. Particularly impressive is the huge dome with its flower-like pendant resembling some fantastic stalactite. However, the total effect of the temple is perhaps more one of marvellous virtuosity than artistic beauty.

Carved dome of Jain sanctuary at Mount Abu, Rajpu- ▶
tana. Marble. Late Medieval period, thirteenth century

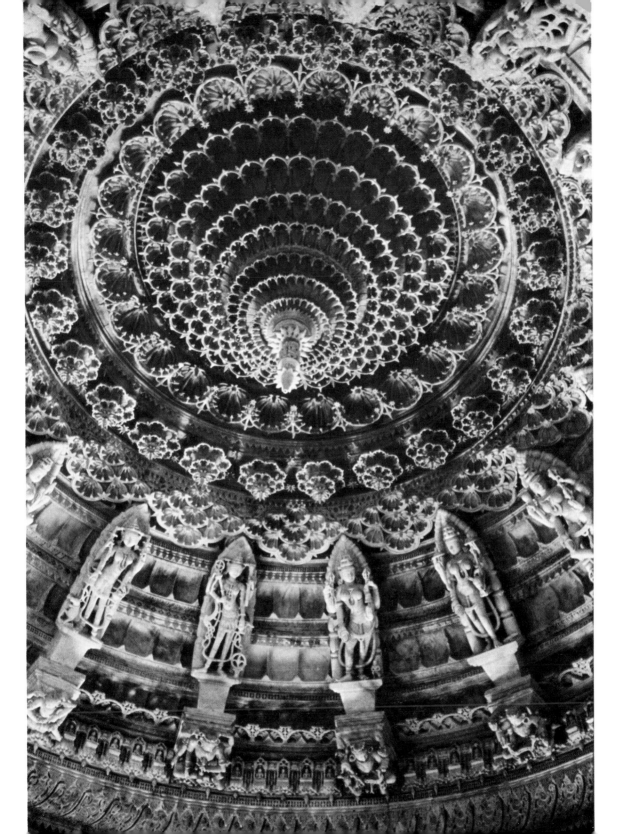

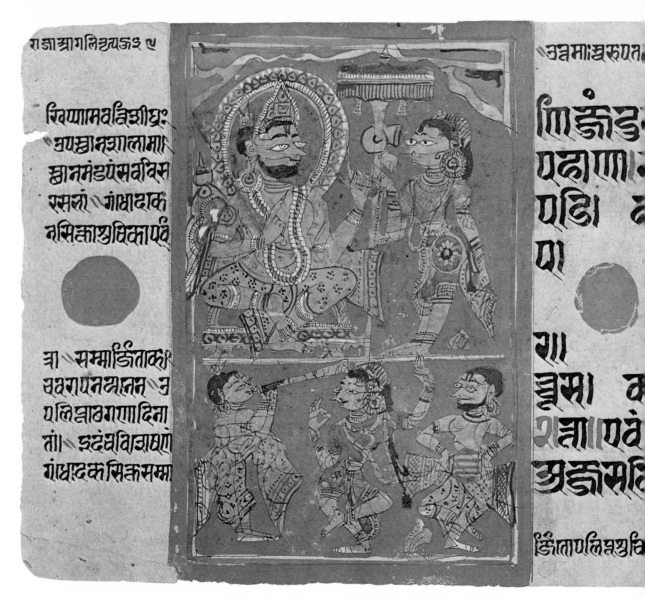

रिच्यामवविशीघ्रः
ञघञ्ञश्शालामा
ज्ञानमंडयंसवविस
रसली गंधाद्दक
नसिक्ाश्वधिकाप॑

ञा सम्मांडिताक
चक्राणनश्ञ्ञन नु
चलिञ्ञावगणादिना
तां इदंचविञघ्ां
गंधद्दकसिक्समम

Jain illuminated manuscript showing Siddharta celebrating Mahavira's birth festival. Color on paper, height $4\frac{1}{2}''$. Late Medieval period, sixteenth century. Munsterberg Collection, New Paltz, N. Y.

This same rather mannered quality is even more clearly evident in Jain painting which consists for the most part of illustrated manuscripts made in the Gujarati region of western India from the thirteenth to the sixteenth century. Bold in design and vivid in color, they are among the earliest and most beautiful of surviving Indian miniatures, and they contributed greatly to the development of this genre in Indian pictorial art. The subjects are taken from Jain teachings, a favorite topic being the life of Mahavira, the founder of Jainism, who was a

contemporary of Sakyamuni Buddha. A strange and quite unique convention which is found in these pictures is that the eyes of the figures protrude beyond the surface of the face, a device which has been explained by some scholars as an attempt to portray images with inlaid eyes projecting beyond the facial plane. The style of these paintings is very linear and dry, tending toward mannerism and repetition.

While Jain artists produced some of the important early miniatures, the most outstanding school of Indian miniature painting flourished at the Hindu courts, notably those of Rajputana. This type of work is usually called Rajput painting even though much of it was actually not made in Rajputana but in adjacent

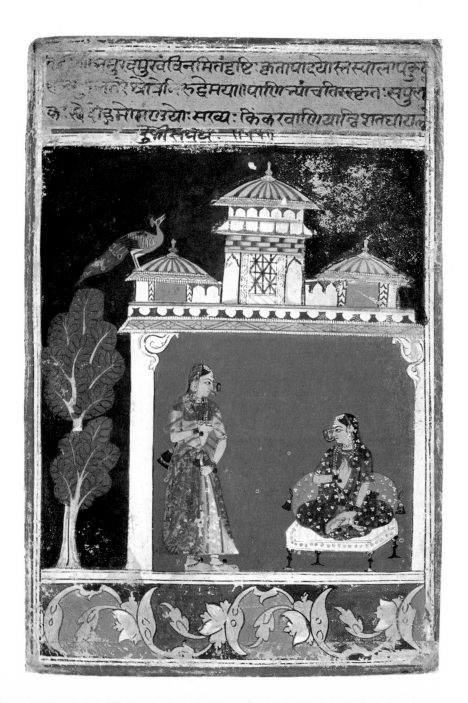

Two female companions conversing. Color on paper, height 8″. Malwa School, seventeenth century. Hudson Collection, New York

areas. In fact some of the finest of early Indian miniatures come from Central India, especially Malwa which was an important artistic center during the seventeenth century. The best of these works, although small in scale, are masterpieces of color and design which are far superior to the larger pictures produced at that time. The flat decorative use of brilliant colors and the strong emphasis on pattern appeal to modern taste, and it is not surprising that Klee and Matisse greatly admired Rajput painting.

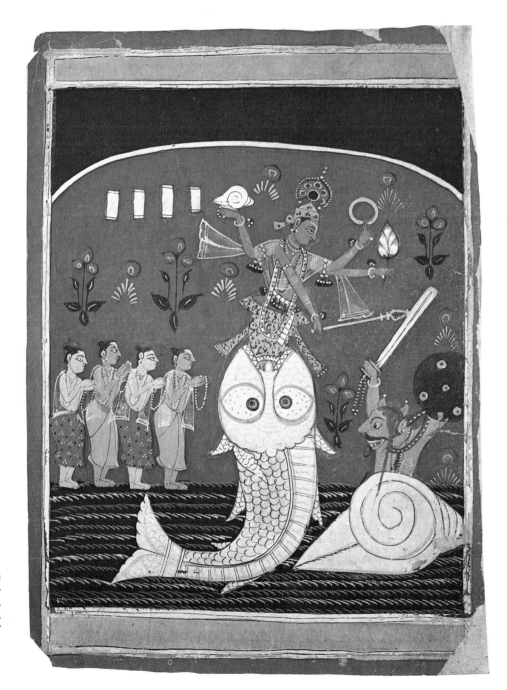

Vishnu assuming the form of a fish to destroy the sea-demon. Color on paper, height 8¼". Malwa School, seventeenth century. Wiener Collection, New York

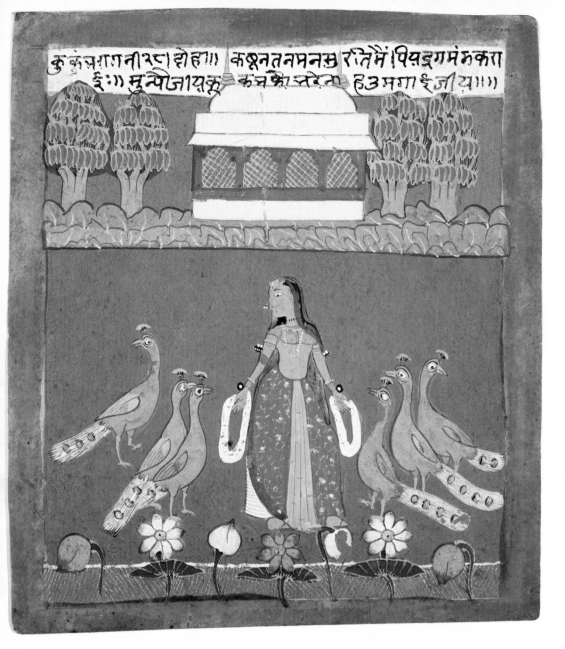

Kakubha Ragini. Color on paper, height 7″. Malwa School, seventeenth century. Munsterberg Collection, New Paltz N.Y.

The subjects of the miniatures were usually taken from Hindu legend, especially stories relating to Krishna who is one of the many manifestations of Vishnu. His love for Radha, his favorite among the milkmaids, was treated again and again by the Rajput artists, for to them it embodied the very essence of romantic love. Another popular subject was the musical modes, or ragas, which are related both to various times of day and to emotional states. Here again, the romantic element was emphasized, with the colors and forms having all kinds of symbolical connotations. Red, for example, stood for passion, the peacock was connected with romantic love, and night scenes with a stormy sky mirrored the turbulence and longing in the hearts of the lovers.

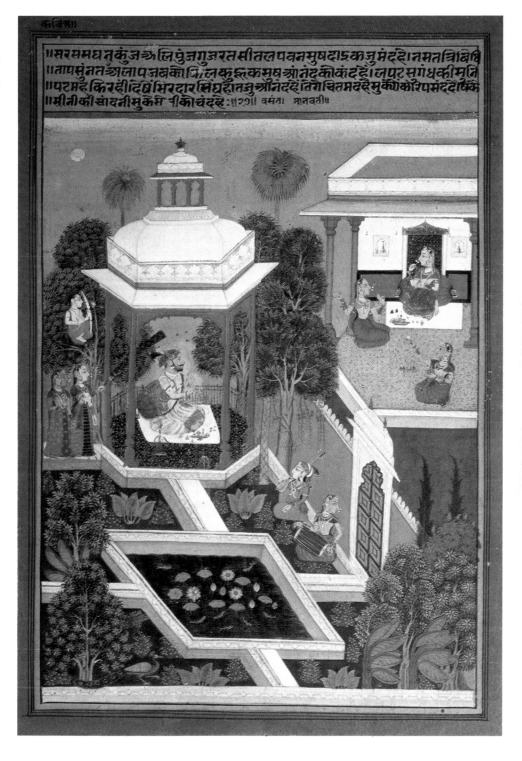

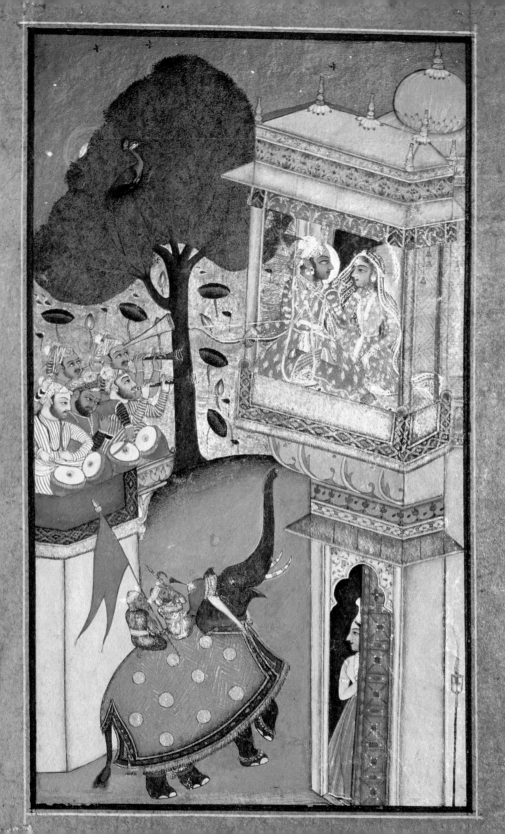

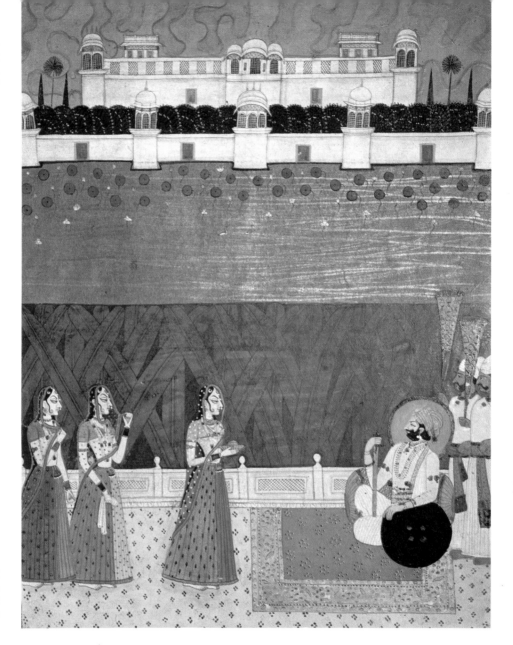

◀ Krishna and Radha on balcony. Color on paper, height 7″. Bundi School, dated 1748. Walter Collection, New York

Maharaja Takhat Singh of Jaipur. Color on paper, height 14¹/₂″. Kishangarh School, dated 1850. Burden Collection, New York

Rajput painters also portrayed scenes from the life of the Rajput courts, showing the local Hindu rulers accompanied by their female companions and attended by their ministers and servants. These pictures are not only charming as works of art but also very interesting as social documents since they give an idea of what the rulers looked like, as well as portraying the fashions of the period, and the gardens and courtyards and interiors of the palaces. While the early Rajput paintings were bold in color and abstract in design, the later works, dating from the eighteenth and early nineteenth century, tend to be more detailed and naturalistic, thus losing something of the strength and beauty of the earlier pictures.

The last great center of Indian miniature painting was not in Rajputana but in the northern region of the country, especially the foothills of the Himalayas. This school is generally called Pahari or Punjab Hills painting, although there are many local centers, each of which developed an individual style. The most traditional one, closely related to Rajput painting, is that found at Basohli. However there are other types of painting from the Punjab Hills area, such as that of the Guler court which is closer to Mughal painting of the type which had flourished at the Islamic courts at Delhi and Lahore.

Krishna and Radha. Color on paper, height 9¹/₄″. Basohli
School, seventeenth century. Museum of Fine Arts, Boston

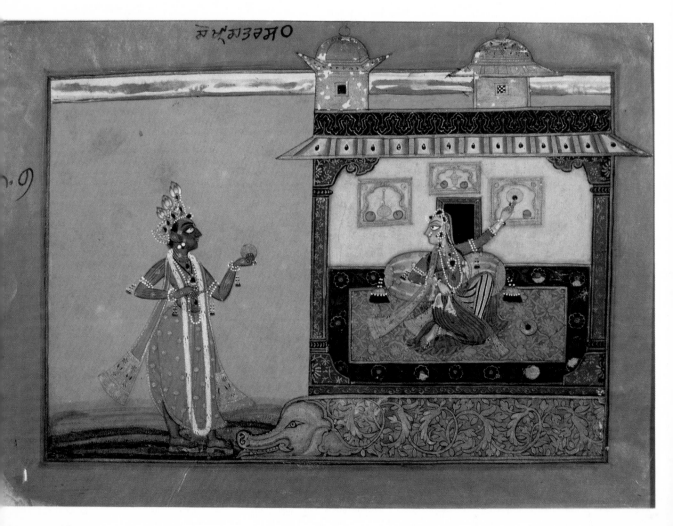

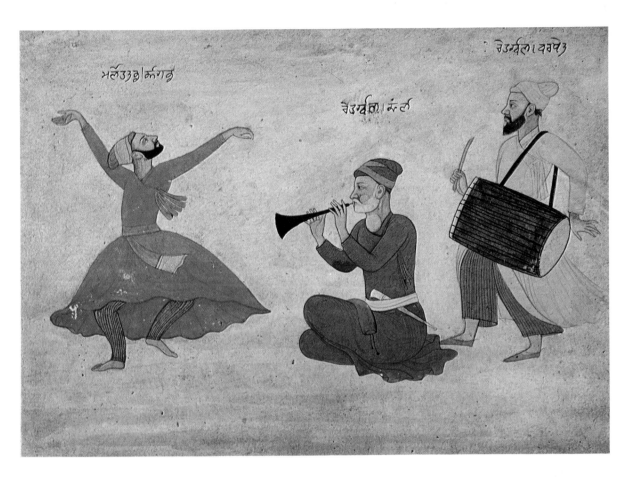

Dancing dervish and musicians. Color on paper, height 8″. Pre-Kangra School, eighteenth century. Burden Collection, New York

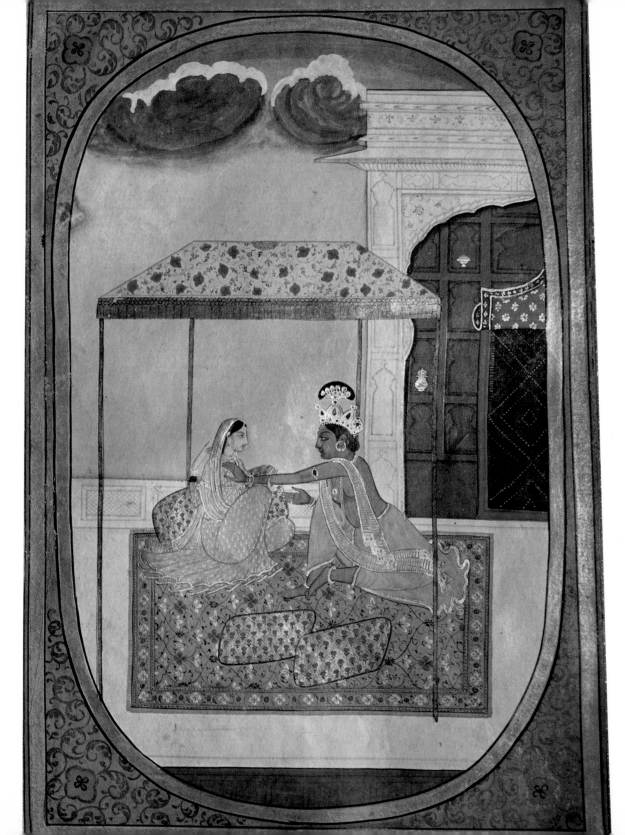

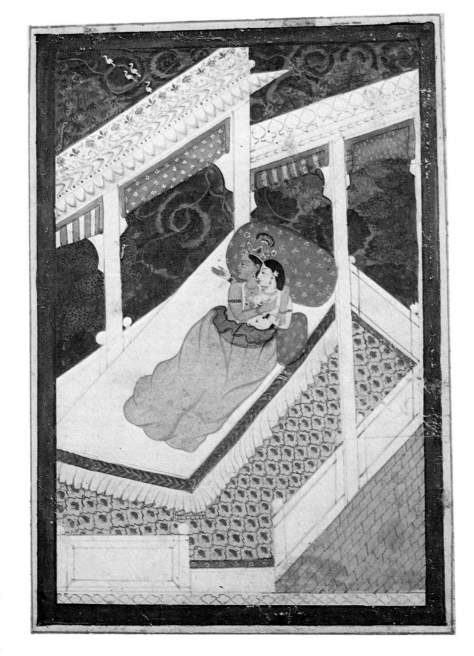

Krishna and Radha embracing. Color on paper, height 9″. Kangra School, eighteenth century. Wiener Collection, New York

Krishna and Radha looking at a monsoon cloud during the month of rain. Color on paper, height 8¹/₂″. Kangra School, c. 1800. Munsterberg Collection, New Paltz, N. Y.

The fully developed Pahari style is best seen in the miniatures of the so-called Kangra school, a term which strictly speaking is not accurate since several of the local centers are not in the Kangra valley. This school, which flourished during the eighteenth and early nineteenth century, represents the last really creative phase of traditional Indian art before its final decay. The style of the Kangra artists represents a synthesis of Rajput painting with certain elements derived from Mughal India, resulting in a new, very delicate and romantic type of art which at its best is extremely charming. The favorite subject was that of Krishna with his beloved Radha, a theme which symbolizes the desire of the soul to be united with God.

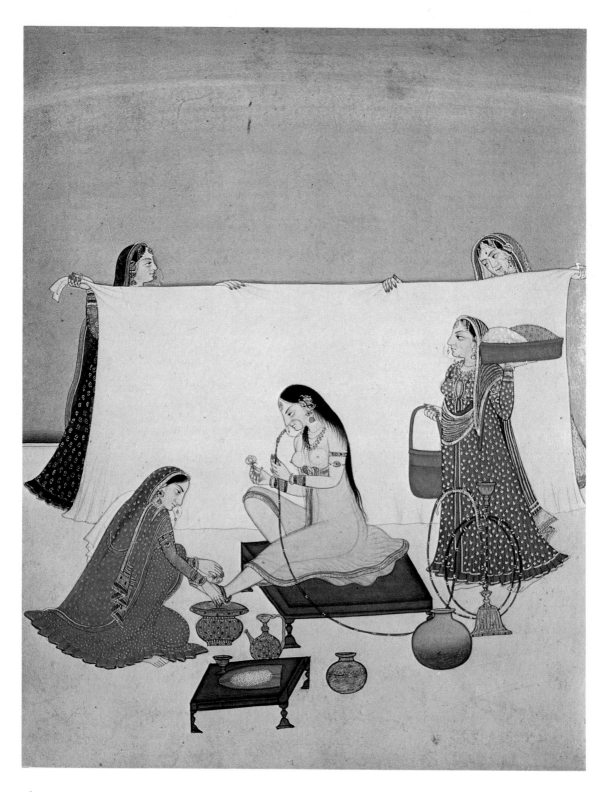

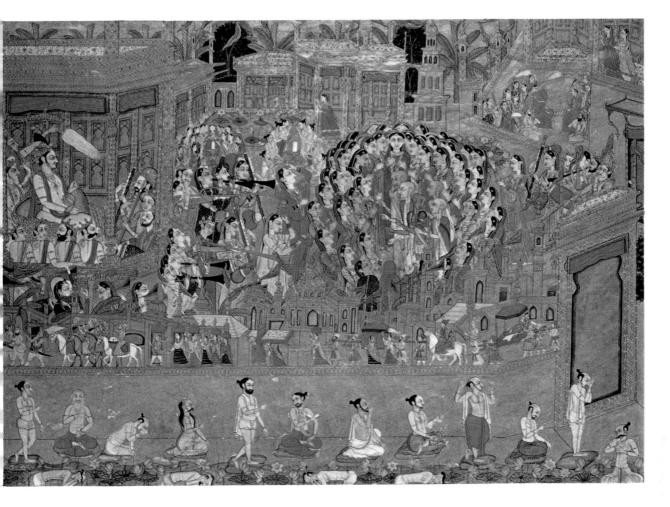

Panoramic marriage scene showing a princess choosing her husband. Color on paper, height 11″. Kangra School, c. 1800. Hudson Collection, New York

In Kangra painting, particularly in its later phases, the subject matter is by no means restricted to religious stories, for all kinds of scenes from contemporary life were also represented. Some are genre scenes from the life of the local courts, such as ladies at their toilet or with their lovers.Others show more official occasions, like banquets, festivals, or hunting scenes, and still others are portraits of the rulers with their attendants. The style, especially of the later works, tends to be detailed and realistic, without that feeling for abstract design which had characterized the earlier works. By the middle of the nineteenth century, the Kangra school had come to an end, and modern Western art became the dominant influence.

◀ Toilet of a princess. Color on paper, height 9″. Kangra School, early nineteenth century. Walter Collection, New York

From India proper the influence of Indian art spread in all directions, reaching as far afield as China and Japan. In the northern and eastern areas this was largely due to Buddhism which as a missionary religion sent emissaries to the far-flung corners of Asia. This Buddhist influence is particularly evident in the area just north of the Gandhara province, the territory which was known as Bactria in ancient times but is now called Afghanistan. The two most important sites are Bamiyan, where two giant Buddha images and numerous wall paintings have survived, and Hadda near modern Jalalabad where archaeologists have found a wealth of sculptures in the Greco-Buddhist style.

Colossal Buddha, Bamiyan, Afghanistan. Sandstone, originally colored and gilded, height 175'. Fourth–fifth century A.D.

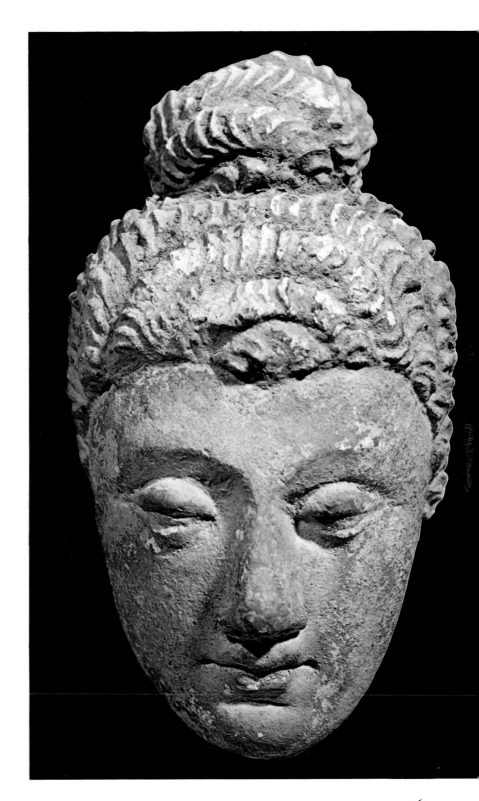

Buddha head, from Afghanistan. Stucco, height 7″. Fourth century A.D. Munsterberg Collection, New Paltz, N. Y.

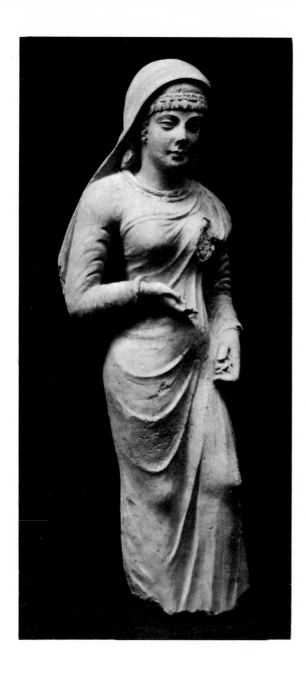

Female figure, from Tash Kourgan, Chinese Turkestan. Stucco, height 30″. Fourth century A.D. Wellesley College, Mass.

In contrast to the sculptures from Gandhara which are largely made of hard gray schist, the Hadda sculptures are a soft, whitish stucco which achieves a much warmer effect. Later than the Gandharan sculptures, those from Hadda show a lessening of classical influence and a reassertion of the more sensuous Indian tradition,

Seated devotee, from Afghanistan.
Stucco, height 13″. Third century A.D.
Ellsworth Collection, New York

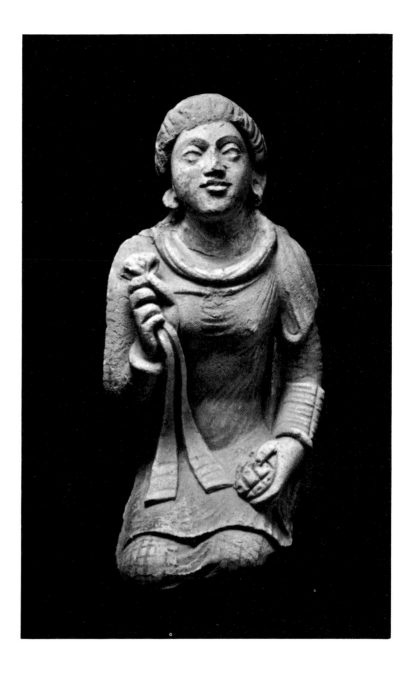

which gives these works a kind of warmth and expressiveness which the Gandharan sculptures did not have. At the same time the draped female figure and the ideal of beauty represented in these images indicate that the Hadda sculptures also belong to the Greco-Buddhist school.

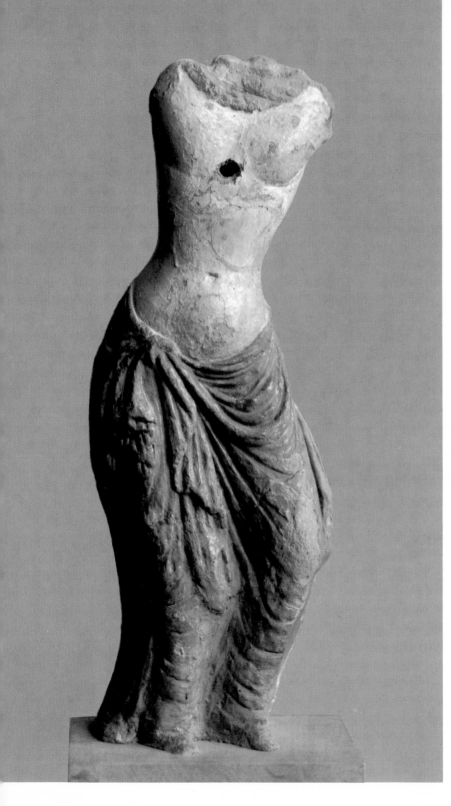

Female torso, from Sorcuk, Chinese Turkestan. Painted clay, height 15³/₄". Seventh–eighth century A.D. Museum für Indische Kunst, Berlin

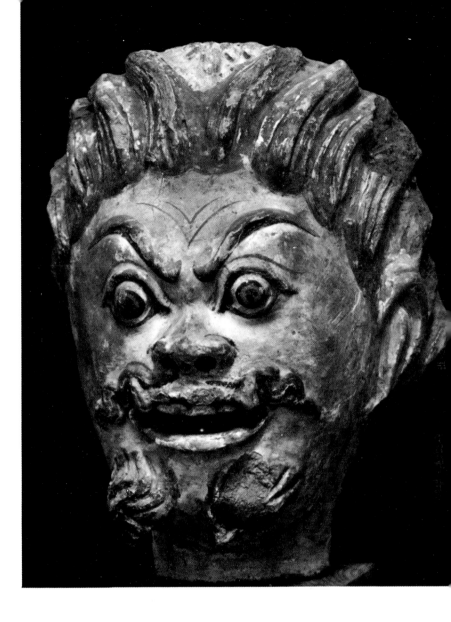

Head of a demon, from Koco, Chinese Turkestan. Painted clay, height 8¹/₂″. Seventh–tenth century A.D. Museum für Indische Kunst, Berlin

From Afghanistan the Indian Buddhist influence spread to Central Asia and ultimately to the Far East. During the early centuries of the Christian era, Central Asia played a very important role since it represented the link between China and the Roman empire on the one hand, and China and India and Iran on the other. As a result, the art of this region combined elements of all these various cultures in a way that is often very fascinating. Along with late classical elements, there were others derived from Sassanian Persia and China, but the most important influence was always that of Buddhist India which supplied both the style and the iconography.

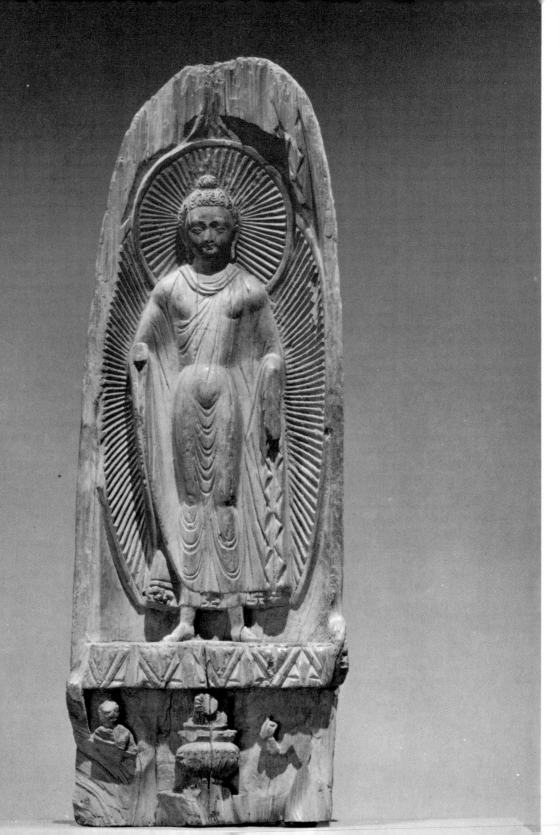

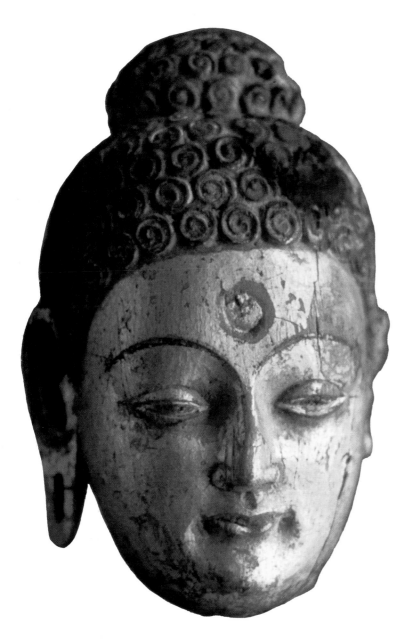

◀ Buddha head, from Tumsuk, Chinese Turkestan. Gilded wood, height 5″.
Fifth–sixth century A.D. Museum für Indische Kunst, Berlin

Standing Buddha, from Central Asia. Wood, height 14¹/₄″. Seventh century
A.D. The Metropolitan Museum of Art, New York City

While the works produced in the western part of Central Asia tend to be very strongly influenced by Indian art, the farther east one goes and the later the date of the finds, the more does Chinese influence make itself felt. In the early days of Buddhism, China had been largely a recipient of cultural influences from Central Asia and ultimately India, but during the T'ang dynasty it became a great center of Buddhist art and in turn exerted a powerful influence on the surrounding countries. These cultural currents are clearly reflected in the sculptures found at Central Asian sites, most of which were made of clay or wood since no stone was available.

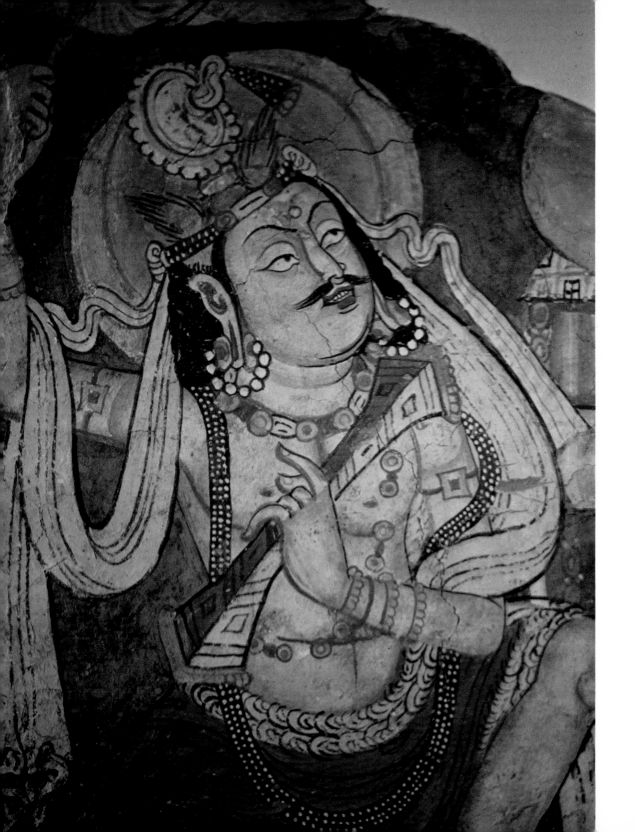

The most remarkable finds in Central Asia are the numerous wall paintings which have been dug out at the desert monasteries by modern archaeologists. The fact that these great Buddhist sanctuaries had been buried for more than a thousand years after being overrun by Moslem conquerors proved a boon for archaeologists because, since they were covered by sand and located in a very dry region, their frescoes (today largely in Berlin, Paris, and New Delhi) were found to be in excellent condition.

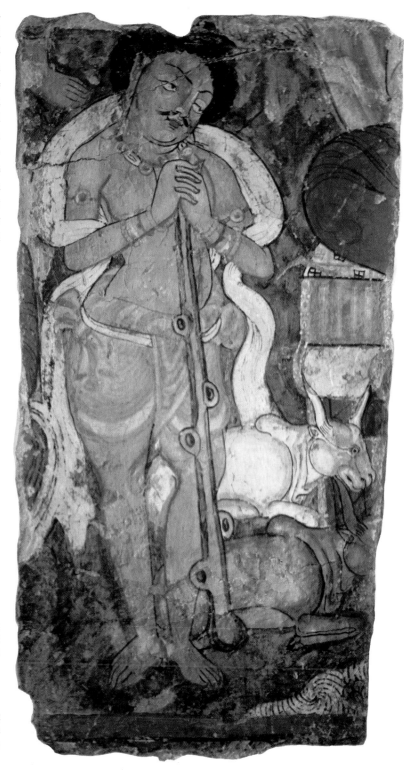

◀ Fragment of preaching scene, wall painting from Kizil, Chinese Turkestan. Height $27^1/_2$". Seventh century A.D. Museum für Indische Kunst, Berlin

Shepherd listening to sermon, wall painting from Kizil, Chinese Turkestan. Seventh century A.D. Museum für Indische Kunst, Berlin

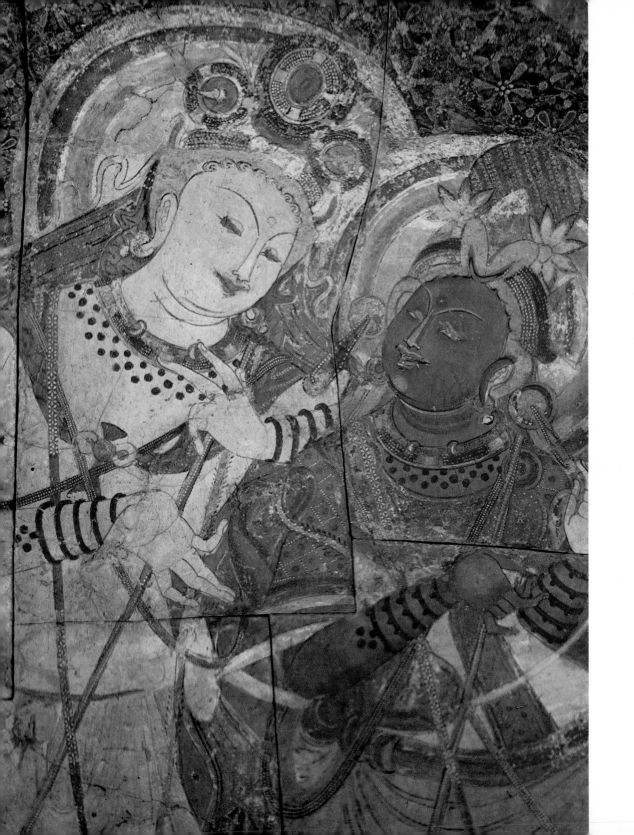

The subjects depicted in these wall paintings are largely taken from Buddhist legend, showing Buddhas, bodhisattvas, heavenly Apsarases, and demons. Other frescoes portray more worldly scenes, some from the Jataka stories and others representing the donors and worshipers responsible for these works. The style of the wall paintings, although ultimately derived from Indian prototypes, shows a Central Asian version of the Indian manner in which the soft and sensuous Indian forms are replaced by more linear and abstract ones, with a greater accent on the flat decorative pattern. The finest of these works, notably those from Kizil, are, along with the frescoes from Ajanta in India and Tun-huang in China, the best of the surviving works of early Buddhist painting.

◄ Goddess and musician, wall painting from Kizil, Chinese Turkestan. Height 86$^1/_2$″. Seventh century A.D. Museum für Indische Kunst, Berlin

Worshiper, wall painting from Kizil, Chinese Turkestan. Height 18$^1/_8$″. Seventh century A.D. Museum für Indische Kunst, Berlin

177

Buddhist monks, wall painting from Kizil, Chinese Turkestan. Height 18¹/₂″. Seventh century A.D. Museum für Indische Kunst, Berlin

The tendency toward clear linear contours and a two-dimensional color pattern is particularly marked in the later works which are strongly influenced by Chinese art. Yet even here the iconography is strictly Indian, for the Buddhist art of China and Japan is almost wholly derived from Indian sources. The most beautiful element of these paintings is the color, with brilliant blues, turquoise greens, and warm browns applied in a very effective manner. Yet the frescoes are not just striking in their colors, they are also deeply moving from a religious viewpoint.

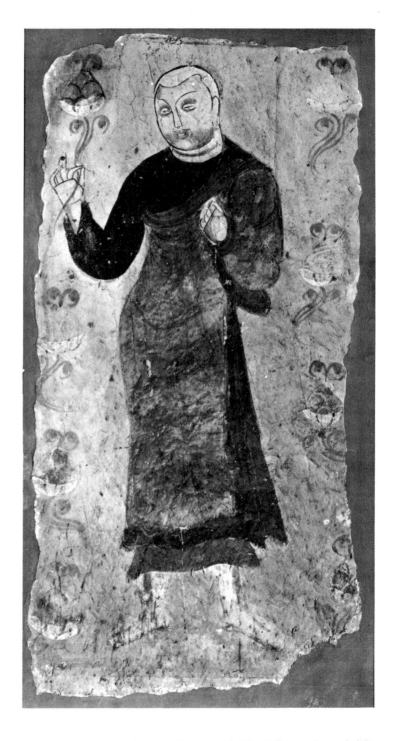

Monk holding flower, from Turfan, Central Asia. Color on plaster, height $25^{1}/_{2}''$. Eighth century A.D. The Metropolitan Museum of Art, New York City

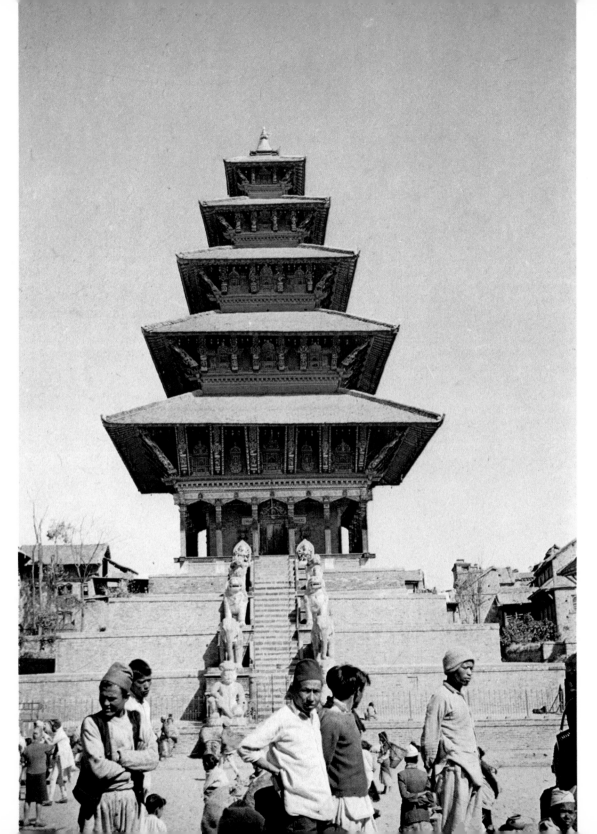

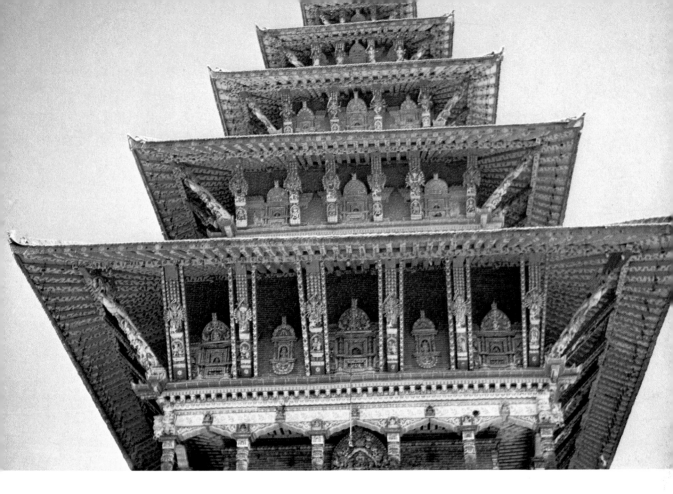

Stupa at Katmandu, Nepal

THE ART OF NEPAL AND TIBET

Although Buddhism was replaced by Hinduism in India and by Islam in Pakistan, Afghanistan, and Central Asia, it has continued to flourish in Nepal and, in a somewhat different form, in Tibet. In fact Nepal and the island of Ceylon are probably far closer to what ancient Buddhist India was like than any other part of the present-day world. Buddhism, which was introduced to Nepal under Ashoka during the first century B.C., has continued to play a vital role in this isolated country in the mountains north of India, and even today the landscape is dotted with impressive Buddhist stupas, monasteries, and temples built in the form of five-story towers.

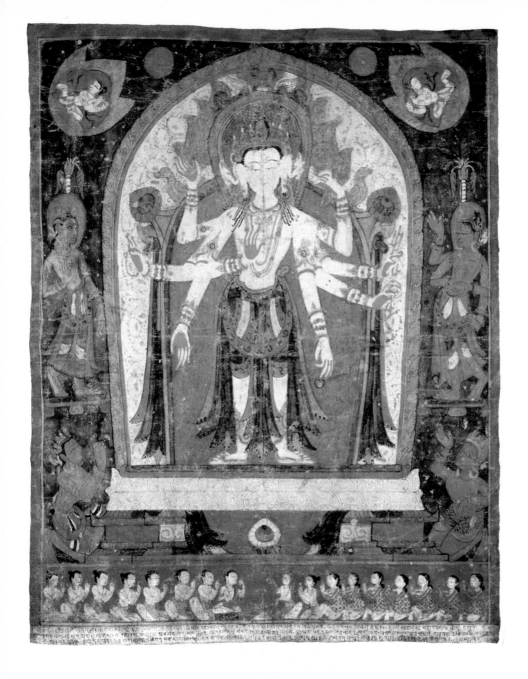

Scroll, from Nepal. Dated 1436

Buddhist Mandala, from ▶ Nepal. Color on cloth, height 12″. Eighteenth century. Private collection, New York

Another traditional Indian art form found in Nepal is palm-leaf painting. Sacred texts were copied onto the leaves and illustrated with pictures from Buddhist legends.

These works reflect the late Buddhist school of painting which flourished in Bengal during the Pala period, indicating again how close the Nepalese artistic tradition was to that of the motherland of Buddhism. Other Nepalese paintings were in the form of hanging scrolls, the subjects representing either Buddhist divinities, or magic diagrams, called mandalas, which were used as visual aids in the act of meditation. Their execution follows a strictly prescribed formula, for in order to be effective they must be correct representations of the world as envisaged by Mahayana Buddhism.

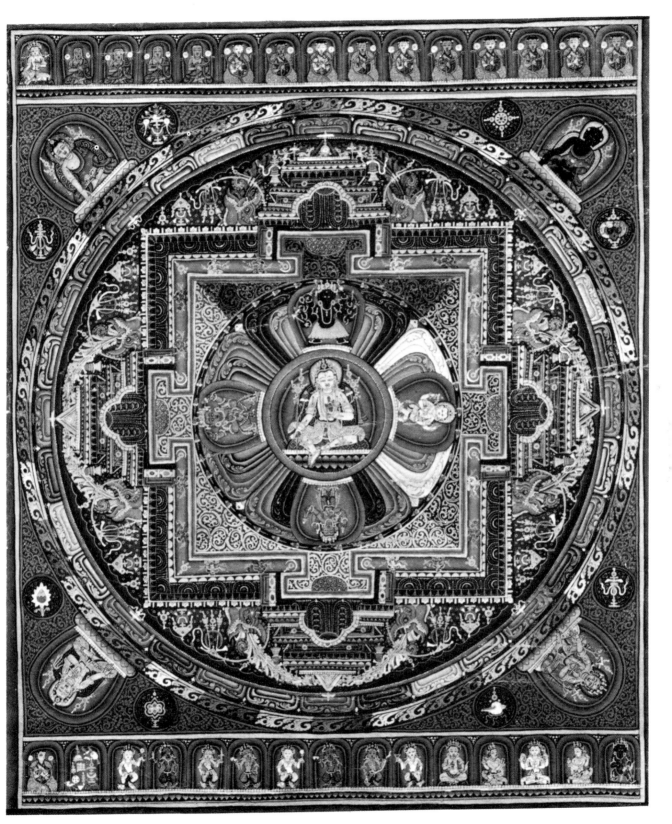

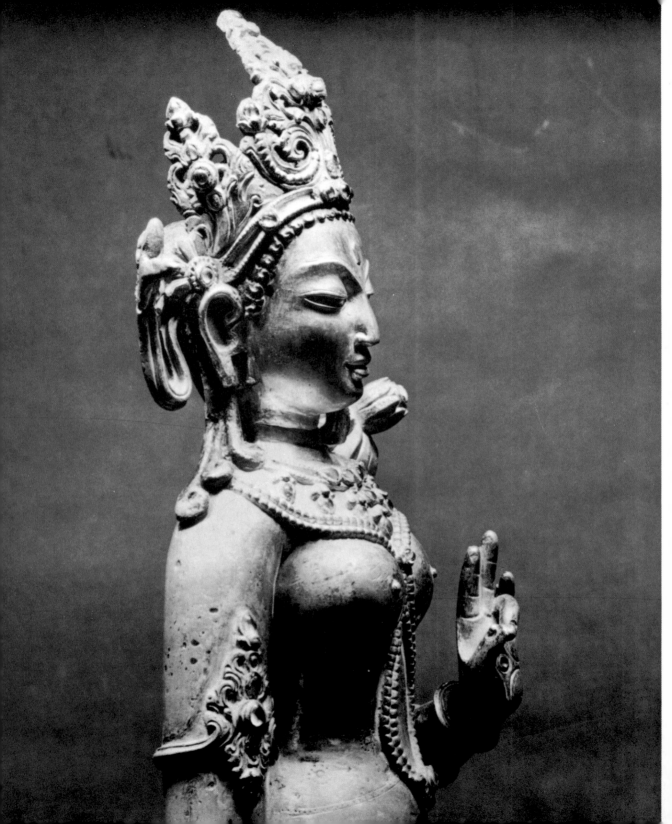

In addition to architecture and painting, Nepal also produced a flourishing school of Buddhist sculpture which continued to create religiously expressive and aesthetically pleasing images long after Buddhist sculpture had ceased to be made in India itself. The favorite medium was bronze or copper, often gilded and inlaid with precious stones. The style of these images was derived from Indian prototypes, especially the North Indian icons made under the Pala dynasty, but the forms are somewhat more ornate, with a marked emphasis on jewels and other ornamental detail. Perhaps the best term for this style would be manneristic, for the forms are highly artificial and at the same time very elegant.

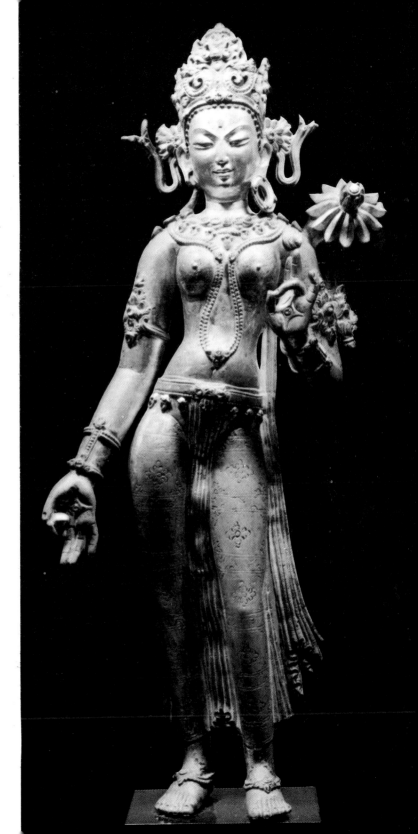

Tara, from Nepal. Gilded copper, height 20$^1/_2$″. Fifteenth century. The Metropolitan Museum of Art, New York City. Facing page: detail of side view

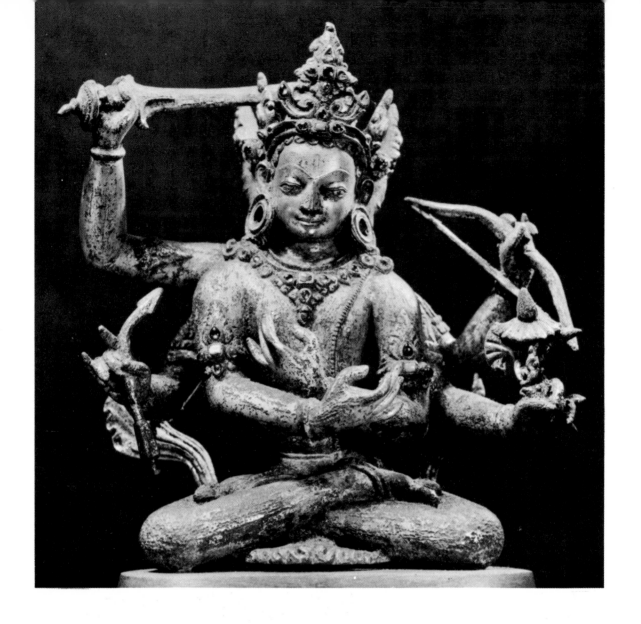

Generally speaking, the Buddhist art of Nepal differs greatly from most of the Buddhist art of India in that it reflects the Tantric type of Buddhism which was very popular in Nepal and Tibet. The main deities are no longer the historical Buddha Sakyamuni and his disciples as in most Hinayana Buddhist art, nor are they the multiple Buddhas and bodhisattvas who were the dominant figures in Mahayanist art. Instead, there are new deities who show a mixture of Buddhist and Hindu elements. While in original Buddhist art, female deities were virtually unknown, Tantric Buddhism frequently portrayed savioresses, or taras, who represent prajna, or the spiritual wisdom of the Buddhas and bodhisattvas.

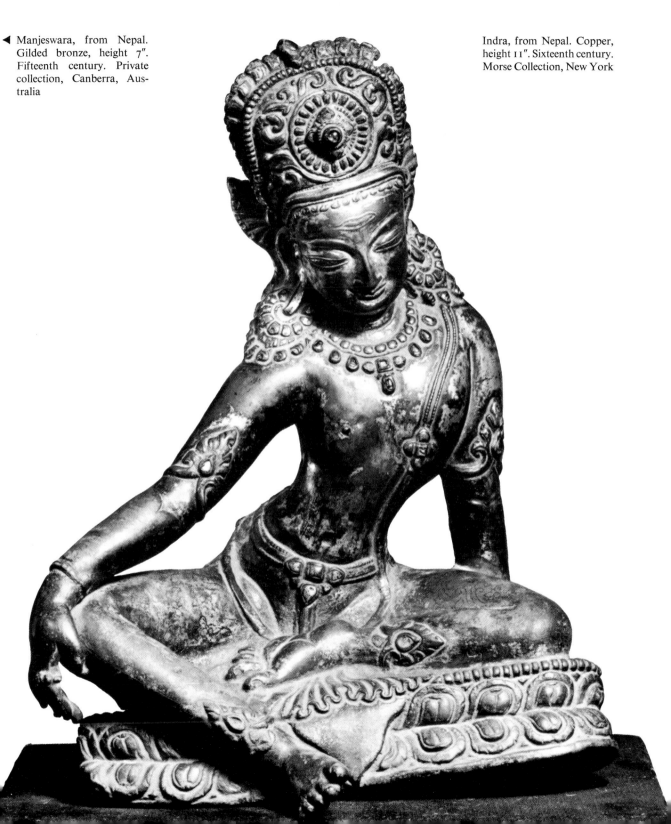

◀ Manjeswara, from Nepal.
Gilded bronze, height 7″.
Fifteenth century. Private
collection, Canberra, Aus-
tralia

Indra, from Nepal. Copper,
height 11″. Sixteenth century.
Morse Collection, New York

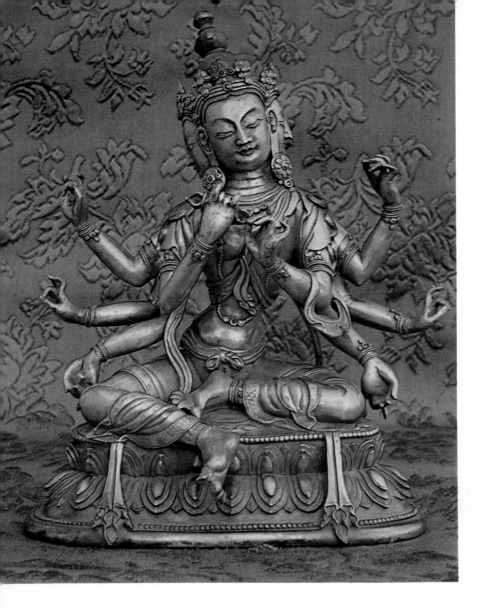

Tantric Avalokitesvara, from Tibet. Gilded bronze, height $7^7/_8''$. Eighteenth century. Canella Collection, Ferrara, Italy

Closely related to the art of Nepal is that of Tibet which originally received its impetus from India and Nepal, but later influenced Nepalese art. The type of Mahayana Buddhism which flourished in Tibet is known as lamaism after the spiritual leaders, called lamas, who ruled the Forbidden Kingdom. The artistic forms used by lamaism were usually Tantric in character, showing the gods with multiple heads and arms which symbolize their supernatural power, a device first used in Hinduism but also common in both Nepalese and Tibetan Buddhist art.

Eleven-headed Avalokitesvara, from Tibet. Gilded bronze, height 12¼″. Eighteenth century. Canella Collection, Ferrara, Italy

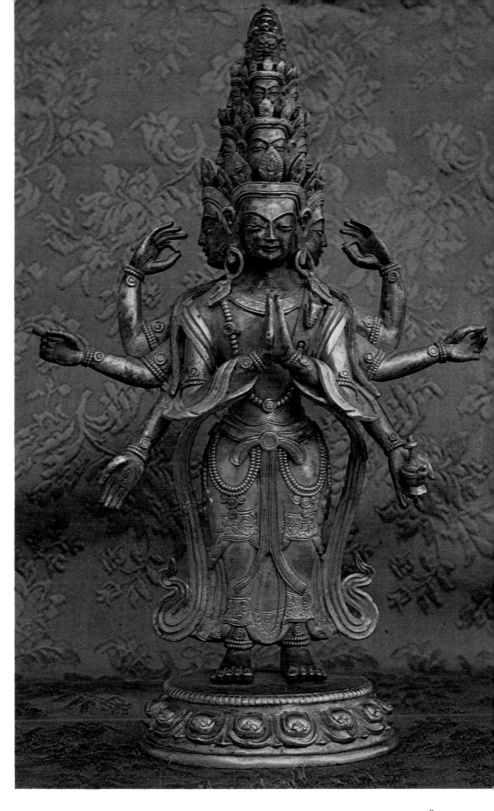

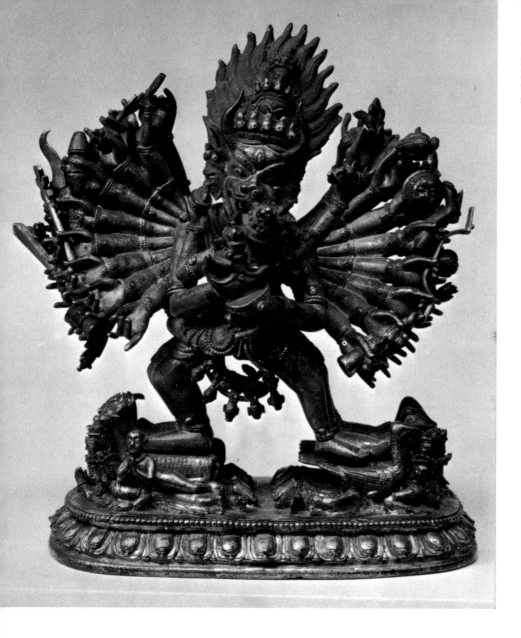

Yamantaka with shakti, from Tibet. Gilded bronze, height 6¹/₈". Eighteenth century. The Metropolitan Museum of Art, New York City

The iconography used by the Tibetan artists is often bizarre and esoteric, with all kinds of strange new gods and goddesses introduced into the Buddhist pantheon. In addition to the traditional Buddhas and bodhisattvas there were now also female counterparts, the equivalents of the Hindu shaktis, who symbolize the female energy of the deity. Taken together, the male and the female figures represent the Realization of the Absolute.

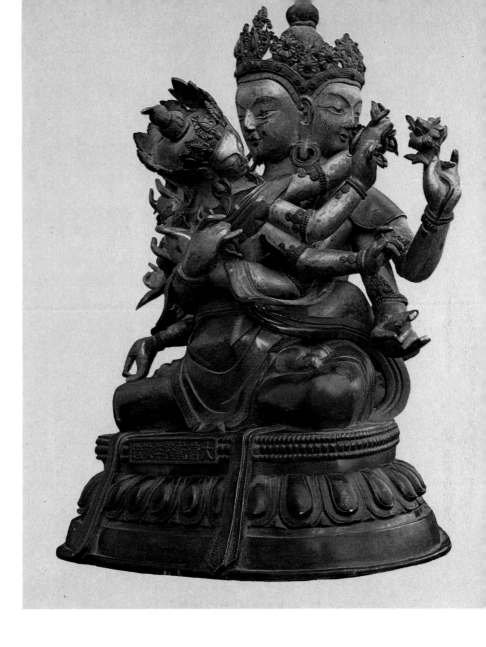

Sangdui with shakti, from Tibet. Gilded bronze, height 14^1/$_8$". Eighteenth century. Canella Collection, Ferrara, Italy

Some of the manifestations of the deities are quite terrifying, as for example Yamantaka, who represents the fierce aspect of the Bodhisattva Manjusri, and Vajrapani, the guardian deity who in his demonic form is awe-inspiring indeed.

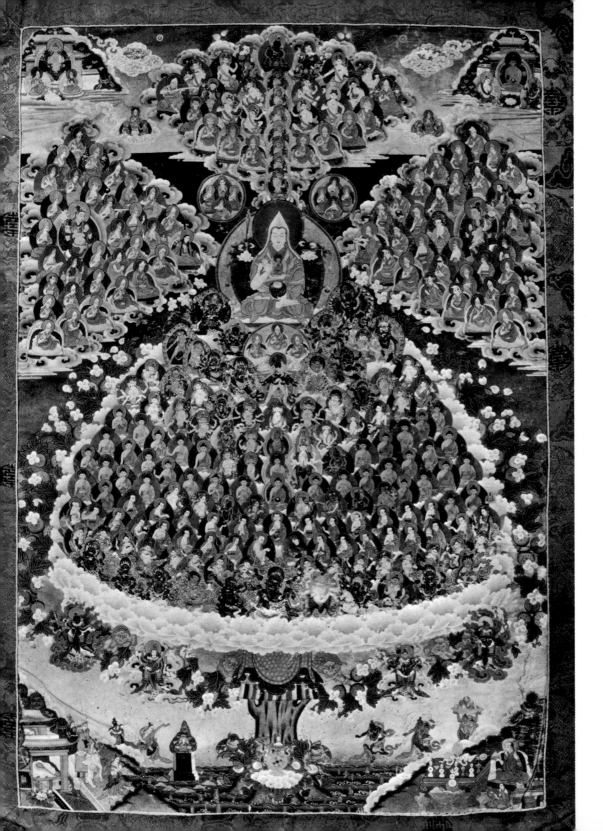

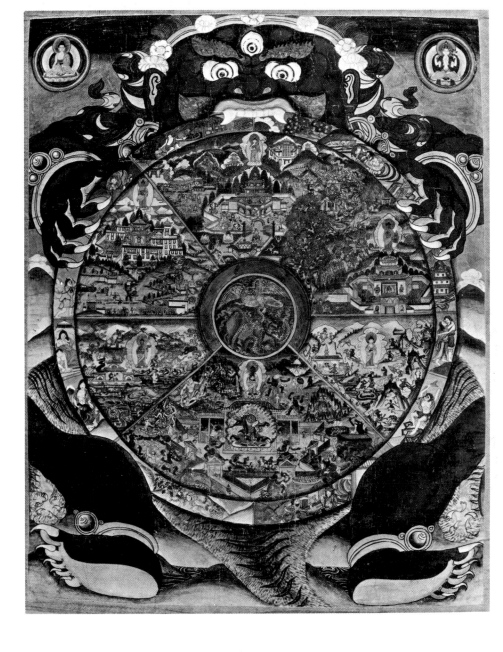

◀ Gelugpa Assembly Tree tanka, from Tibet. Paint on cotton, height 30″. Eighteenth–nineteenth century. Newark Museum, N. J.

Wheel of Life tanka. Paint on cotton, height 43″. Nineteenth century. Newark Museum, N. J.

Of all the artistic creations of Tibet, the most typical and interesting are the religious paintings, or tankas. Although the earliest are said to date from the tenth century, most of the tankas on display in Western museums were made during the seventeenth, eighteenth, and nineteenth centuries. They are often called banners, for they were carried in religious processions, hung in Buddhist temples, or placed on family altars in the houses of worshipers. Their subjects are usually lamaist deities and scenes from the life of the Buddha or the lamaist saints. The two most popular themes are the Assembly Tree, in which the founder of the Yellow Cap sect of lamaism is shown in the center surrounded by a multitude of sacred beings, and the Wheel of Life, in which the transmigration of souls is portrayed in visual form.

Miniature stupa, from Tibet. Bronze, height 22¹/₄″. Nineteenth century. Newark Museum, N.J.

The elaborate magic rituals performed by the lamaist monks required all kinds of implements, some of which possess real aesthetic quality. Made of bronze, brass, copper, pewter, and silver, they show the high level of craftsmanship which prevailed among the metal workers of traditional Tibet. Among the many objects they

produced were altar furniture, musical instruments, charms, amulets, vases, cups, incense burners, bells, thunderbolts, magic daggers, and reliquaries. Particularly interesting are the Wheel of Law, which is the Dalai Lama's emblem of authority, and the prayer wheels used in the worship of Avalokitesvara.

THE ART OF CEYLON AND INDONESIA

Turning from the north to the south, the country most closely linked to India both in its cultural and artistic traditions is Ceylon, a large island located off the east coast of southern India. It was one of the very first countries to adopt the Buddhist faith, and it has remained a stronghold of Hinayana Buddhism to the present day. Of all the artistic monuments surviving in Ceylon, probably the finest are the wall paintings in the rock fortress at Sigiriya which date from the sixth century. They are very close to those at Ajanta, though their style is freer and bolder, probably reflecting their provincial origin, and the racial types represented are Singhalese rather than Indian.

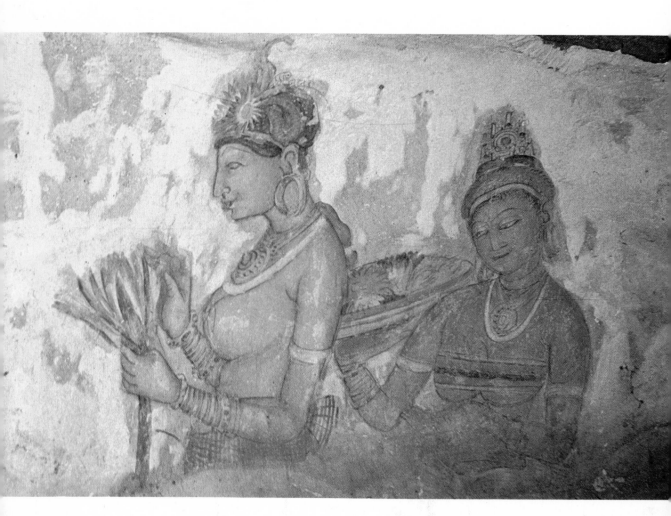

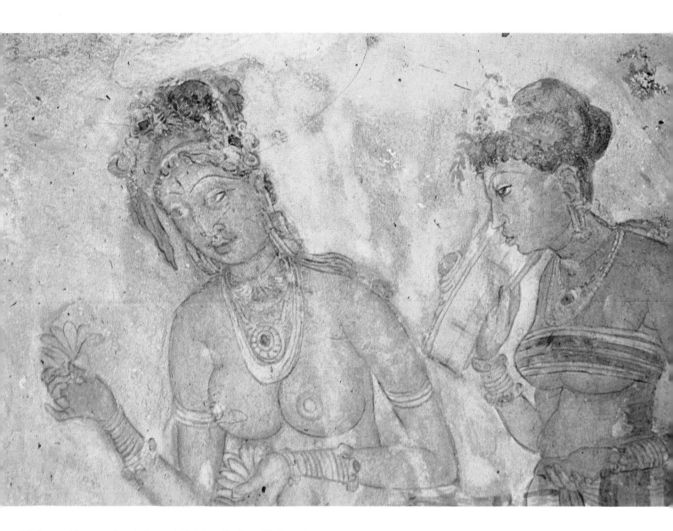

Divine maidens, wall paintings at Sigiriya, Ceylon. Sixth century A.D.

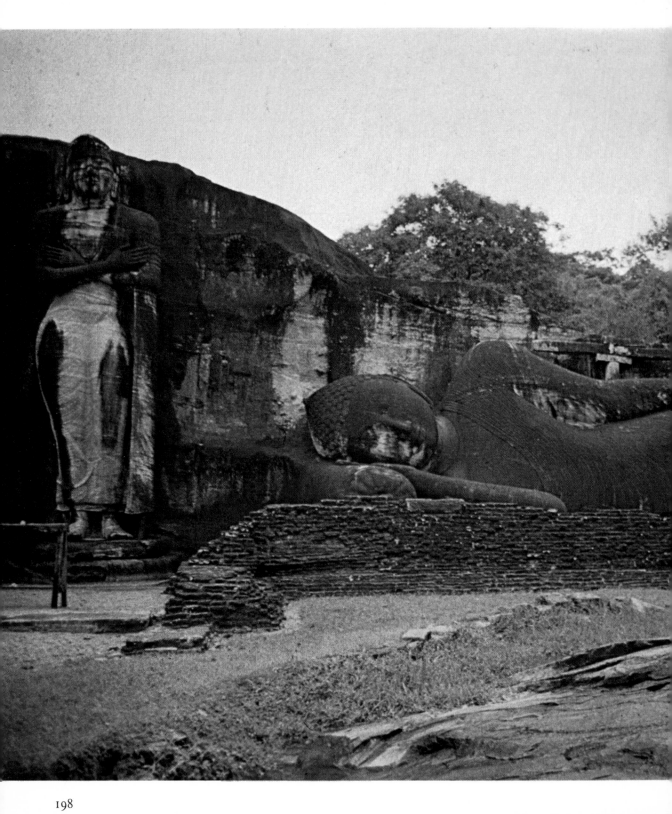

The two most important Ceylonese sites for the study of ancient Buddhism are Anuradhapura and Polonnaruwa where there are numerous dagabas, as the Singhalese call their stupas. At these sacred sites, there are also a large number of Buddhist carvings which are often of great beauty and expressive power. Their style is closely related to that found in the sculptures from southern India, especially the ones from Amaravati, although the forms are less sensuous in keeping with the native conventions. The most impressive of these carvings is the colossal image, nearly fifty feet long, of the Buddha's Death, or Nirvana, at the Gal Vihara at Polonnaruwa, a sculpture which gives moving expression to the Buddhist ideal of serenity and ultimate peace.

Colossal image of Buddha's Nirvana, Gal Vihara at Polonnaruwa, Ceylon. Sandstone, length c. 50'. Twelfth century

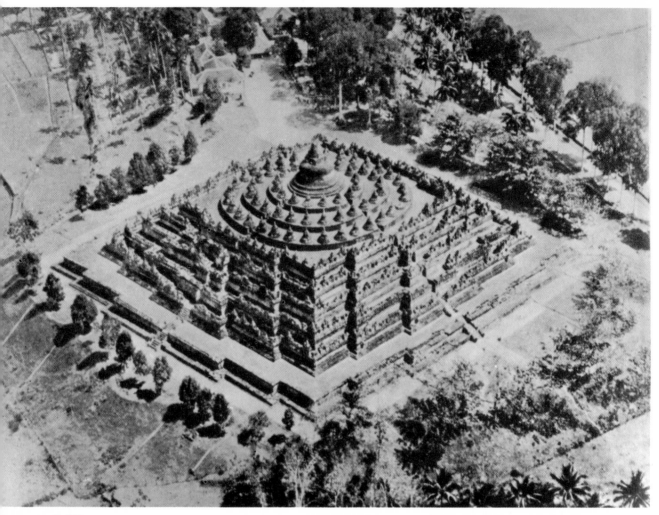

p. 200

Aerial view of Great Stupa at Borobudur, Java. Eighth century A.D.

Interestingly enough, the single greatest monument of Buddhist art is not located in India itself but on the island of Java at Borobudur in present day Indonesia. Here pious Buddhists under the Indian Sailendra dynasty in the eighth century created one of the most remarkable masterpieces of religious art. Rising majestically from the plains of central Java, Borobudur is an artificial mountain which combines the conception of the Buddhist stupa with that of Mount Meru, the World Mountain. The whole is thought of as a huge magic diagram which is a mystic rendering of the cosmos. As the pilgrim mounted the terraces of the sanctuary, he was believed to re-enact symbolically the ascent of the soul from the world of desire, which he was leaving behind, to the world of spiritual perfection and ultimate union with the Cosmic Buddha himself.

View of the terraces of Great Stupa at Borobudur, Java. Eighth century A.D.

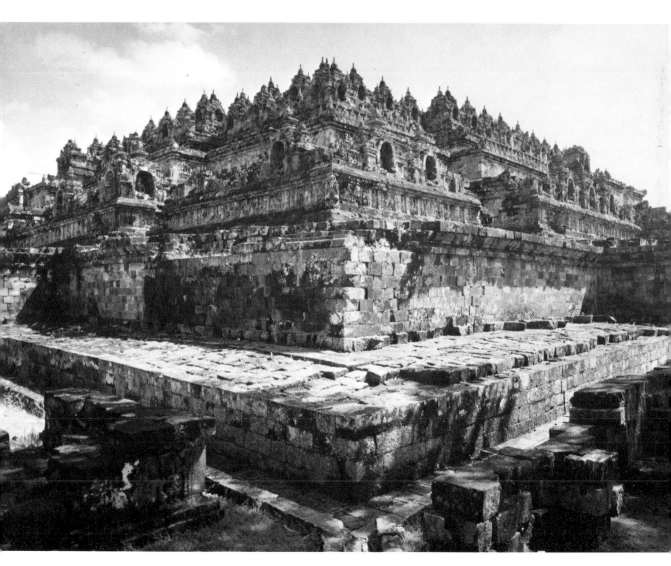

As the worshiper climbed up the sanctuary, he first encountered five walled terraces decorated with sculptured reliefs which portray the life of Sakyamuni as told in the Lalita Vistara. The scenes start with the Jataka stories which relate the previous incarnations of the Buddha, show his birth as Prince Siddharta, and culminate in his first sermon at the Deer Park in Benares. This sequence is followed by the story of Maitreya, the Buddha of the Future, who is awaiting his rebirth as the Savior of Buddhism, and the series ends with the mystic Dhyani Buddhas who embody the ultimate esoteric teachings.

Prince Sudhana's ladies drawing water. Volcanic stone, height 108″. Borobudur, Java. Eighth century A.D.

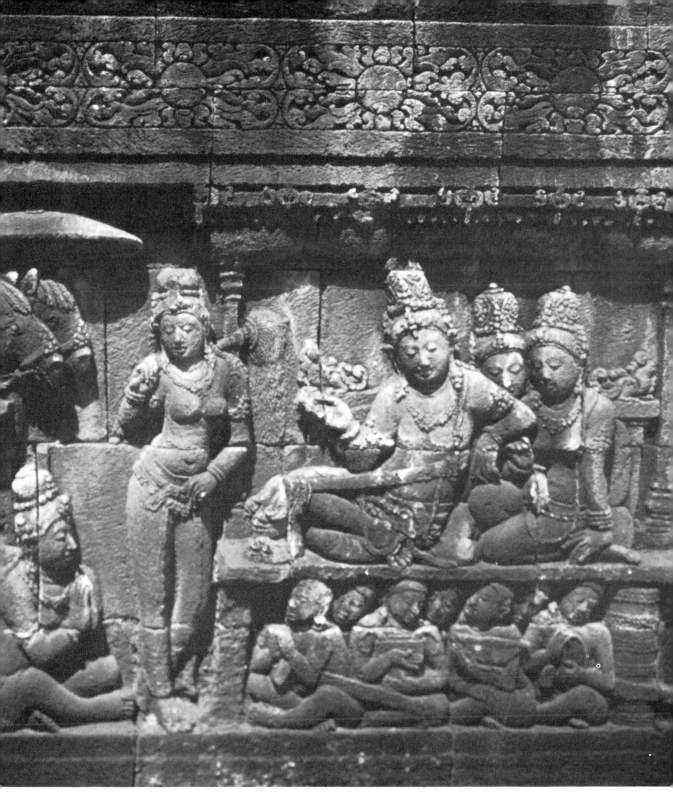

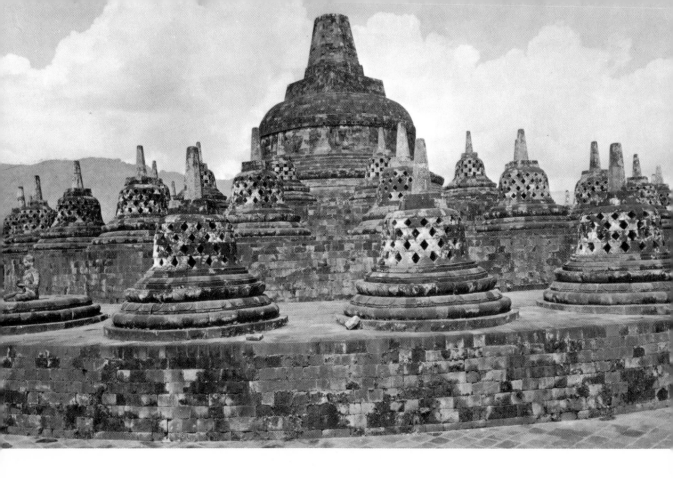

Above these galleries are three terraces containing seventy-two latticed stupas, and at the very summit of the structure, as the culmination of the whole monument, there is a huge closed stupa symbolizing the ultimate mystery. Each of the smaller stupas contains an image of a seated Buddha shown in the yoga position with his hands in the dharma cakra mudra, the gesture of turning the Wheel of the Law, a symbol which means that just as a wheel set into motion will go on moving, so the Buddha's teaching, once having started, will continue throughout the ages. The ultimate Cosmic Buddha, whose being contains the entire universe, is represented by the central stupa, which either contained an unfinished statue or was left empty. The whole design of the upper part of the sanctuary is a kind of giant mandala, or magic diagram representing the Buddhist concept of ultimate reality.

The style of the sculptures at Borobudur is closely related to the art of Gupta India, which is not surprising since the Sailendra kings had originally come from India proper before they established their great empire which extended from Java and Sumatra to the Malay Peninsula. Yet the carvings at Borobudur, although deeply indebted to Indian models both in form and iconography, show characteristics which are typically Javanese. The material itself is different, a black volcanic stone unlike anything found in India. Then, too, the racial type portrayed is Malayan rather than Indian, and the forms themselves are softer and gentler than those produced by the Gupta carvers.

204

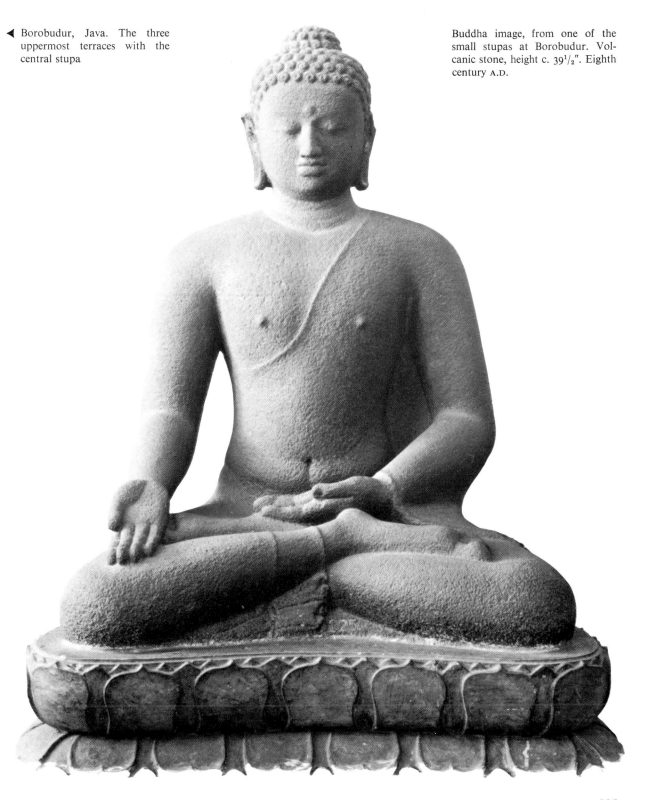

◀ Borobudur, Java. The three uppermost terraces with the central stupa

Buddha image, from one of the small stupas at Borobudur. Volcanic stone, height c. 39¹/₂″. Eighth century A.D.

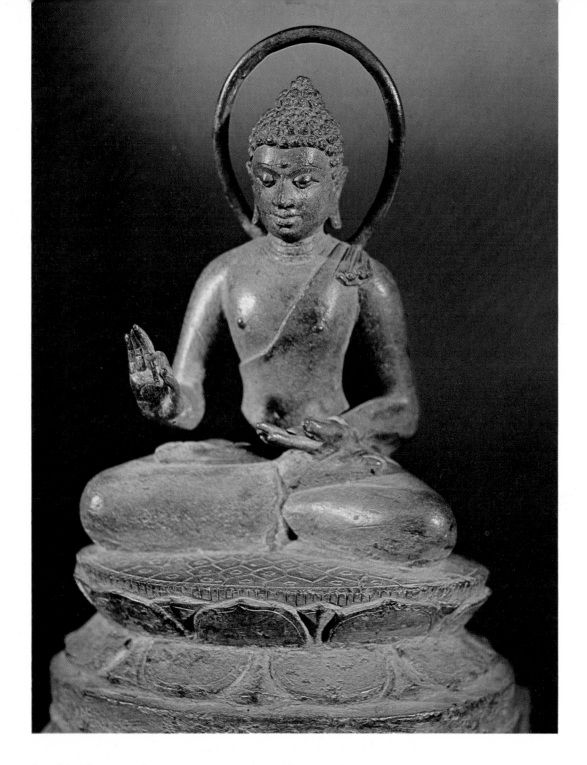

Seated Buddha expounding the Law. Bronze, height 7½″. Eighth–ninth century A.D. Eilenberg Collection, New York

Although Borobudur is the most impressive artistic monument of Indonesia, many other works of Buddhist art have survived. In addition to stone, the most common material for sculpture was bronze, but gold, silver, ivory, and wood were also used. The style of these images is marked by the gentle beauty so characteristic of Indonesian art. The forms, although ultimately based on those of Gupta India, are more abstract and lack the sensuousness so typical of Indian art. The iconography is generally derived from Indian sources, but certain local variations occur.

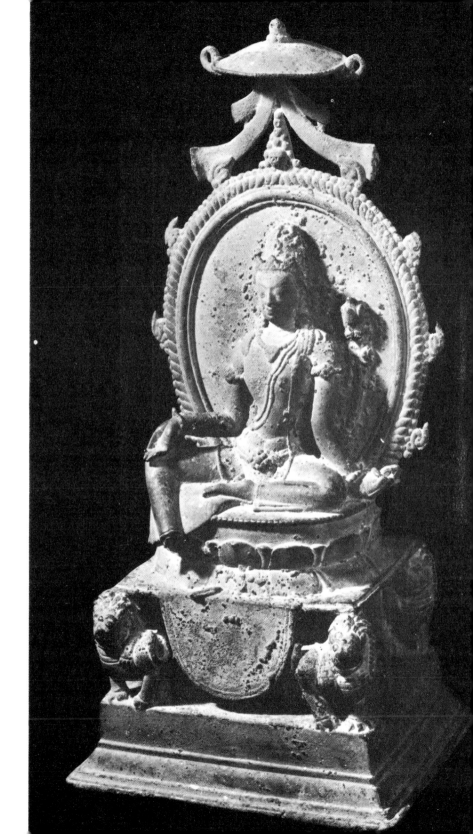

Padmapani, from Sumatra. Bronze, height 14″. Ninth century A.D. Boney Collection, Tokyo

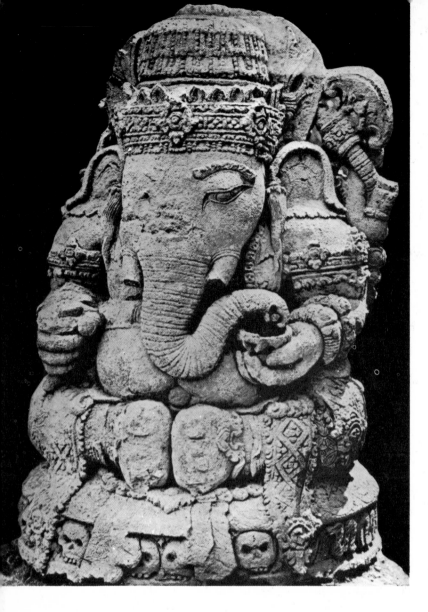

Ganesha, from Java. Stone. Thirteenth century. Bara Museum, Java

Scene from Ramayana, Prambanan, Java. ▶ Stone relief, tenth century

Along with Buddhism, Hinduism also found its way to Java. In fact during the later centuries of the medieval period before Islam replaced both these religions, Hinduism was the dominant religious force on the island. As in India, Shiva, Vishnu, and other deities of the Hindu pantheon were worshiped. Particularly popular was the elephant-headed god of learning, Ganesha, who was frequently represented in Javanese art. The single most interesting of these carvings is a large stone image which shows two aspects of Ganesha, the one as a benevolent and protective deity, and the other as a fierce and terrible god whose throne is ornamented with skulls.

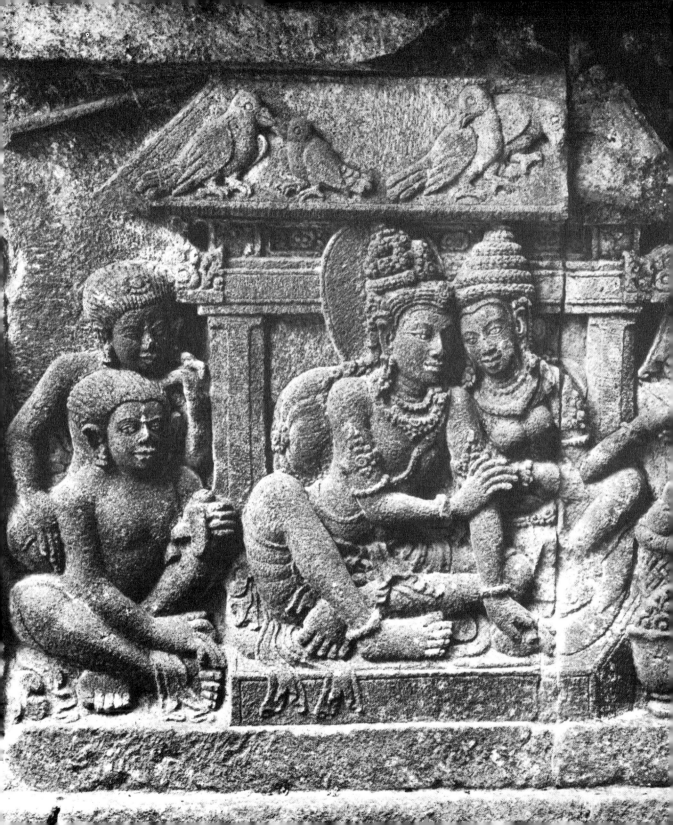

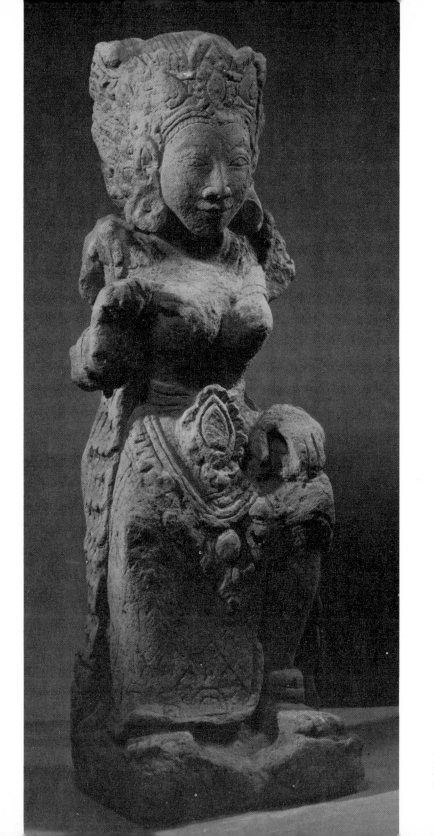

Female figure, from Bali. Sandstone, height 29¹/₈″. Eighteenth century. Museum für Völkerkunde, Munich

Compared to the high art, both Buddhist and Hindu, which had flourished in Java before the conquest of Islam, that of Bali was more a folk art existing on an unsophisticated level. However in Bali traditional Hindu culture survived into modern times, and a rich popular culture is still flourishing today. The graceful, charming quality which had marked the earlier productions is even more pronounced in these later Balinese versions of traditional Hindu art where the deeply religious spirit of the ancient work has given way to something purely ornamental and playful. The best of these works, especially in the decorative arts, are extremely attractive.

Door of palace, from Bali. Wood, height 69¹/₄″. Nineteenth century. Museum für Völkerkunde, Munich

The folk-art quality so typical of Balinese art is particularly evident in the textiles for which Java and Bali are famous. One of the most popular techniques was batik dying which was no doubt originally imported from India, for the use of such wax-resist dying is indicated in the textiles shown in the Ajanta paintings, but it was in Indonesia that this process was most fully developed and it is still commonly used today. Also interesting are the painted cotton rolls used in certain types of traditional drama. They represent scenes from Balinese life and legend and they are marked by that fine sense of decorative design so typical of Indonesian art.

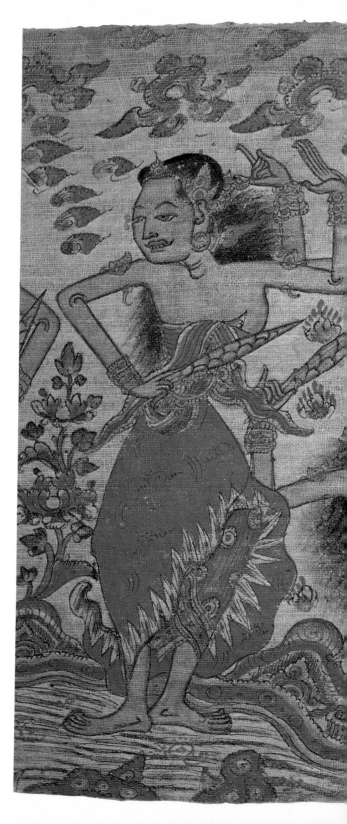

Mythological scene showing woman feeding snake, from Bali. Color on cotton, height $12^5/_8''$. Eighteenth century. Museum für Völkerkunde, Munich

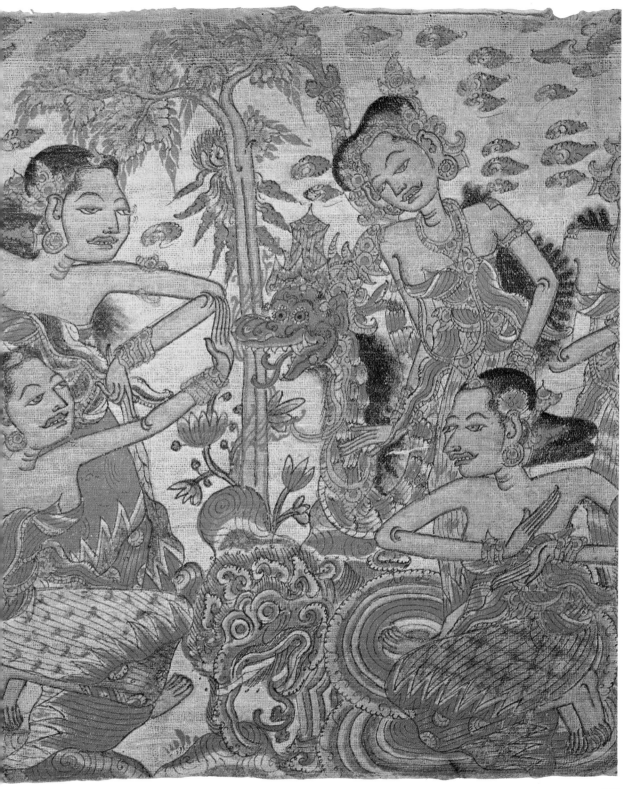

213

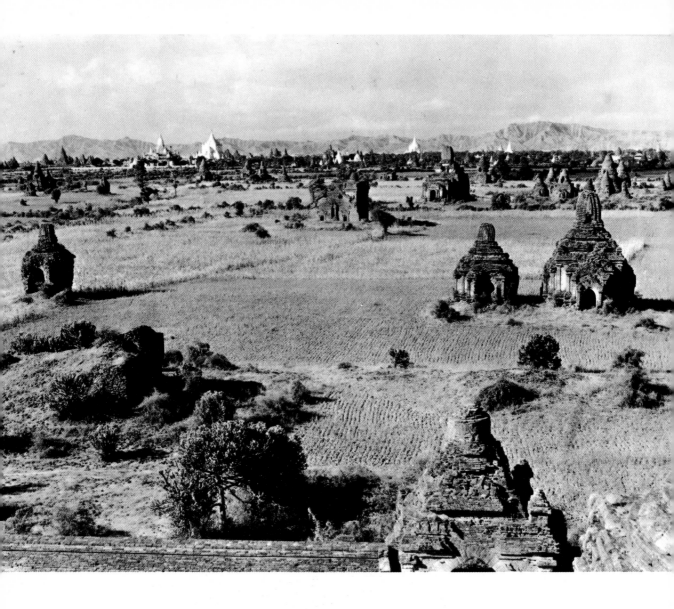

THE ART OF BURMA AND THAILAND

In addition to carrying the Buddhist gospel to the north and the south, Indian missionaries went into Southeast Asia, and Burma, Thailand, and Indo-China also became Buddhist countries. In Burma the golden age of Buddhist art was the period from the eleventh to the thirteenth century when many great temples were erected. The religious center of the country, which to this day contains thousands of temples, is Pagan located on the left bank of the Irrawaddy river. Although most of these sanctuaries (built of brick and stucco) are in ruins today and the wooden buildings in which the monks lived have disappeared, the area is still very impressive as a reminder of the glories of the past.

◀ Ruins of Buddhist temples and stupas at
Pagan, Burma. Tenth–twelfth century

Sabbanun Temple, Pagan, Burma. Twelfth century

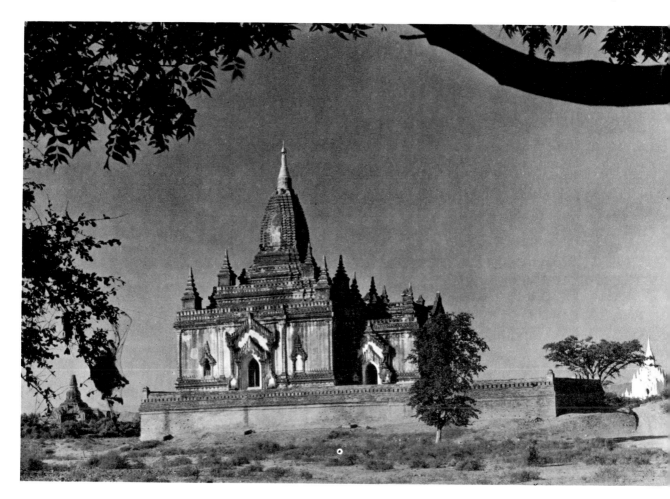

The main structures, which resemble the stupas of Buddhist India, are the cetiyas, literally reminders, which are supposed to recall the person and the teaching of the Buddha. They usually contain relics, records of the Buddha's words, or images of the Buddha. With very few exceptions, all these structures are devoted to Theravada Buddhism which is still the religion of Burma today. The most extensive and famous of the cetiyas is the Ananda Temple which, although very much restored in modern times, still reflects the original design which combines the Mount Meru concept in its lower part with the stupa in its upper story. The silhouette of these Burmese temples is much more slender and vertical than that of the Indian stupas, probably reflecting the influence of the sikkharas, or towers, of Hindu India.

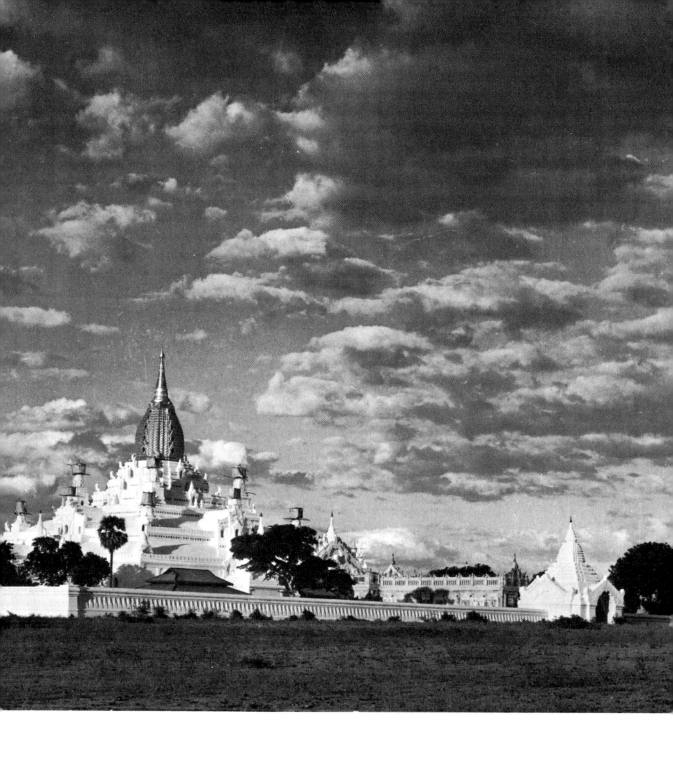

Ananda Temple, Pagan, Burma. Eleventh–twelfth century

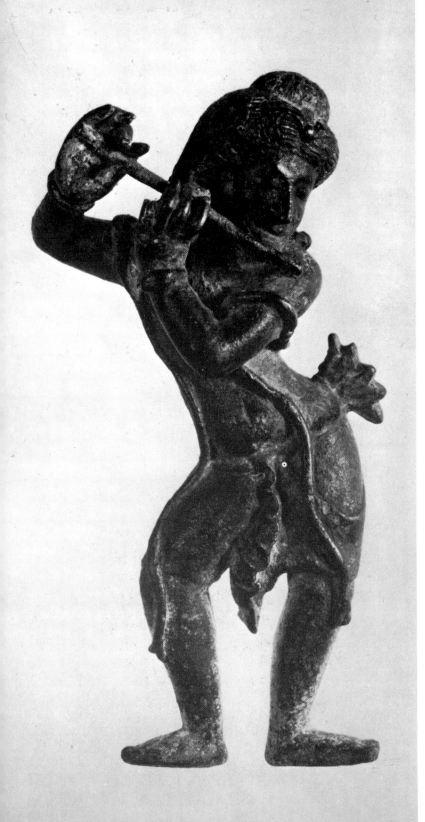

Flute player and dancer, from Burma. Bronze, height 4″. Eighth century A.D. Private collection, New York

While the architecture is no doubt the most impressive and important aspect of Burmese art, sculpture and painting were also produced with some of the best having real merit. Most of the surviving works from the earlier phases of Burmese art are relief carvings in stone, terra cotta, and stucco which decorated the temples, and wall paintings depicting scenes from the life of the Buddha

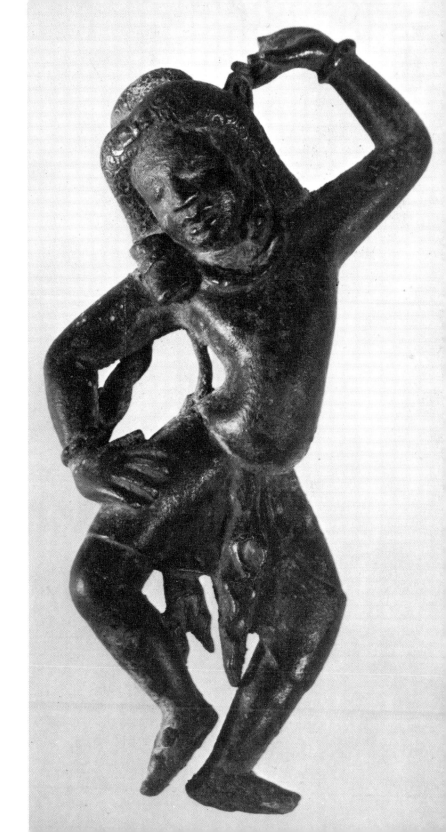

and his saints. Some of the sculptures are images in the round executed in stone, bronze, or wood, and the finest are works of quality. Here again the profound influence of Indian art is very apparent, but in spite of the dependence on Indian prototypes, the Burmese images have a grace and attenuated beauty not found in the Indian images of the same time.

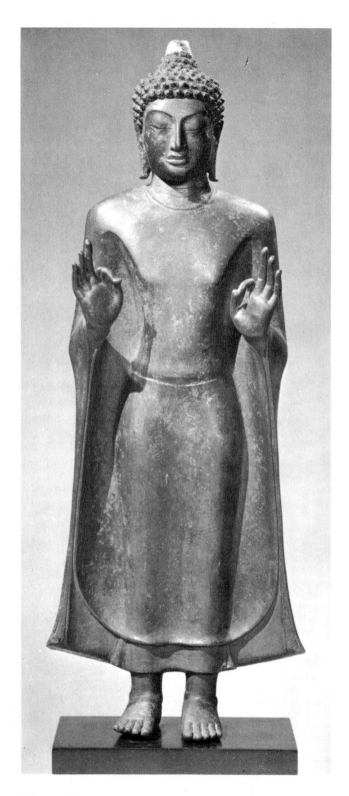

Buddha explaining the Law, from Thailand. Bronze, height 27″. Ninth century A.D. The Metropolitan Museum of Art, New York City. Facing page: detail of head

Adjacent to Burma, another of the Southeast Asian countries which has a rich and ancient tradition of Buddhist art is Siam or, to use its modern name, Thailand. While Burma was primarily outstanding for its temples, the chief artistic contribution of Siam was its sculpture which continued to be a vital art form right up to modern times. The earliest phase of this tradition dates from the sixth to the twelfth century, a period when the Dvaravati kings ruled at the lower reaches of the Menam. The people who created this art were of Mon stock related to the Mon of Burma and not to the Thais who came at a later period as invaders from southern China. The style of the Mon images was derived from the Gupta art of India and showed the same classical beauty.

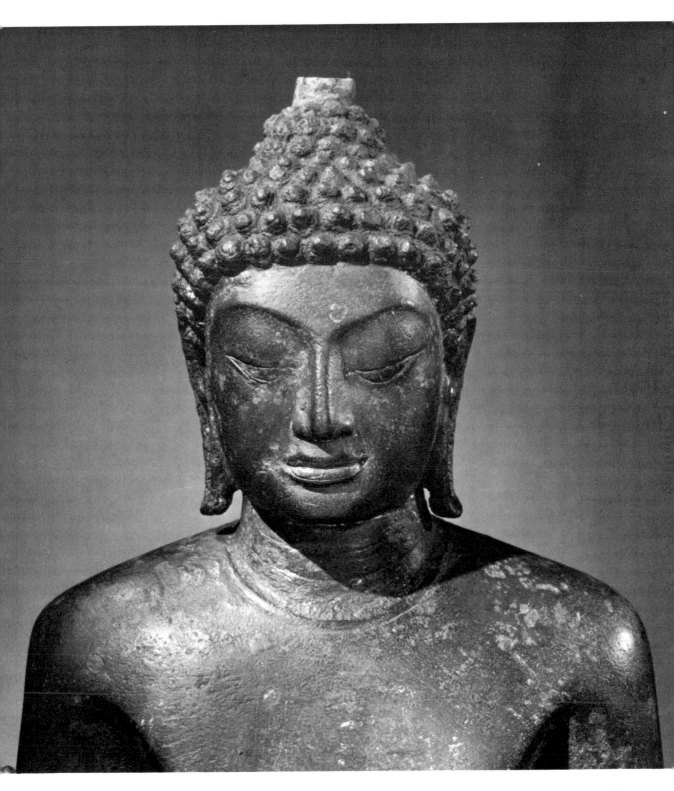

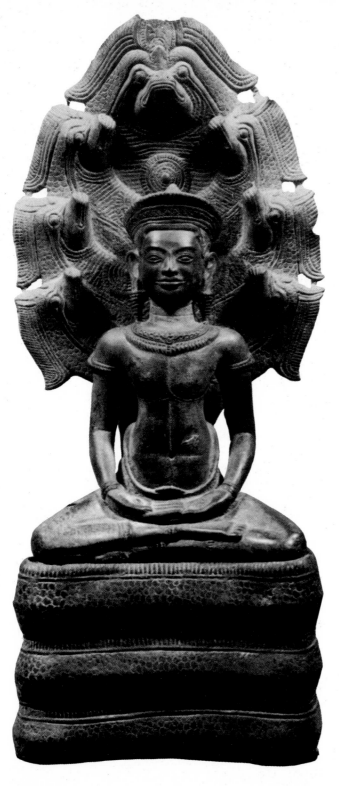

The second phase of Siamese art occurred when the Khmer people had conquered large parts of Siam and the art of the country was greatly influenced by that of Cambodia. The chief artistic site from this period is Lopburi in southern Siam not far from modern Bangkok. The forms of these images continued to reflect Indian canons of beauty, but there is more emphasis on the plastic form and less of the feeling for sensuous beauty so typical of the Indian images. Compared to the earlier Mon statues, the Lopburi ones reflect the change of racial type, with the faces broader and flatter and the linear detail less pronounced. But the iconography changed very little, since Hinayana Buddhism was still the main source of inspiration.

Buddha on Naga Throne, from Thailand. Bronze, height 11$^1/_2$". Thirteenth century. Detroit Art Institute

Buddha head, from Thailand. Stone, height 30$^3/_4$". ▶ Twelfth century. Museum für Völkerkunde, Munich

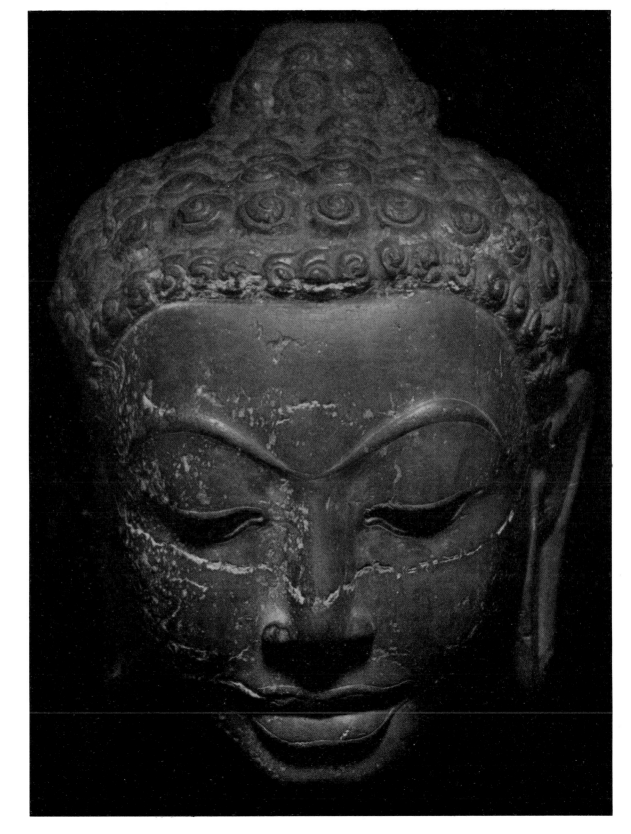

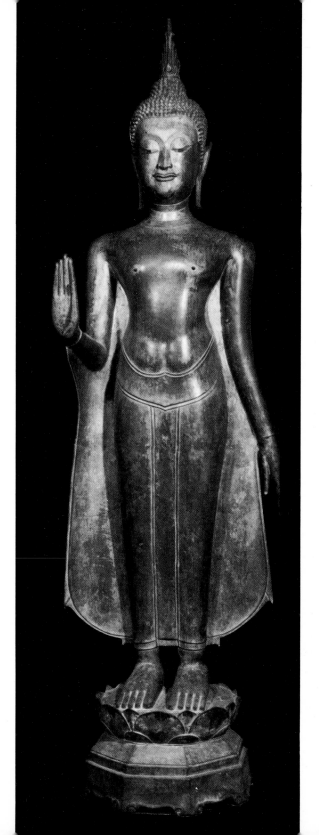

Thai art proper began with the consolidation of Thai power during the thirteenth century, and the establishment of the Sukhothai kingdom. For the first time a truly national art developed, no longer dependent on Gupta or Khmer models. While the iconography is still derived from Indian sources, the style of these images is distinctly Thai and quite different from that found in Siamese sculpture of previous centuries. The two most striking characteristics are a greater elegance and a tendency to elongate the forms, with the vertical emphasis continued by the flamelike protuberance on the top of the head. Particularly striking is the treatment of the long slender arms and the delicate hands which add to the feeling of refinement and sophistication so characteristic of these images.

Standing Buddha, from Thailand. Bronze, height 69″. Fifteenth century, Wolff Collection, New York

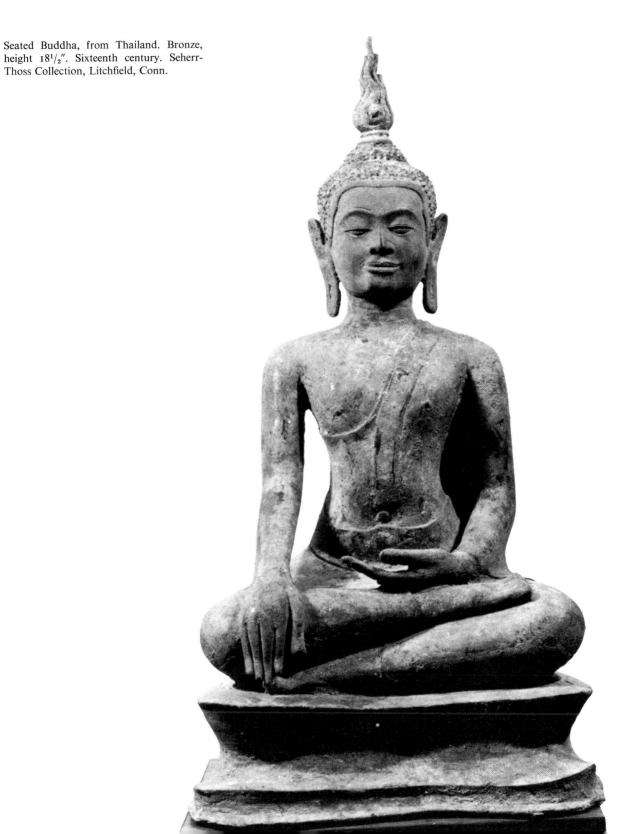

Seated Buddha, from Thailand. Bronze, height 18½". Sixteenth century. Seherr-Thoss Collection, Litchfield, Conn.

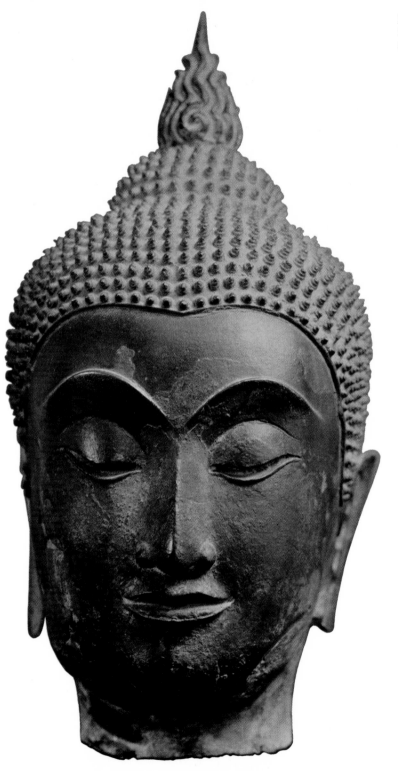

Buddha head, from Thailand. Gilded bronze, height c. 10¹/₄″. Style of Ayudhya, sixteenth century. Private collection

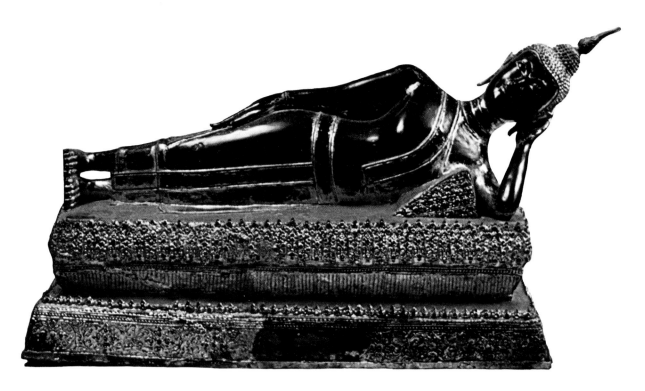

Death of Buddha, from Thailand. Bronze, height $12^5/_8''$. Nineteenth century. Museum für Völkerkunde, Munich

The tendency toward ever greater refinement coupled with a loss of spiritual intensity is even more marked in the works of the later periods when the characteristic Thai features become exaggerated and mannered. The artistic center was now at Ayudhya in southern Thailand where a huge number of Buddhist icons was produced. Following certain standard iconographical types which were produced repeatedly, these images show little variation but have a remarkably high general level of artistic competence. They continued to be made long after Buddhist art had ceased to play any significant role in the rest of the Indian world.

Thailand today is one of the few countries where Buddhism and Buddhist art are still a living force. This is most evident in Bangkok which, although largely a modern city, has a number of impressive temples and pagodas whose over-all design goes back to older models even if the details clearly reveal their modern provenance. Yet seen from a distance the general effect, especially of the silhouettes against the sky, is lovely indeed. Here again there is the same feeling for graceful and elegant forms which had marked the later Thai sculptures.

Buddhist temple, Bangkok, Thailand. Nineteenth century

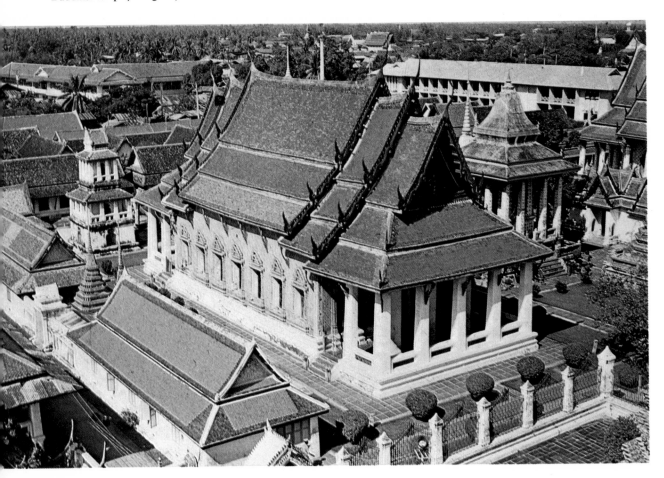

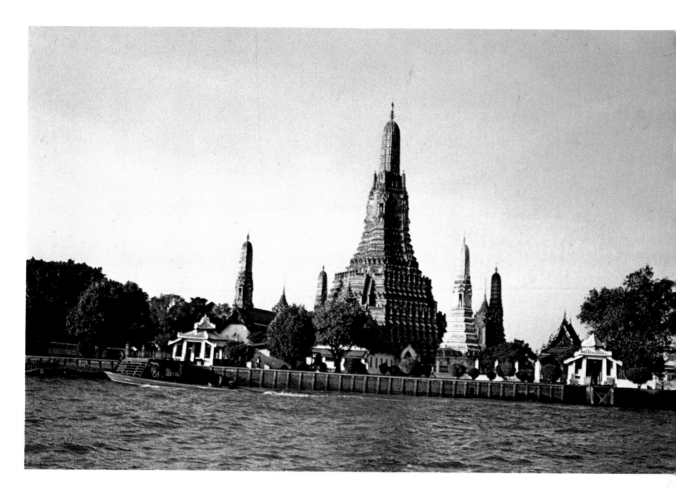

River view with Dawn Temple, Bangkok, Thailand. Nineteenth century

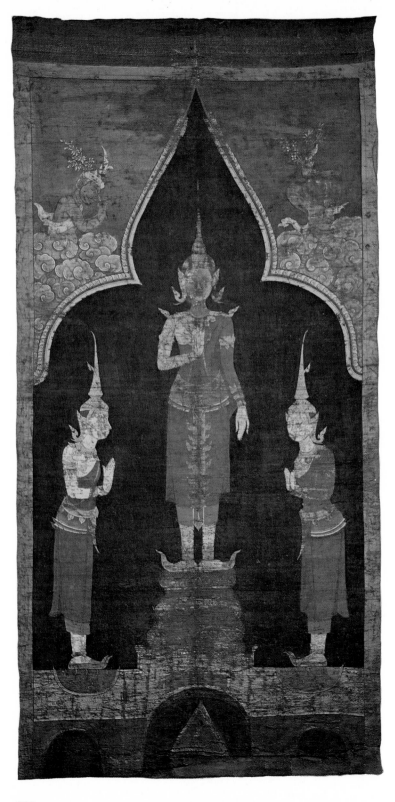

Buddha with disciples, from Thailand. Color on cloth, height 76³/₈″. Eighteenth century. Museum für Völkerkunde, Munich

Door decoration, from Thailand. Gold and black lacquer on wood, height 87″. Nineteenth century. Museum für Völkerkunde, Munich

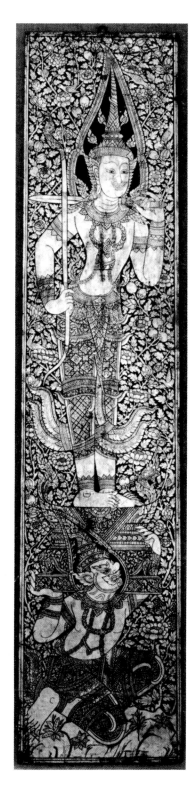

Very little early Thai painting has survived and, as with the architecture (which was largely of wood), one has to depend for the most part on relatively modern works. However, many paintings on wood or cloth from more recent centuries have come down to us, and they give a good idea of the subjects treated and the style used in traditional Thai painting. Produced in the later periods of Thai art, the manneristic tendencies already noted in the Ayudhya sculpture are more apparent, yet these works are not without a certain grace and elegance even if they lack any real expressive power. The forms are still more elongated, and the vertical accent has become completely dominant in the over-all design.

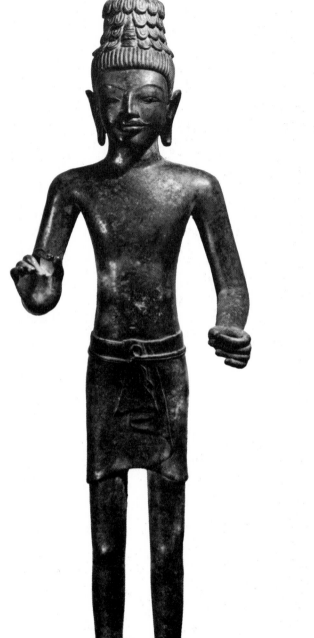

THE ART OF CAMBODIA AND VIET NAM

The greatest of the artistic traditions of Southeast Asia is that of Cambodia. Although a small country today with no role to speak of in world art, Cambodia under the Khmer rulers of the tenth to thirteenth century was a great kingdom which controlled a territory much larger than present-day Cambodia and produced an art which ranks among the great art traditions of the world. In fact, before the Khmer rulers came to power, a school of sculpture had arisen which produced masterpieces of both Buddhist and Hindu carvings. The quality which marks these works is a fine feeling for sculptural form with an emphasis upon the solid, cylindrical shape quite unlike the much fuller and more voluptuous Indian sculptures.

Maitreya, from Cambodia. Bronze, height 22″. Seventh century A.D. Private collection, New York

Prajnaparamita, goddess of transcendent wisdom, from ▶ Cambodia. Bronze, height 21¹/₂″. Seventh century A.D. Private collection, New York

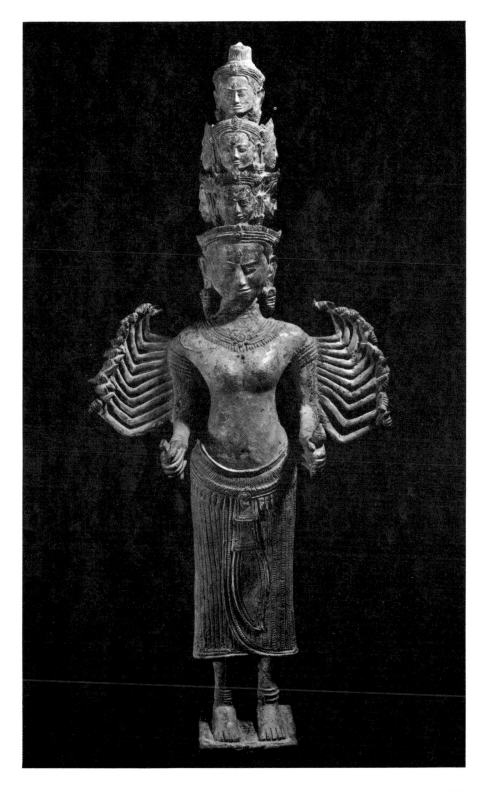

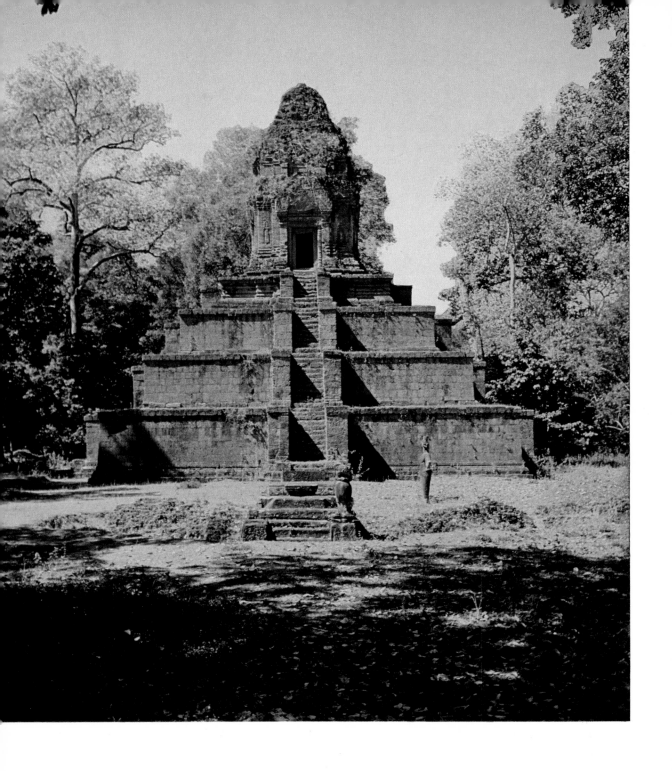

Step pyramid temple, Baksei Chamkrong, Cambodia. Brick. Tenth century

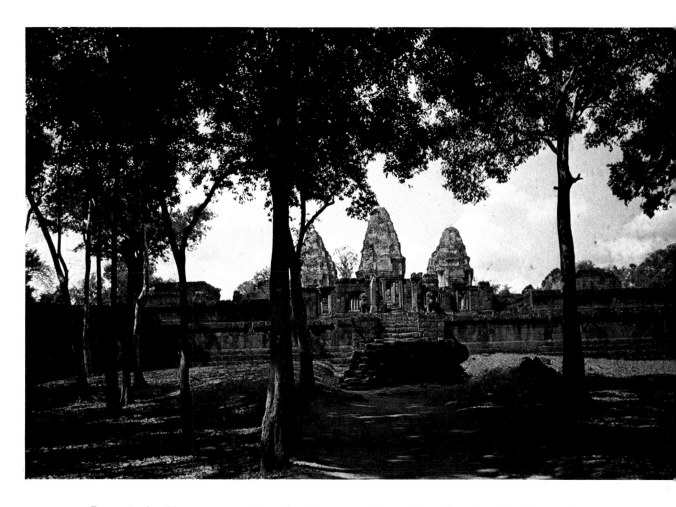

Bayon, Angkor Thom, step pyramid temple of Jayavarman VII. Sandstone. Second period of Bayon style, c. 1200

The great period of Cambodian art did not begin until the tenth century when the Khmers consolidated their power and the remarkable temple-palaces were built. The early ones are simple Mount Meru-type structures with the sanctuary on top of a step pyramid, while the twelfth-century one at Angkor Vat is a vast architectural complex serving simultaneously as a temple for the god Vishnu and a sanctuary for the divine king, the devaraya, for whom it was conceived as a heavenly palace. (In fact, the Khmer ruler was believed to be an earthly incarnation of Vishnu himself.) Surrounded by a moat over which bridges lead and with a series of walls and galleries and five mighty towers at its center, this great edifice, which was looked upon as the very center of the Khmer empire, is still one of the architectural wonders of the world.

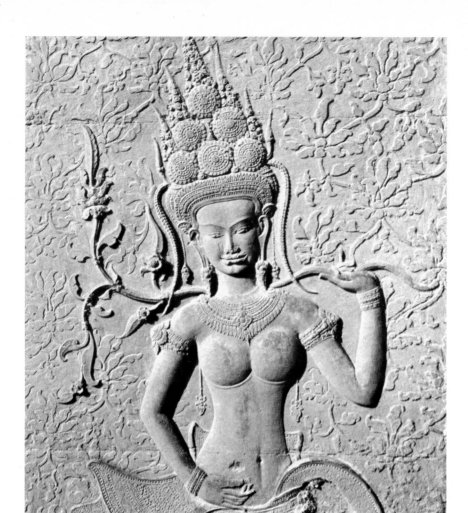

Dancing Apsaras at Angkor Vat, Cambodia. Sandstone, height c. 47^{1}/$_{4}$". Twelfth century

Not only is Angkor Vat one of the masterpieces of world architecture, it also has relief carvings which are among the finest in the Indian world. Combining a vivid sense of narrative with a beautiful feeling for decorative design, they fuse the functional with the purely aesthetic. Although they extend over hundreds of feet and include thousands of figures, they are of a uniformly high quality, indicating the level of craftsmanship which prevailed. Their subjects are taken from Hindu legend and Khmer history, showing gods and demons on the one hand, and on the other, the Khmer kings and their triumphant armies. But the loveliest of all these figures are the Apsarases, or heavenly maidens. Portrayed like Cambodian dancing girls, their beautiful forms and graceful movements are truly worthy of the celestial realm.

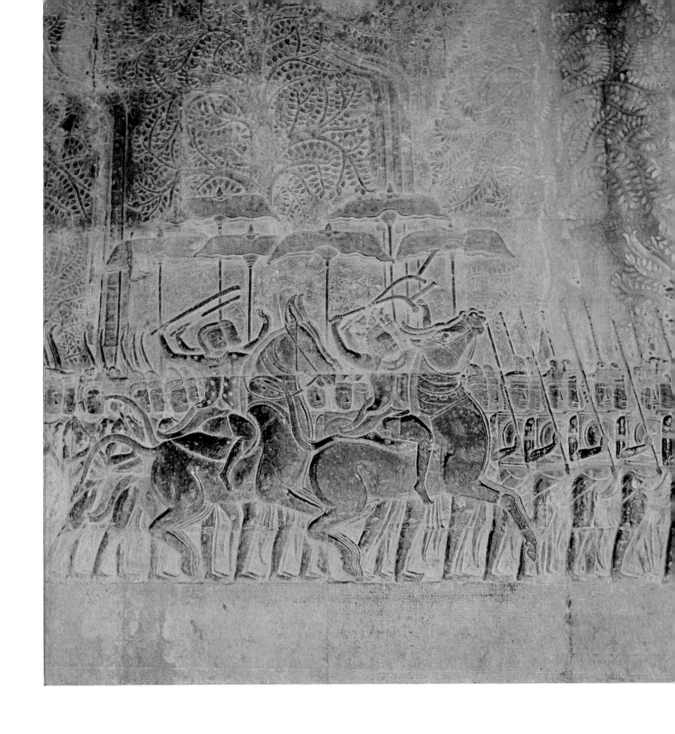

Parade of the army of King Suryavarman II, relief carving in gallery at Angkor Vat, Cambodia. Sandstone. Twelfth century

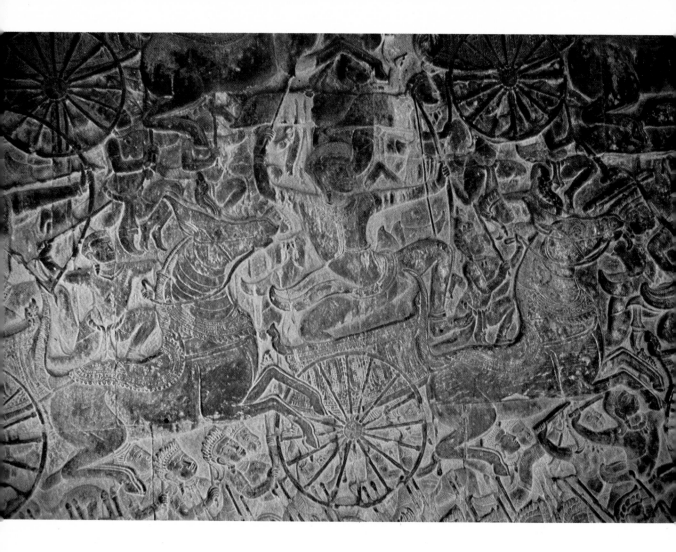

Among the most interesting sculptures at Angkor Vat are the numerous panels depicting the royal processions and the Khmer armies on the march. Like the carvers of ancient Egypt, the Cambodian sculptors have here recorded and celebrated the power and glory of the Khmer rule, leaving a lasting monument to the golden days of their empire. The majestic figures of the rulers riding on elephants and horses are surrounded by their soldiers, no doubt faithfully recording scenes from contemporary life. Yet though these scenes are treated in vivid detail, at the same time the Khmer sculptors generalize the forms and emphasize the pattern of the decorative design, making these among the most beautiful of ornamental carvings in all of Southeast Asian art.

◄ Battle scene from Mahabharata, relief carving in gallery
at Angkor Vat, Cambodia. Sandstone. Twelfth century

Royal procession of elephants and soldiers, in Bayon,
Angkor Thom, Cambodia. Sandstone. Thirteenth century

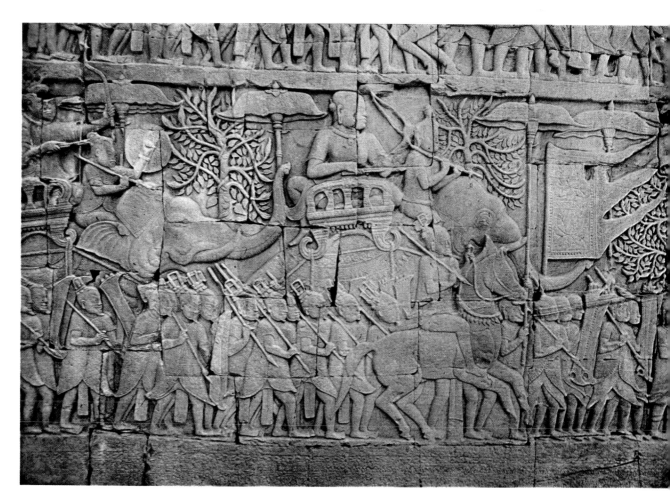

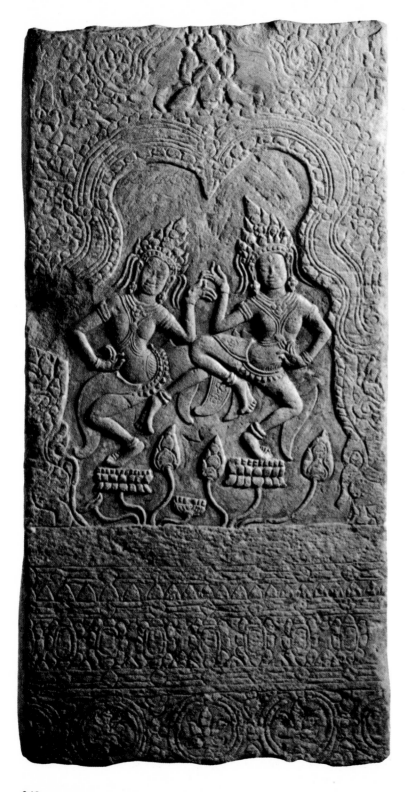

Dancing Apsarases, from Bayon, Angkor Thom, Cambodia. Thirteenth century. The Metropolitan Museum of Art, New York City

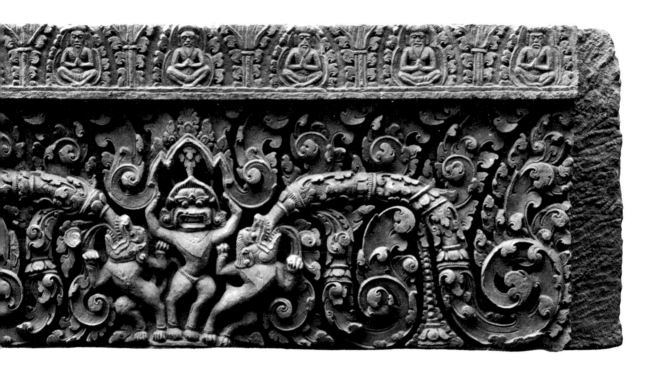

Carved lintel from Sla Vet Temple, Cambodia. Stone. Tenth century. The Metropolitan Museum of Art, New York City

The ornamental carvings decorating the facades and lintels of the Cambodian temples are among the most appealing productions of this art. The strong sense of decorative all-over design is even more pronounced, with a wealth of sculptural detail which is very effective in creating rhythmic patterns of moving forms and vivid contrasts of light and dark. Ultimately, of course, the art of Cambodia is derived from that of India, but the style which they evolved has distinctly Cambodian features. Strangely enough, there is almost no difference between the Buddhist and the Hindu works, and both religions flourished side by side in the Khmer kingdom.

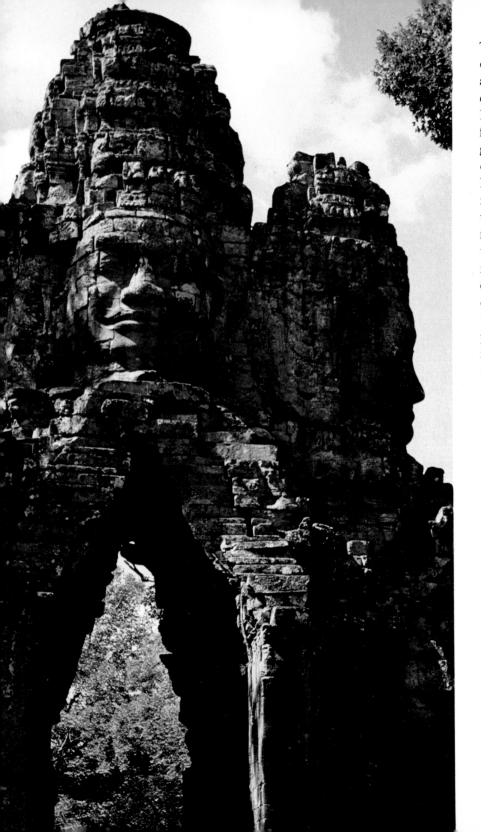

The greatest of the thirteenth-century sanctuaries, the Bayon at Angkor Thom, was a Buddhist structure dedicated to Lokesvara, the Cambodian form of Avalokitesvara, whose giant heads decorate the towers of this impressive structure. In the eyes of many critics, the images at this site are among the greatest of all Buddhist icons, equaling the finest statues found either in India or in the Far East. Certainly the concept of the Buddha as the divine being who has attained Nirvana has never been expressed more beautifully than in these smiling images from Cambodia.

Towers with giant faces of Lokesvara, Bayon, Angkor Thom, Cambodia. Thirteenth century

Giant face of Lokesvara, Bayon, ▶ Angkor Thom, Cambodia. Thirteenth century

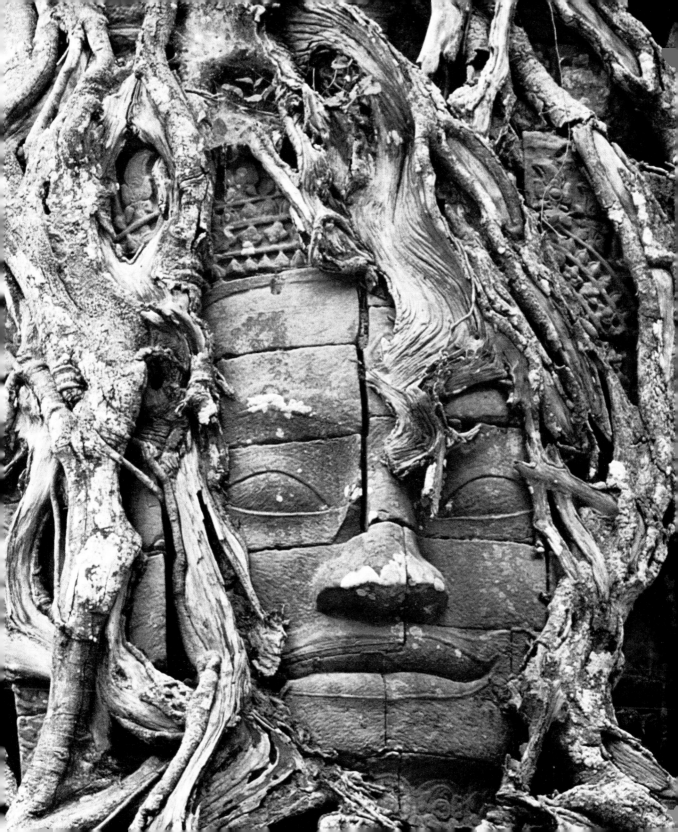

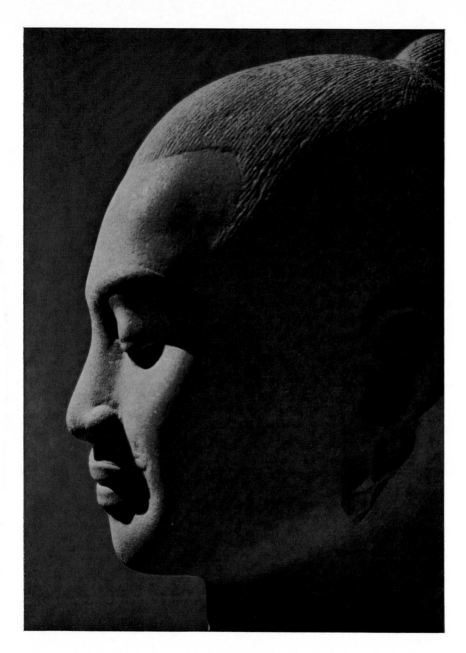

Portrait head of King Jayavarman VII. Sandstone, height $16^1/_8''$. Twelfth century. National Museum, Phnom Penh, Cambodia

The ruler responsible for the construction of this great Buddhist sanctuary at Angkor Thom was Jayavarman VII who brought the Khmer empire to the height of its glory by defeating the enemies of the Khmer people and extending the frontiers of the realm in all directions. A head found at Preah Khan is believed to be a likeness of Jayavarman. Although we cannot be certain about this identification, the carving is one of the most beautiful and moving of portrait sculptures made by the Khmer carvers and certainly suggests that this must be the portrayal of a profound and remarkable person. The forms are simplified and abstracted and show the wonderful feeling for the underlying plastic shape so characteristic of Cambodian sculptures.

Khmer army in battle, relief carving, Bayon, Angkor Thom, Cambodia. Sandstone, height $47^1/_4''$. Thirteenth century

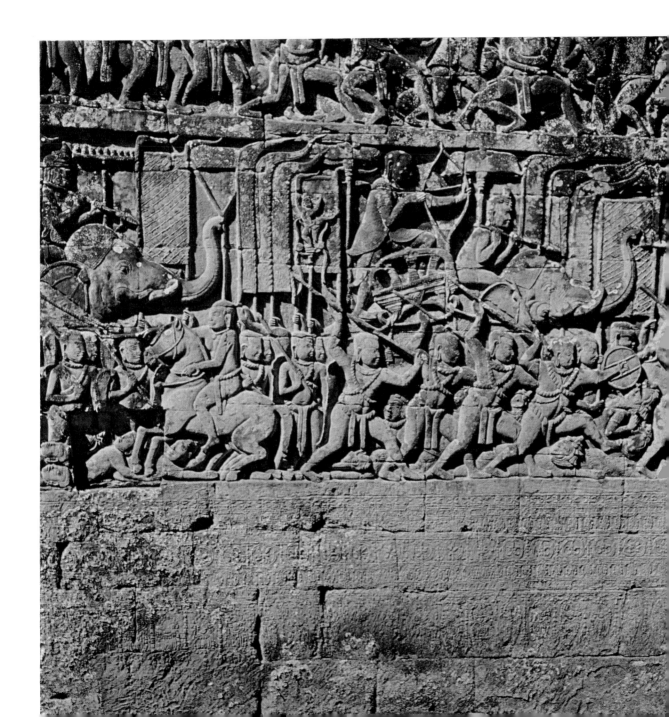

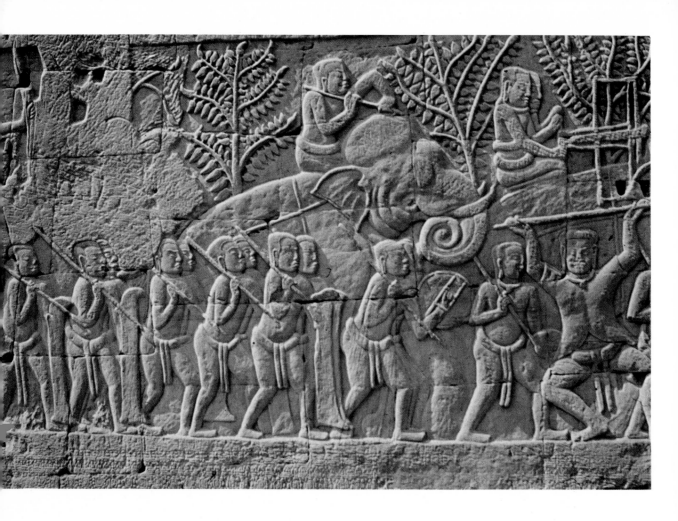

At the Bayon at Angkor Thom as at Angkor Vat, the Cambodian sculptors represented scenes from the life of the time in low-relief carvings which decorate the walls of the galleries surrounding the inner sanctuary. Executed with great skill and showing a wonderful sense of composition and all-over ornamental design, they are carvings of rare beauty and sensitivity. Particularly interesting are the battle scenes showing the Khmer armies fighting their Cham enemies (who at one point actually succeeded in occupying Angkor Vat), and the naval vessels carrying the soldiers and sailors. The style of these carvings, which are somewhat later than those at Angkor Vat, tends to be more realistic and detailed than those of the earlier works.

Episodes from the Khmer war with Cham people, relief carvings, Bayon, Angkor Thom, Cambodia. Thirteenth century

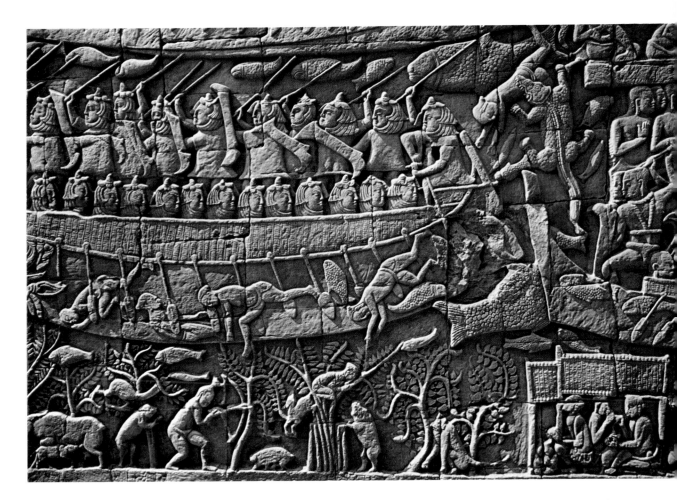

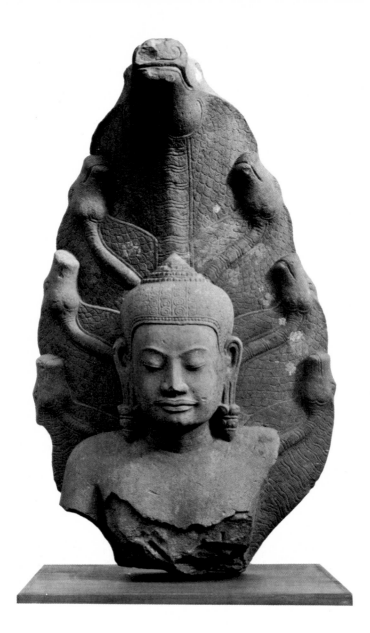

Buddha head with Naga Halo, from Cambodia.
Tenth century. The Metropolitan Museum of Art,
New York City

While the giant heads at the Bayon had represented Lokesvara, whose earthly counterpart had been the Khmer ruler himself, other carvings of the time portrayed the historical Buddha Sakyamuni. Particularly interesting are the representations of the Buddha beneath the Naga king, the ancient serpent-deity of pre-Buddhist India. Here again the emphasis is on the serenity and inner peace of the Blessed One whose beatific smile and inwardly directed gaze suggest that he is indeed the Enlightened Being. Certainly the spiritual ideal of Buddhism has never found nobler expression than in these Cambodian images which equal the finest of Gupta icons and certainly surpass any Buddhist images being made in India at this time.

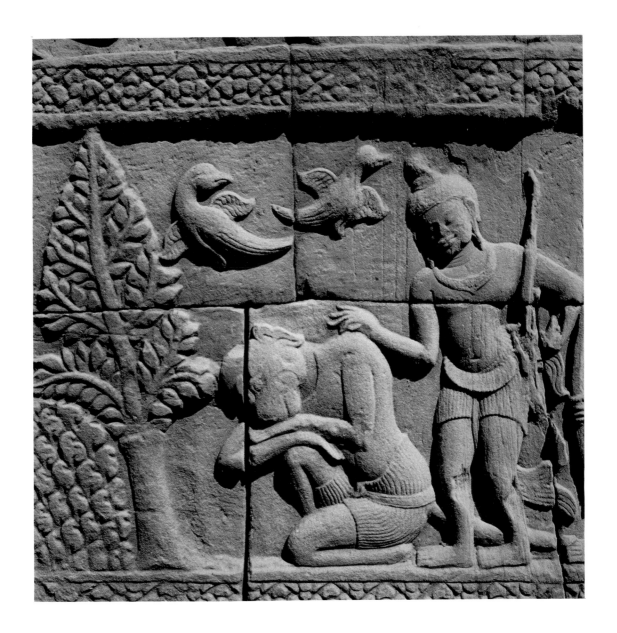

Rama comforts Sugriva, relief carving, Baphuon,
Angkor Thom, Cambodia. Eleventh century

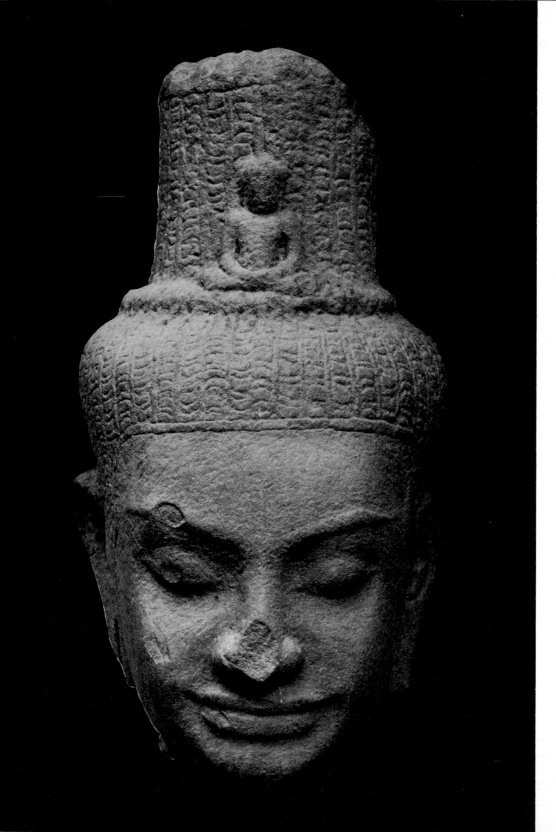

Whether they are giant stone images like those at the Bayon or small, delicate bronzes, all the Buddhist statues of Cambodia reflect the same artistic style and show the racial type which is characteristic of the Khmer people. The face is broad, almost square; the forehead is flat; the eyes are shown nearly closed, indicating that the Buddha is looking inward; and most characteristic of all, the full lips are touched with the mysterious smile so typical for Cambodian images. Next to the Buddha, the most popular of the divinities was Avalokitesvara, the Bodhisattva of Mercy and Compassion, who can always be recognized by the small image in his headdress of his spiritual counterpart, the Buddha Amitabha.

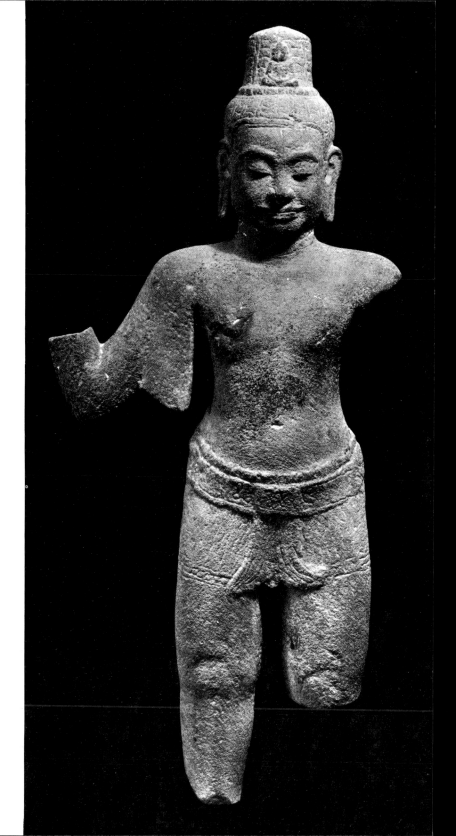

◀ Lokesvara from Phimeanathas Chapel at Angkor Thom, Cambodia. Stone. Twelfth century. The Metropolitan Museum of Art, New York City

Lokesvara from Cambodia. Stone, height 33″. Twelfth century. Ellsworth Collection, New York

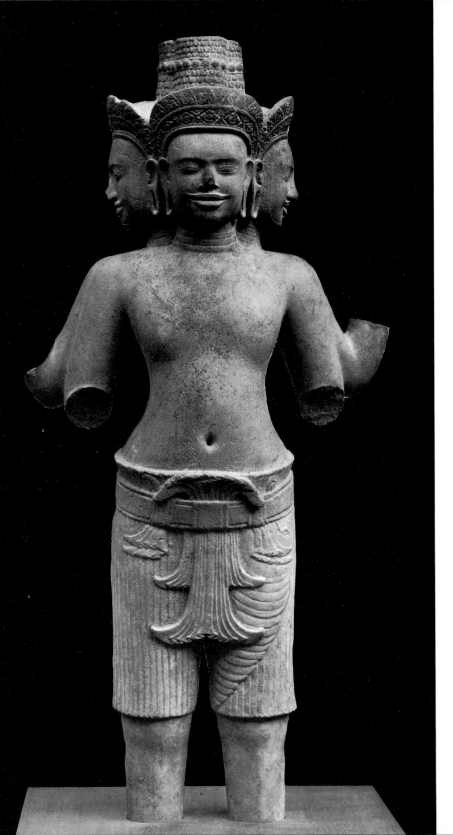

Brahma, from Prasat Prei, Cambodia. Stone, height 47$^1/_2$″. Tenth century. The Metropolitan Museum of Art, New York City

Equally common among Khmer sculptures were the representations of the gods of the Hindu pantheon, notably Vishnu, Shiva, and Brahma. The style in which they were rendered was quite similar to that used for the Buddhist images, and it is very likely that the same carvers produced Buddhist and Hindu statues, making one or the other depending upon what was commissioned. The iconography, however, is very different. Multiple limbs and heads, although not unknown in Buddhist carvings, are far more common among Hindu ones, and the treatment of the body tends to be less abstract in the Hindu images. It is interesting that the same smile which hovers over the lips of the Buddhist deities is also found in the Hindu statues.

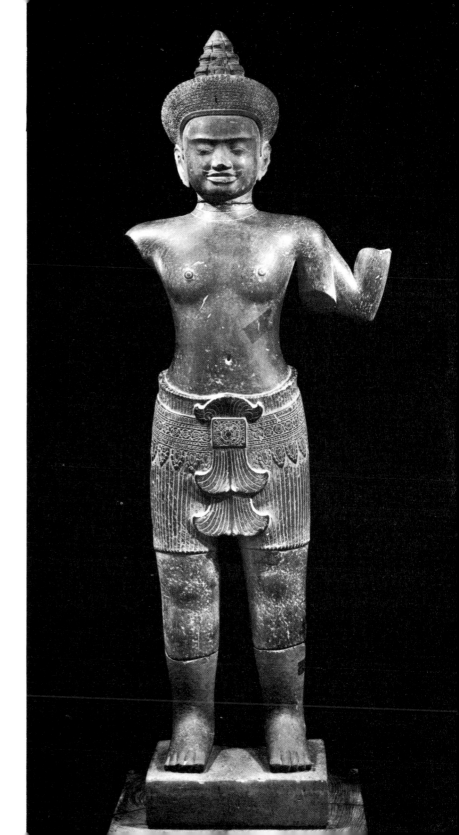

Vishnu, from Cambodia. Stone, height 40″. Eleventh century, Goldie Collection, New York

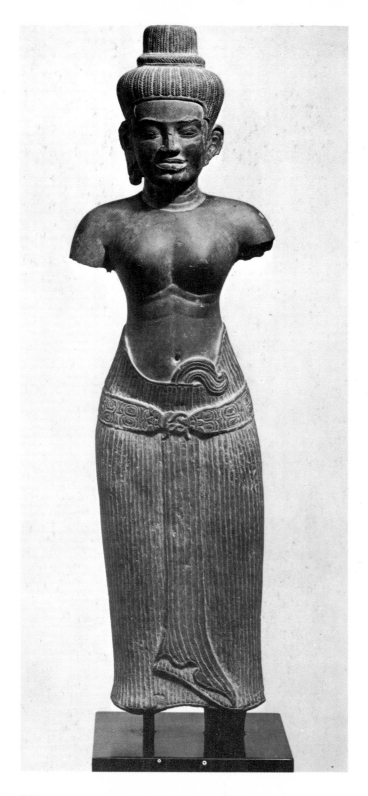

The companions to these statues of the gods are the images of the goddesses, notably Uma, the consort of Shiva, and Lakshmi, the wife of Vishnu. As in the representations of the Apsarases at Angkor Vat, these carvings show the Cambodian artists' sensitive feeling for the female form. The shapes are pliant yet firm, with a wonderful sense of the underlying plastic form. Breathing life,

Uma, from Cambodia. Stone, height 23″. Eleventh century. Ellsworth Collection, New York

vibrant yet abstract, they are works of a high artistic order not unlike those produced by modern Western sculptors. These images of the twelfth and thirteenth centuries represent not only the climax but also the end of the great tradition of Cambodian art, for after the defeat of the Khmer rulers by the Thai, this art sank into a decline.

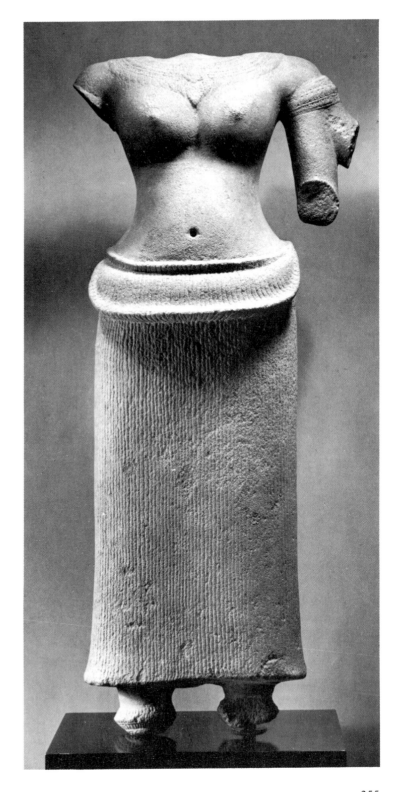

Uma torso, from Cambodia. Stone, height 33¹/₂″. Twelfth century. Sackler Collection, New York

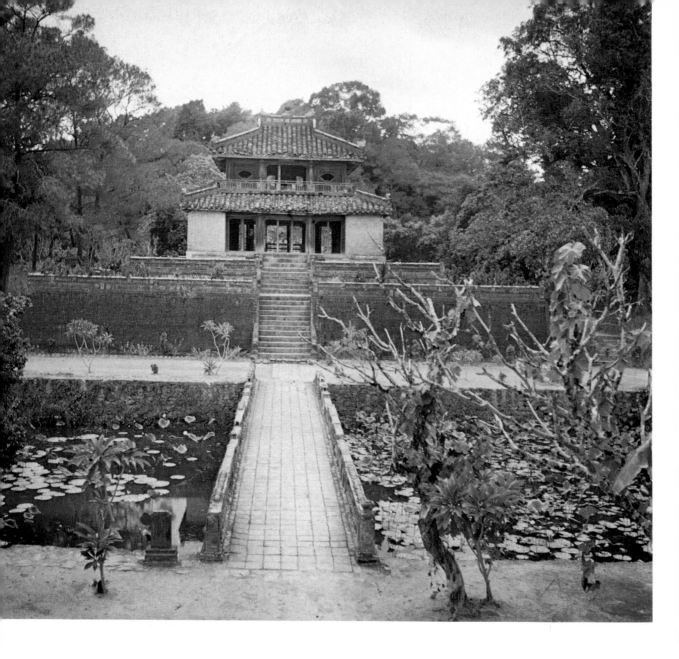

There is one more country which falls into the Indian sphere of influence, and that is the land which was once known as Annam and ruled by the Cham kings but today is part of modern Viet Nam. Although artistically less significant than Cambodia, between the sixth and tenth century Annam produced some splendid temples and fine carvings of which the graceful dancer from the seventh-century Hindu temple at Tra Kien is probably

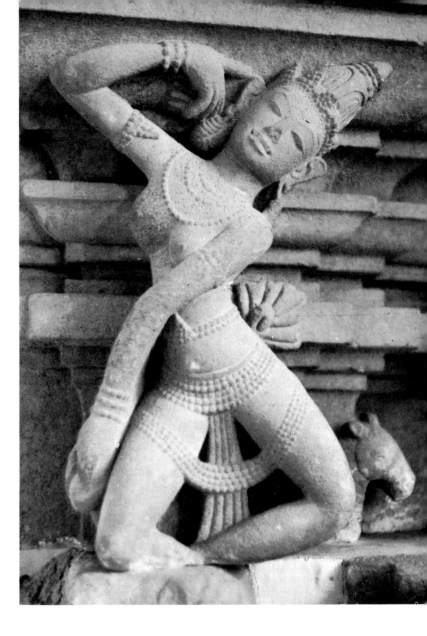

◄ Imperial Palace at Hue, Central Viet Nam. Stone, wood, and brick. Built by Gia-Long, 1833

Celestial dancer, from Mi Son, Champa, Viet Nam. Sandstone, height 36″. Tenth century. Musée Parmentier, Tourane, Viet Nam

the most famous. While the early art was influenced by India and closely related to that of Southeast Asia, the later art tended to be more under Chinese influence as is evident in the stately buildings of the imperial palace at Hue which date from the nineteenth century.

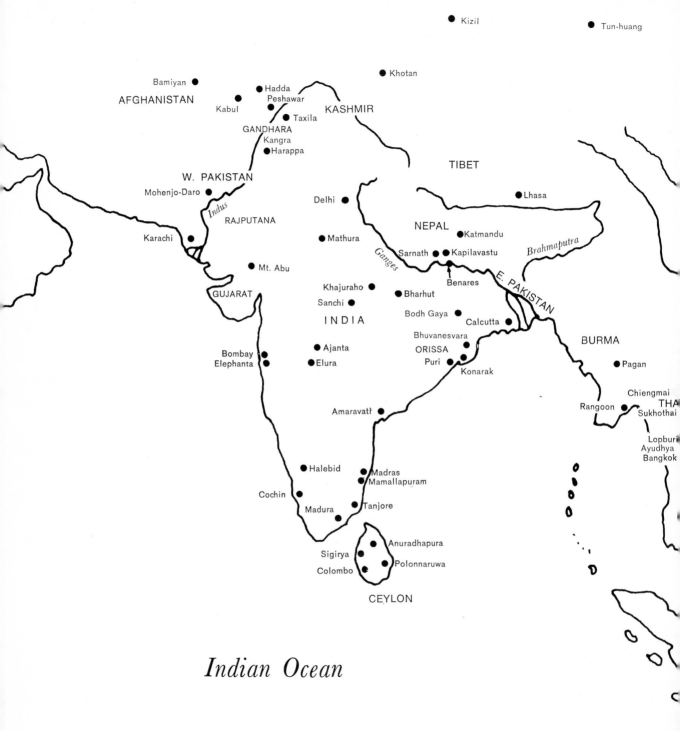

Turfan •

• Kizil • Tun-huang

• Khotan

Bamiyan •
AFGHANISTAN • Hadda
 Peshawar •
 Kabul • KASHMIR
 • Taxila
 GANDHARA
 Kangra
 • Harappa TIBET

W. PAKISTAN
Mohenjo-Daro • Delhi • • Lhasa

Karachi • RAJPUTANA NEPAL
 Indus • Katmandu
 Sarnath • • Kapilavastu *Brahmaputra*
 • Mt. Abu *Ganges* ↑
GUJARAT Benares E. PAKISTAN

 Khajuraho • • Bharhut
 Sanchi • • Bodh Gaya
 I N D I A • Calcutta BURMA
 Bhuvanesvara • • Pagan
Bombay • • Ajanta ORISSA
Elephanta • • Elura Puri • • Konarak Chiengmai
 Rangoon • • THA
 Amaravati • Sukhothai

 Lopburi
 Ayudhya
 Bangkok
 • Halebid
 • Madras
 • Mamallapuram
Cochin •
 • Madura • Tanjore

 • Anuradhapura
 Sigirya •
 Colombo • • Polonnaruwa

 CEYLON

Indian Ocean

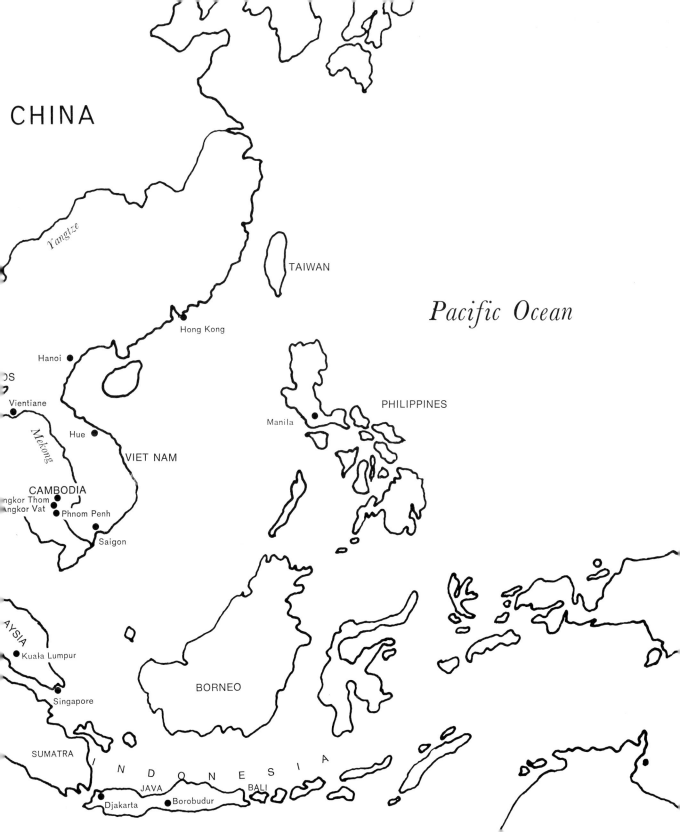

CHINA

Yangtze

TAIWAN

Pacific Ocean

Hong Kong

Hanoi ●

OS

Vientiane ●

Mekong

Hue ●

VIET NAM

PHILIPPINES

Manila ●

CAMBODIA

ngkor Thom ●
ngkor Vat ● ● Phnom Penh

Saigon ●

AYSIA

Kuala Lumpur ●

BORNEO

Singapore ●

SUMATRA

I N D O N E S I A

JAVA
Djakarta ● ● Borobudur
BALI

Bibliography

GENERAL BOOKS ON INDIAN ART

ANAND, M. R., *The Hindu View of Art,* London, 1933
ASHTON, L., ed., *The Art of India and Pakistan,* Catalogue of the Exhibition at the Royal Academy of Arts, London, 1947
CODRINGTON, K. DE B., *Ancient India,* London, 1926
COOMARASWAMY, A. K., *Catalogue of the Indian Collection of the Museum of Fine Arts,* Boston, 1923–30, 5 vols.
COOMARASWAMY, A. K., *The Dance of Shiva,* New York, 1918
COOMARASWAMY, A. K., *History of Indian and Indonesian Art,* New York, 1927
DIEZ, E., *Die Kunst Indiens,* Potsdam, 1925
FISCHER, K., *Schöpfungen indischer Kunst,* Cologne, 1959
FRÉDÉRIC, L., *L'Inde, Ses Temples, Ses Sculptures,* Paris, 1959
GOETZ, H., *India,* New York, 1959
GROUSSET, R., *India,* New York, 1931
HAVELL, E. B., *A Handbook of Indian Art,* London, 1920
HAVELL, E. B., *Indian Sculpture and Painting,* 2nd ed., London, 1928
KRAMRISCH, S., *The Art of India,* New York, 1954
KRAMRISCH, S., *Grundzüge der Indischen Kunst,* Hellerau, 1924
LEE, S. E., *A History of Far Eastern Art,* New York, 1964
ROWLAND, B., *The Art and Architecture of India,* rev. ed., London, 1967
SMITH, V. A., *A History of the Fine Arts in India and Ceylon,* rev. ed., Oxford, 1930
WINSTEDT, R., ed., *Indian Art,* London, 1947
ZIMMER, H., *The Art of Indian Asia,* New York, 1955, 2 vols.

INDUS VALLEY CIVILIZATION

DIKSHIT, K. N., *Prehistoric Civilization of the Indus Valley,* Madras, 1939
MACKAY, E., *The Indus Valley Civilization,* London, 1935
MARSHALL, J., *Mohenjo-Daro and the Indus Valley Civilization,* London, 1931
MODE, H., *Indische Frühkulturen,* Basel, 1944
PIGGOTT, S., *Prehistoric India,* Harmondsworth, 1950
SANKALIA, H. D., *Indian Archaeology Today,* New York, 1962
WHEELER, R. E. M., *Early India and Pakistan,* New York, 1959
WHEELER, R. E. M., *The Indus Civilization,* Cambridge, 1953

INDIAN ARCHITECTURE

ACHARYA, P.-K., *A Dictionary of Hindu Architecture,* London, 1927
BROWN, P., *Indian Architecture,* Bombay, 1942
CUNNINGHAM, A., *Mahabodhi or the Great Buddhist Temple at Boddha Gaya,* London, 1892

FERGUSSON, J., *History of Indian and Eastern Architecture,* London, 1876
FERGUSSON, J., and BURGESS, J., *The Cave Temples of India,* London, 1880
GANGOLY, O. C., *Konarak,* Calcutta, 1956
HAVELL, E. B., *Indian Architecture,* London, 1913
KRAMRISCH, S., *The Hindu Temple,* Calcutta, 1946
SMITH, V. A., *The Jain Stupa and Other Antiquities at Mathura,* Allahabad, 1901
ZANNAS, E., *Khajuraho,* The Hague, 1960

INDIAN SCULPTURE

BACHHOFER, L., *Early Indian Sculpture,* New York, 1929, 2 vols.
BARRETT, D., *Early Chola Bronzes,* Bombay, 1965
BARRETT, D., *Sculptures from Amaravati in the British Museum,* London, 1954
COHN, W., *Indische Plastik,* Berlin, 1921
FOUCHER, A., *L'Art Gréco-Bouddhique du Gandhâra,* Paris, 1905–18, 2 vols.
GANGOLY, O. C., *South Indian Bronzes,* London, 1915
INGHOLT, H., *Gandharan Art in Pakistan,* New York, 1957
MARSHALL, J., *The Buddhist Art of Gandhara,* Cambridge, 1960
MARSHALL, J., *A Guide to Sanchi,* Calcutta, 1918 and 1936
RAO, P. R. R., *Pallava Sculpture,* Madras, 1957
ROSENFIELD, J., *The Dynastic Arts of the Kushans,* Berkeley, 1967
ROWLAND, B., *The Evolution of the Buddha Image,* New York, 1963
SARASWATI, S. K., *Early Sculpture of Bengal,* Calcutta, 1937
SIVARAMAMURTI, C., *South Indian Bronzes,* New Delhi, 1965
VOGEL, J. P., *La Sculpture de Mathura,* Paris and Brussels, 1930

INDIAN PAINTING

ARCHER, W. G., *Central Indian Painting,* London, 1958
ARCHER, W. G., *Indian Miniatures,* Greenwich, Conn., 1960
ARCHER, W. G., *Indian Painting,* New York, 1957
ARCHER, W. G., *Indian Painting of the Punjab Hills,* London, 1952
BARRETT, D., and GRAY, B., *Painting of India,* Geneva, 1963
CHANDRA, M., *Mewar Painting,* New Delhi, 1957
COOMARASWAMY, A. K., *Rajput Painting,* Oxford, 1916
GRIFFITHS, J., *The Paintings in the Buddhist Cave Temples of Ajanta,* London, 1897, 2 vols.
HERRINGHAM, LADY, et al., *Ajanta Frescoes,* Oxford, 1915
KHANDALAVALA, K., *Pahiri Miniature Painting,* Bombay, 1958
KRAMRISCH, S., *A Survey of Painting in the Deccan,* London, 1937

LEE, S. E., *Rajput Painting,* New York, 1960

MARSHALL, J., *The Bagh Caves,* London, 1927

MEHTA, N. C., *Studies in Indian Painting,* Bombay, 1926

RANDHAWA, M. S., *Basohli Painting,* New Delhi, 1959

RANDHAWA, M. S., *Kangra Valley Painting,* New Delhi, 1954

RAWSON, P. S., *Indian Painting,* New York, 1961

ROWLAND, B., and COOMARASWAMY, A. K., *The Wall Paintings of India, Central Asia, and Ceylon,* Boston, 1938

SINGH, M., ed., *Indian Painting from the Ajanta Caves,* New York, 1954

YAZDANI, G., et al., *Ajanta,* Oxford, 1931–46, 4 vols.

INDIAN CRAFTS

BUSHAN, J. B., *Indian Jewellery, Ornament, and Decorative Designs,* Bombay, 1958

MEHTA, R. J., *The Handicrafts and Industrial Arts of India,* Bombay, 1960

SWARUP, S., *The Arts and Crafts of India and Pakistan,* Bombay, 1957

WHEELER, M., et al., *Textiles and Ornaments of India,* New York, 1956

THE ART OF AFGHANISTAN AND CENTRAL ASIA

BARTHOUX, D. J., *Les Fouilles de Hadda,* Paris, 1930

BUSSAGLI, M., *Painting of Central Asia,* Geneva, 1963

HACKIN, J., *Les Antiquités Bouddhiques de Bamiyan,* Paris, 1931

HACKIN, J., *Archéologie Bouddhique,* Tokyo, 1933

LE COQ, A. VON, *Buried Treasures of Chinese Turkestan,* London, 1928

LE COQ, A. VON, and WALDSCHMIDT, E., *Die Buddhistische Spätantike in Mittelasien,* Berlin, 1922–33, 7 vols.

MIZUNO, S., et al., *Ancient Art of Afghanistan,* Tokyo, 1964

RICE, T. T., *Ancient Arts of Central Asia,* New York, 1965

ROWLAND, B., *Ancient Art from Afghanistan,* New York, 1966

STEIN, M. A., *Serindia,* Oxford, 1921, 4 vols.

WALDSCHMIDT, E., *Gandhara, Kutscha, Turfan,* Leipzig, 1925

THE ART OF NEPAL AND TIBET

GETTY, A., *The Gods of Northern Buddhism,* Oxford, 1914

GORDON, A. K., *The Iconography of Tibetan Lamaism,* New York, 1939; rev. ed., Tokyo, 1959

GORDON, A. K., *Tibetan Religious Art,* New York, 1952

GRISWOLD, A., KIM, C., and POTT, P., *The Art of Burma, Korea, and Tibet,* New York, 1964

HUMMEL, S., *Die Geschichte der Tibetischen Kunst,* Leipzig, 1953

KRAMRISCH, S., *The Art of Nepal,* New York, 1964

ROERICH, G., *Tibetan Paintings,* Paris, 1925

TUCCI, G., *Tibetan Painted Scrolls,* Rome, 1959, 3 vols.

THE ART OF CEYLON AND INDONESIA

COOMARASWAMY, A. K., *Bronzes of Ceylon,* Colombo, 1914

COOMARASWAMY, A. K., *Mediaeval Sinhalese Art,* London, 1908

GANGOLY, O. C., *The Art of Java,* Calcutta, 1928

KEMPERS, A. J. B., *Ancient Indonesian Art,* Cambridge, Mass., 1959

KROM, N. J., *Barabudur, Archaeological Description,* The Hague, 1927, 2 vols.

KROM, N. J., *The Life of Buddha on the Stupa of Barabudur,* The Hague, 1926

MODE, H. A., *Die Skulpturen Ceylons,* Basel, 1942

MUS, P., *Barabudur,* Hanoi, 1935

SIVARAMAMURTI, C., *Le Stupa du Barabudur,* Paris, 1961

WAGNER, F. A., *Indonesia,* New York, 1959

WITH, K., *Java,* Hagen, 1920

THE ART OF BURMA, THAILAND, AND CAMBODIA

ARTHAUD, J., and GROSLIER, B., *Angkor,* New York, 1957

BEZACIER, L., *L'Art Vietnamien,* Paris, 1955

BOISSELIER, J., *La Statuaire Khmère et son Evolution,* Saigon, 1955, 2 vols.

CHAND, E., and YIMISIRI, K., *Thai Monumental Bronzes,* Bangkok, 1957

DÖHRING, K. S., *Buddhistische Tempelanlagen in Siam,* Berlin, 1920, 3 vols.

DUPONT, P., *L'Archéologie Mône de Dvaravati,* Paris, 1959, 2 vols.

DUPONT, P., *La Statuaire Préangkorienne,* Ascona, 1955

FRÉDÉRIC, L., *The Temples and Sculptures of Southeast Asia,* London, 1965

GRISWOLD, A., *Dated Buddha Images of Northern Siam,* Ascona, 1957

GRISWOLD, A., KIM, C., and POTT, P., *The Art of Burma, Korea, and Tibet,* New York, 1964

GROSLIER, B., *The Art of Indochina,* New York, 1962

GROSLIER, G., *La Sculpture Khmère Ancienne,* Paris, 1925

LE MAY, R., *A Concise History of Buddhist Art in Siam,* Cambridge, 1938

MARCHAL, H., *Les Temples d'Angkor,* Paris, 1955

PARMENTIER, H., *L'Art Khmèr Classique,* Paris, 1939

PARMENTIER, H., *L'Art Khmèr Primitif,* Paris, 1927

PARMENTIER, H., *L'Art du Laos,* Paris, 1954

RAWSON, P. S., *The Art of Southeast Asia,* New York, 1967

STERN, P., *L'Art du Champa et son Évolution,* Toulouse, 1942

WIN, U. L. P., *Pictorial Guide to Pagan,* Rangoon, 1955

Index

Photo credits: H. Bechtel, Düsseldorf, p. 118, 119, 196, 197, 198/99, 235, 246, 247. Collection J. R. Belmont, Basel, p. 126, 132, 133. J. Böhm, Mainz, p. 28/29, 30, 31, 32, 33, 37, 61, 77, 80, 81, 82, 85, 86, 87, 90/91, 94/95, 96, 97, 98, 109, 110, 113, 114, 116, 124, 167, 201, 204, 214. Boney Collection, Tokyo, p. 34, 138, 142. Ellsworth & Goldie Ltd., New York, p. 51, 134, 169, 218, 219, 232, 233, 251, 253, 254. Thomas Feist, p. 121. Fogg Art Museum, Cambridge (Mass.), p. 43. H. G. Franz Archives, Graz, p. 27, 53, 69, 104, 106. Holle Verlag, Baden-Baden, p. 17, 35, 63, 70, 256. Larkin Bros. Ltd., London, p. 7, 8, 22, 25, 26, 42, 49, 52, 55, 60, 76. The Metropolitan Museum of Art, New York City, p. 40/41, 54, 56, 120, 122, 136, 172, 179, 190, 220, 221, 240, 241, 248. Museum of Fine Arts, Boston, p. 23. O. E. Nelson, New York, p. 12, 36, 135, 183, 187, 255. Wolf Dieter Rudolph, Stuttgart, p. 228, 229. Foto Scala, Florence, p. 59, 64, 65, 71, 72, 73, 92. Sunami, p. 194. A. L. Syed, Bombay, p. 83, 84. Staatliches Museum für Völkerkunde, Munich, p. 210, 211, 231. Verlag Das Beste, Stuttgart, p. 242, 243. W. H. Wolff, New York, p. 13, 47, 115, 128, 129, 130, 131, 137, 140, 141, 146, 149, 184, 185, 186, 222, 224, 225. All other photographs were provided by the author.

The map was drawn from the author's sketch by J. J. G. M. Delfgaauw, Baden-Baden

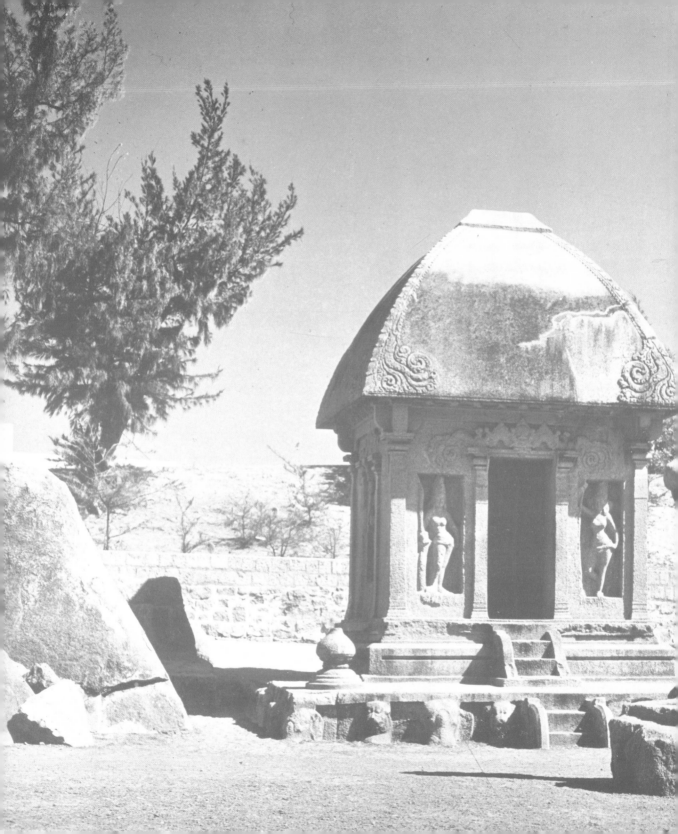